ESSAYS ON QUEBEC CINEMA

edited by
Joseph I. Donohoe, Jr.

ESSAYS ON QUEBEC CINEMA

edited by
Joseph I. Donohoe, Jr.

Michigan State University Press
East Lansing
1991

Copyright © 1991 by Joseph I. Donohoe, Jr.

All Michigan State University Press Books are produced on paper which meets the requirements of American National Standard of Information Sciences — Permanence of paper for printed materials ANSI Z39.48-1984.

Michigan State University Press
East Lansing, Michigan 48823-5202

Printed in the United States of America

Library of Congress Cataloging-in-Publication Data

Essays on Quebec Cinema/edited by Joseph I. Donohoe, Jr.
 p. cm. — (Canadian series ; #2)
 Includes bibliographical references and index.
 ISBN 0-87013-294-6 ; $25.00
 1. Motion pictures — Québec (Province) 2. Motion picture industry —Québec (Province) I. Donohoe, Jr., Joseph I. II. Series.
PN1993.5.C2E8 1991
791.43'09714 — dc20 91-52909
 CIP

In Memory of

Bill De Sua
Georges Joyaux
Dennis Seniff

CONTENTS

I.

Overviews of Quebec Cinema

II.

Filmmakers on Film

III.

Essays on Themes/Directors

IV.

Perspectives on Individual Films

V.

ACKNOWLEDGEMENTS

The editor would like to thank all of those colleagues and friends whose interest and enthusiasm helped to bring this project to fruition. I would also like to acknowledge a generous grant in support of the preparation of the present manuscript from the Government of Québec, administered with thoughtful concern by Susan Baldrey of the Québec Government Office in Chicago. I am equally indebted to the Office national du film and to the Cinémathèque québécoise for their timely and efficient response to my requests for production stills. Finally, I would like to thank Professor Victor Howard and the Canadian Studies Centre at Michigan State University for their unfailing support at every step along the way.

PREFACE

Quebec cinema may exist "de façon structurée et professionnelle" since 1939, as Yves Lever alleges in his impressive *Histoire du cinéma au Québec,*[1] or it may have come into being in the 1950s with the establishment of *France Film* and the relocation of the Office National du Film (ONF) to Montreal, as others of us are inclined to believe. In either case, the list of its accomplishments over the past three decades is both long and impressive. Rock Demers, writing in 1988 in his Preface to the *Dictionnaire du cinéma québécois* of Marcel Jean and Michel Coulombe,[2] is guilty neither of chauvinism nor exaggeration as he extols the achievements of Quebec cinema:

> Canadian cinema has been and will continue to be first and foremost *québécois* because we were the first in Canada to have our own theaters, our own distributors, our own cinema journals, an international festival and a *Cinémathèque*; because the ONF is in Montreal, because *Téléfilm* is in Montreal, because we were the first to create an agency to regulate film production, the IQC (Institut québécois du cinéma); because Quebec is the only province retaining policies which make private investment in the cinema attractive; because our supply of creative people is impressive; because we can film in English and in *French.*[3]

In the same text, Demers invokes the Festival of Festivals, Toronto, 1984, where one hundred film critics and academics voted to place seven *québécois* films among the top ten—including first place for *Mon Oncle Antoine* (1981)—vying for the honor of "Best Canadian Film of All Time," further strengthening the already considerable brief for his national cinema.[4]

It was in fact in recognition of the recent phenomenal growth and development of Quebec cinema that the Canadian Studies Center at Michigan State University convened a symposium in 1989 devoted solely to Quebec's pursuit of the Seventh Art. The interest and concern of the heterogeneous group of participants, drawn from Canada, Great Britain and the United States, led to the formulation of a plan to publish the first volume (in English) of critical studies assaying the shape and quality of Quebec cinema. Chosen for their inherent interest, with an eye as well toward some balancing of perspectives, the essays range in substance from the technical to the philosophical, from the sociological to the aesthetic, representing in roughly equal proportions *québécois* and anglophone authors.

The liminal essay of the collection was contributed by Paul Warren, film critic—his recent *Le Secret du "star system" américain* won the Belgian Film Critics Award earlier this year—and Professor of Cinema at Laval University. Professor Warren's provocative analysis documents the perilous path to be negotiated by Quebec cinema between the smothering blandishments of the Hollywood model and the arduous quest of its own authentic images. Sharing with Paul Warren the opening segment of the text is Professor Philip Reines of SUNY College, Plattsburg, who has put together a succinctly complete account of the development of Quebec cinema from the first exhibition of the Lumière brothers' invention to the present day. Rounding off Part I, Esther Pelletier of the University of Quebec at Montreal traces the growth in importance of preproduction procedures in the industry, especially the preparation of a formal scenario, while throwing some light on efforts to encourage creativity in filmmaking.

The second section is made up of commentaries by two of Quebec's most regarded filmmakers: the documentarist and pioneer of direct cinema, Pierre Perrault, and his younger colleague, the prolific *avant-gardiste*, Jean-Pierre Lefebvre. The text by Perrault, acknowledged by colleagues to contain some of his best writing, consists of a suite of puckish reflections on modern film criticism in turn witty, whimsical, and profound. This single text, in homage to the articulate prose of its often honored author, has been reproduced here in the original language. Jean-Pierre Lefebvre, on the other hand, has chosen to disarm the reader with a set of personal reminiscences on his early exposure to movies—primarily American—and his subsequent earliest efforts at filmmaking. The deftly sketched images of this piece, suffused with the history of pre-Quiet Revolution Quebec, should prove an eye-opener for many an anglophone reader.

In the third section of our text which deals with individual directors or themes, Professor Lucie Roy of Laval University executes a contained semiological analysis of the role of silence in the cinematic language of two early films of Léa Pool, *Strass Café* (1980) and *La Femme de l'hôtel* (1984). Cedric May, sometime Professor at the University of Minnesota, next surveys the considerable contribution of Pierre Perrault to the development of the documentary film in Quebec which May maintains was "the cradle of Quebec cinema, not only at the NFB (National Film Board) but also at the Office du film du Québec and on television." The section is rounded off by "Léa Pool's Gynefilms" by Janis L. Pallister, Distinguished Professor Emeritus at Bowling Green State University. Professor Pallister's contribution consists of a study of two films by Léa Pool, *La Femme de l'hôtel* (1984) and *Anne Trister* (1986) whose visual structures and ideological mythos fuse to create a "geometry" reflecting Jewish and feminist concerns which are culturally nonspecific.

The final set of essays in the collection are concerned primarily with the interpretation of individual films. To begin, Professor Richard Vernier of Wayne State University has penned an urbanely perceptive investigation of the darker considerations underlying the bland, popular grimace of *Le Matou* (1985), Jean Beaudin's film version of the successful novel by Yves Beauchemin. Does the buoyant urban cynicism of hero Florent Boissonneault herald a new Quebec, Vernier asks, and, if it does, is the attendant loss of traditional values too high a price to pay for change? Next, Adrien van den Hoven, University of Windsor, using *The Big Chill* (1983)—a model, he believes for the Arcand film— as a touchstone for elucidating the challenges faced by the *québécois* characters of *Le Déclin de l'empire américain* finds inscribed in the *Déclin* the axiom regarding the necessity of stable values which it shares with other Arcand films. Quebec society and the characters which represent it in the *Déclin* cannot, it appears, survive the "aimless individualism," or the "suicidal anarchism" which ultimately confront the characters of *The Big Chill*. In the final instance, Joseph I. Donohoe, Jr., Michigan State University, after a sideways glance at the unwitting testimony of her fellow filmmakers, points to Micheline Lanctôt's *Sonatine* (1983) as the unique example of a *québécois* film of the period which acknowledges directly the unresolved contradictions in values arising from the breathless pace of change in modern Quebec.

While critical essays comprise the main corpus of the present volume, two additional sections have been appended with the idea of facilitating further inquiry on the part of the reader. One of these is a "Biographical Dictionary" compiled by the filmmaker-critic Marcel Jean, which contains career summaries of thirty-five of the most important directors, writers, and producers in the history of Quebec cinema. The second is a concise bibliography of materials that might be considered indispensable to a wider investigation of the area.

<div align="right">

Joseph I. Donohoe, Jr.
Michigan State University
October 1990

</div>

NOTES

1. Yves Lever, *Histoire du cinéma au Québec* (Montréal: Boréal, 1988), 448.
2. *Dictionnaire du cinéma québécois* (Montréal: Boréal, 1988).
3. Ibid., xiii-xiv. My translation.
4. Ibid.

PART I

OVERVIEWS OF QUEBEC CINEMA

1.

THE FRENCH-CANADIAN CINEMA: A HYPHEN BETWEEN DOCUMENTARY AND FICTION[1]

Paul Warren

In her book, *The Québécois Cinema in Search of Its Public*, Ginette Major writes that "the *québécois* viewers have always been deeply rooted to the American cinema, to such an extent that we can say without exaggeration that the true cinema of the French-Canadians is the American cinema."[2] To extend the thought of Ginette Major, consequently, the *québécois* filmmakers have always had the thankless task of engaging a public that is fascinated by the Hollywood dream.

In fact, Major attributes to herself what many critics of the *québécois* cinema have been saying for years. For example, one can read the following in one of the reports of the Quebec Filmmakers Association: "The American model has succeeded in conditioning a system of expectations, a scale of values and criteria of taste, in brief, in creating for the *québécois* viewer an American vision of the world."[3]

Even though our parents, as viewers of American movies, could not understand the language spoken by the protagonists, they devoted themselves passionately to the cinematic language, to the horizontal reading of the action, anxiously waiting for the end. This reading carried them consistently forward, instilling in them, without their knowledge, the American nation-founding myth par excellence, the great "sacrificial" and "transfiguring" movement toward the West.

Americans know the importance of the frontier: "this myth of the frontier," as Robert Sklar put it, which transformed itself into the "go West young man" motto. What they probably do not know is its impact on the French-Canadian viewers of American films. Through the filmic movement forward, shot after shot, sequence after sequence, they have been exposed to the movement toward the West, as movement only, without sharing the true content of the myth.

It is clear that this movement toward the West, a movement that is historical as well as mythic, has shaped and moulded American cinematography. This movement is profoundly rooted in the immigrants. It had its source far away in the East, in Europe, and often in Eastern Europe; it found itself again in the ports of New England, in New York, on the East Coast of the new world, ready to move again, stronger than ever, stage by stage, frontier by frontier, as far as the Pacific Ocean.

We must add to that how urgent it was for the unity of the nation to ratify and prolong this movement into the mind, into the reality, and, later on, into the cinematography of the Americans.

It is important, here, to mention that the French-Canadians, who (let us repeat it) have always been fans of American films, have at home a substitute for the mythical and historical content of the American movement West, and it is the extraordinary Catholic Christian movement from terrestrial passion to the heavenly resurrection of Christ—a ritual movement which inhabited their traditions for three centuries before the coming of cinema, a movement all the more radical because it was transmitted to them through a liturgy (no less spectacular and fascinating than the cinema will be later on), the Latin language of which was unknown to them.

During the twenties and thirties, 90 percent of our screens were already occupied by American movies. Yet it was during these decades that classical Hollywood cinema definitively structured its patterns of fascination. What is remarkable, indeed, during the golden age of Hollywood, what has astonished the French of France and has structurally touched the French-Canadian viewers, is, as the French theoretician, Gilles Deleuze writes: "the inexorable organico-active unfolding of the plot toward an outcome."[4] As if what was unwinding on the screen imitated, to the letter (to the image), the mechanical unrolling of the celluloid within the projector.

In fact, since the beginning of the twenties, French-Canadian viewers, like American viewers themselves, have been exposed to a global cinematic movement toward an obligatory ending; and through this global movement, they have experienced visually, in film after film, an intensification of partial or sequential movement through a planned and invisible system of shot/reaction shot, always rushing forward. Robert Sklar, in his *Movie-Made America,* links the dream factories of Hollywood to the automobile factories of Detroit. He shows that the production of an American film, from its script to its dubbing, obeys the same process as the production of a car through the mechanics of the assembly line.[5] Then, as soon as the filmic product leaves the studio and displays itself on the screen, it slides into our souls and minds with the same fluidity as the movement of a car on the highway.

GODARD'S REFUSAL

It is, perhaps, Jean-Luc Godard who has tried hardest to stop the inexorable linear movement of the Hollywood cinema. We must keep in mind that Godard, while a critic and before making any films, had been charmed and deeply influenced by Hollywood cinema. I would like to focus on Godard, briefly, because it appears to me that this particular filmmaker does express clearly the *québécois* filmmakers' refusal of the Hollywood cinema (a cinema, let us say it again, that also belongs to the *québécois* viewer).

There is no cinema more anti-American than the cinema of Godard. It is as if the filmic creation of Godard were a kind of undertaking to disorganize the system of integrated and invisible progression of the Hollywood narrative in order to bring back to the eye and to the ear what American filmmakers have persisted in concealing since Griffith. Such was the reaction of an American film professor at UCLA during a mini-festival of Godard's films: "Godard," as he put it, "is a dangerous man who is trying to destroy the cinema."

In his film, *Soigne Ta Droite* (1986), Godard plays the principal part. In the beginning of the first sequence he appears and starts to behave strangely. Standing in the center of the frame, he moves his head to the left, then to the right, all the while whistling. Every time his panoramic movement brings him in the middle of its trajectory facing the public, he either applauds or pretends to box an invisible opponent. In this strange behavior, Godard gives us the key to his cinema and the way to look at his films. He says to the viewer: you must not wait in this film (no more than any other film of mine) to become involved in the seductive voyeurism generated by the shot/reverse shot technique.

As a matter of fact, the system of shot/reverse shot does not exist in Godard's cinema. In addition, to a certain extent, there is no "off-screen" in his films. Consequently, if we accept with Christian Metz that the "off-screen" is the privileged space, the "real" place of the viewer,[6] the place where he conceals and anticipates the luminous shots of the screen, one must conclude logically that the viewer in the dark movie theatre facing Godard's images does not feel at home (which is the very least we can say!).

Let me focus on two or three things I know about Godard's cinema. It will help us better to understand the authenticity of the *québécois* cinema. What seems to me the most important characteristic of Godard is the strong presence of the actor (or the actress), the strong presence of the word, of the note of music, within the sequence. A presence that intervenes between two elements, in "l'entre-deux," between two things, between the shot and the reverse shot, between the one who is looking

and the one who is looked at. It is as if Godard were trying to disjoin the shot from its twin brother, the reverse shot, and then to install his camera in between in order to create freely his images and his sounds.

Juliette: Two years ago in Martinique. Exactly like in a Simenon novel. No, I don't know which one . . . yes, *Banana Tourists,* that's the one. I have to manage somehow. Robert earns one hundred ten thousand francs a month, I think.

Commentary off: *Now, she turns her head to the left . . . she does not turn . . . but it doesn't matter . . . she turns her head to the left. . . .*[7]

What appears here, clearly, more so than in the similar sequence from *Soigne Ta Droite,* is at the same time the systematic refusal of the shot/reverse shot and the consequence of this refusal. In causing Marina Vlady alias Juliette Janson to turn her head to the right, then to the left, and in getting himself involved through the *commentary off* to say that it does not matter, Godard contradicts the viewer's imperious need to see what the character is staring at. In so doing, he eliminates the "hors-champ" (the off-screen) and destroys the fictional Hollywoodian system: that is, "to sell stars to the public" through the transformation (the metamorphosis) of the actor into the character via the comings and goings of the shots and the reverse shots.

Then, the viewer, since he can no longer give himself to his usual linear galloping, is obliged to look personally at and listen to this woman on the screen, who, strangely enough, has not been caught by the star system, who has succeeded in escaping it. It is the actress, Marina Vlady, who comes to life in front of us. It is she who brings us to her character, Juliet Janson, preventing us from ever fusing the two together.

To sum up, Godard, in blocking the horizontal movement from shot to shot, forces us, at the vertical level (so to speak), to make the distinction between the actor and the character, between the real and the imaginary, between documentary and fiction.[8]

QUEBECOIS CINEMA'S REFUSAL OF HOLLYWOOD

If we focused that long on Godard's cinema, it is because it resembles the *québécois* cinema. That does not, however, make our cinema Godardian. The *québécois* cinema is no more Godardian than Godard himself is Eisensteinian or Vertovian. As a matter of fact, Eisenstein and Vertov tried to "marxicize" their cinema in the face of the most bourgeois system of production in the cinematic world; Godard wants to save cinema from what he calls "the gestapo of the Hollywood system." The *québécois* cinema tends to protect the cinematic "québécitude" from the fascinating Hollywood patterns. What these cinemas do have in common is a refusal of the star system.

We must start with Pierre Perrault in order to reach the heart of Quebec cinema. Perrault is to the *cinéma québécois* what Capra is to American cinema. Perrault's documentarism comes as much from the need of direct contact with the *québécois* reality as from his hatred for cinematic fiction. When Perrault says that he doesn't know the actress Carole Laure, "not even the color of her hair," as he puts it, he means of course the Carole Laure who became a star due to the star system, a star he is indirectly accusing Gilles Carle of having produced.

La Bête lumineuse

According to the nationalistic poet, Pierre Perrault, the fiction that mass produces stars is a lie and a trap. So, to abandon oneself to fiction is to lose one's own identity. It means "to sell one's soul for money." The Perrault texts on Hollywood fiction are violent. He compares it to "Colonel Sanders," to "Pepsi," or to "artificial flowers." These references remind us of Godard's ferocious anti-American criticism during his

Dziga-Vertov period. They recall to us the Soviet Kinoks manifestos concerning American films: "cine-stubs," "cine-haschich," "cine-opium," and so forth.

There is no risk, whatsoever, for the "characters" of Perrault's films, of being deprived of their identity and their French-Canadian speech, their "parlure," as Perrault calls it, least of all. When Perrault has his characters speak *en direct,* directly and spontaneously, in front of the camera, he gives them their space and their own habitat, and moreover, because he is making a documentary, he protects his characters, preventing them from being caught up in the machinery of the systematic shot/reaction shot, and consequently, in the fictional gearing of the looked at and the looking at.

These two characteristics of Perrault's cinematic space—colloquial French-Canadian language and documentary instantaneity—are the basic characteristics of Quebec cinema, the fictional as well as the documentary.

Our cinema, it has been noticed many times by *québécois* critics, is extremely—and colloquially—talkative. At the beginning of our cinema, when the National Film Board was located in Ottawa, making films— for the few *Québécois* who could—was the equivalent, more or less, of taking up the cause of their own language in an environment where English was dominant. This was a much more urgent need than making images. It is important to point out that the *Québécois* have never made silent movies, so they were not used to playing with images. In fact, we started to make "talkies," and then went in search of our images. In Quebec Catholic tradition, the language was the protector of the faith *(la langue gardienne de la foi).* When we lost our faith, sometime during the fifties, we had to express ourselves strongly in our French-Canadian language in order to discover and to protect our images.

Add to that the fact that having been, for decades, the half-deaf and voiceless viewers of American movies had reinforced in us the need to hear our cinema speak our own language. Then, after the move of the National Film Board to Montreal, in 1956, in a period when Quebec was beginning its "quiet revolution" and the taking on of its own cultural and political identity, the need to speak openly and in "official" *québécois* made itself felt very strongly indeed.

The *québécois* documentary put down its roots during the sixties, in the thick of the "Quiet Revolution" with the films of Perrault as its cornerstone. In this cinema, it was the microphone that first went into action, in order to pick up the liberated and improvised words of ordinary people, and to drag the camera toward the spoken word. We convinced ourselves then that our images could not flow except in parallel with, and through the stream of, our authentic *québécois* tongue. As if our

language, by dint of its being spoken, was capable of creating the very images that suited it.

In the middle of the sixties, the *québécois* cinema took up fictional feature films. Yet, from that time until the present, our fiction has always been marked by the documentary approach and, above all, by the direct oral accent of the French-Canadian language. There have been, from time to time, a few break-aways toward the French accent of France and, at the same time, toward a freer visual creation, as if the separation from our linguistic tradition could provoke the liberation of the images. That happened, particularly, in the euphoria of our first fiction films: *A Tout Prendre* (Claude Jutra, 1963), *Le Chat dans le sac* (Gilles Groulx, 1964), *Le Festin des morts* (Fernand Dansereau, 1964), *Poussière sur la ville* (Arthur Lamothe, 1965), *Kid Sentiment* (Jacques Godbout, 1967), and *La Chambre blanche* (Jean-Claude Lefebvre, 1969). However, the great majority of *québécois* features avoid the use of the French way of speaking with the same energy as they push away American image-making. True to its documentary approach, Quebec cinematic fiction starts with Quebec colloquial language and wraps its images tightly around it.

In order to catch correctly the peculiarity of the *québécois* "parlure," its savour and the antiquity of its expressions, Perrault, the documentarist, moved deep into Quebec, into the "québécoisie," as he puts it, as far as James Bay (the "Jamesie"), there, where Quebec is still intact, undamaged, not yet spoiled by the Anglo-Saxon invader.

As far as feature films are concerned, the *québécois* filmmakers, in order not to weaken the popular vigor of the *québécois* vernacular and, at the same time, in order to contextualize its particular accent, relegate their protagonists either to their past (through retro films) or to their present: in their kitchens, in the back of their shops, and in their backyards. In short, the *québécois* fiction filmmakers make documentary images as a fitting background against and through which the characters speak *québécois.*

Fernand Dansereau, one of the most respected *québécois* filmmakers, has mentioned more than once the difficulty for *québécois* cinema of abandoning itself in fantasy. I think one must go further and say bluntly that our cinema is, in itself, a refusal of fiction. It refuses completely to play (and it is not merely a question of money) the industrial and commercial game of the big cinematographic buildup that creates stars. It refuses to tap into the current that lights up actors and actresses like electric bulbs, in order to make them fit the dualist system of luminous screen/dark theatre.

It seems, at times, as in *Mon Oncle Antoine* (Claude Jutra, 1971) or in *La Tête de Normande St-Onge* (Gilles Carle, 1975), that we will play the game and enter the cinema of fascination, that we will break loose

and get into fiction. One finds, in fact, in these movies, the paraphernalia of sliding industrial patterns that allow the viewer to gallop from shot to shot and sequence to sequence. There is, for instance the usual progression of plot, the voyeurism generated by the dualist game of the "looked at" and the "looking"; but after a while things branch out: many plots begin, yet not one is developed to the end—we could make three or four films with *Mon Oncle Antoine*. It is almost as if, in the last rescue scenes, we were drawing back from the cinematographic machine, refusing to be dragged into it.

Mon Oncle Antoine

So, we refuse commercial filmic language in order to preserve our national colloquial language. This refusal expresses itself primarily in the behavior of the actors and actresses. As a matter of fact, they do not really play the game. One has the impression, in a *québécois* feature, as well as in a TV serial, that the actors are always searching for their character, forcing themselves to find the right accent and the proper "parlure." As if they were trying to be as real and true to life as in a documentary. If the non-actors of Perrault "have the country in their feet," the actors of our features never leave their characters by so much as a single inch.

This particular way of acting gives the characters of our features a kind of human depth, and, to a certain extent, an unusual presence on the screen. This happens to a degree that the viewer, at least the *québécois* viewer, may feel ill at ease. It seems that the impression of reality, to which the *québécois* viewer is accustomed, and which is obligatory for the identification process to play its role, does not really work with a *québécois* feature. But let us be more precise. As we have implied already, on the horizontal level, our movie images do not aim at relaying one another according to a forward movement that draws the characters in its wake. If we add to that the fact that, on the vertical level (so to speak), the actor does not lose himself in his character, but rather imitates it, playing the natural, we can understand why it is difficult for a viewer to abandon himself to a *québécois* fiction film.

We sometimes reproach the *québécois* actors for playing badly or for overacting. We criticize equally our filmmakers for the incompetent direction of their actors. There is something else, however. It seems to me that there is an unavowed fear, both in the actor and in the filmmaker, of losing oneself in fiction. All of which brings us back to Godard. Strangely enough, it is not the *québécois* films directly inspired by Godard's films—especially those produced during the sixties—that are nearest to Godard's approach. It is rather the *québécois* fiction film that is more directly related to the documentary.

When Perrault writes in *Caméramages,* "in fiction film, I am in a foreign country, in documentary I am at home," he expresses what is fundamental in the *québécois* cinema.[9] We tried, during the sixties and the seventies, to separate clearly fiction from documentary. Yet, a great number of our filmmakers, considering (probably) that the attempt was unsatisfactory, decided to let documentary enter their fiction. I am thinking in particular of the following motion pictures of the eighties: *Marc-Aurel Fortin* (André Gladu, 1983); *Le Dernier Glacier* (Jacques Leduc, 1984); *Les Années de rêves* (Jean-Claude Labrecque, 1984); *Caffè Italia Montréal* (Paul Tana, 1985); *Contes des mille et un jours, ou Jean Desprez* (Y. Rossignol, 1986); and *O Picasso* (Gilles Carles, 1987).

In a few of our features, we go so far that one of the characters may leave his fictional story line and start speaking directly, "documentarily," to the viewers (to the public). In *La Quarantaine* (Anne-Claire Poirier, 1983), whereas all the characters were already involved in the plot, the fiction stops suddenly to let a documentary scene intervene. The actress, Monique Mercure, appears in medium close-up and starts to speak to us. She is seated on the steps of St.-Hyacinthe church, at exactly the same place where, one image before, the fiction was taking place. She tells the age, the name, and the profession of Louise, the character she is playing in the movie. Looking us right in the eyes, she explains the rules

of the fictional structure that has already started to develop and that will return to its normal progression right after she returns to her character.

Why is this documentary shot within the fictional sequence? Narratively speaking, it is absolutely not necessary. Nothing is said in this shot that could not have been said and integrated into the indirect discourse of the fiction. As a matter of fact, this very shot (this sequence of shots, to be precise), brings to us, *directly (en direct)*, the speech of Mercure/Poirier. Adding to the fact that it reveals a few autobiographical traits of the filmmaker—lawyer, journalist, for instance—this sequence of shots does express to us a feminist dimension that concerns, in reality, both Anne-Claire Poirier and Monique Mercure. As if it were necessary to set aside the fiction in order to make ourselves heard and understood correctly. As if certain truths, certain obvious facts, certain national realities would risk being unnoticed or being swept along in the fictional flow.

There is something else in this sequence. Monique Mercure, when she speaks to us directly, using her own *québécois* accent (her own version of the *québécois* accent that we already know, because we have seen her in interviews on television), does so because she wants us to know that she will do her best to maintain the same style and the same "parlure" when she returns to fiction to rejoin her character once again.

Québécois cinematic fiction can go still further in its integration of documentary. In her feature film, *Laure Gaudrault,* Yolande Rossignol forces her protagonist, Louisette Dussault, to move constantly, and often in the same shot, from fiction to documentary and vice versa, as if this very movement should become the national movement of our motion pictures.

It is clear to me that for the *québécois* filmmakers, fiction and, above all, Hollywood fiction, is seen as a trap.

The writer and filmmaker Jacques Godbout has just made an interesting documentary, *Alias Will James* (1988). It is about a French-Canadian by the name of Ernest Dufault, who really (we are in reality) trapped himself into the mythology of "go West young man." He was so fascinated by westerns that he went so far as to despise and repudiate his French-Canadian origins, pretending he was born in Nevada. He became a celebrity among American cowboys. At the end, however, he became confused, started to drink, and lost everything.

If the *québécois* cinema fears falling into Hollywood patterns and esthetic conventions it is because it feels the technique is not gratuitous and that it always reflects a certain mythology.

When we dare to play the game of the successful Hollywood cinema—as in the case of the big box-office film, *Les Tisserands du pouvoir* (Claude Fournier, 1990), and the extraordinarily popular TV serial, *Lance et*

compte (Jean-Claude Lord and Richard Martin, 1986)—we usually take precautions. We bring into the fictional story line and among its stars some non-actors—a few *québécois* personalities from sports, journalism, and politics—in order to give viewers the illusion of being so grounded in national realities that they do not run the risk of losing themselves in the fiction.

Cinémathèque québécoise

Jacques et novembre

We dare to risk everything and throw ourselves into the impetuous current of Hollywood fiction without a life preserver when we think we are Spielberg and we plunge into the dragon's belly—as happened with Yves Simoneau's film (which has this very title, as a matter of fact, *Dans le ventre du Dragon,* 1989), which has attracted French-Canadian viewers as honey attracts flies—and this causes problems. In Simoneau's film, our *québécois* heroes sink intrepidly into the factory of the Hollywood action film. So much so, that they are carried away by the binary couples, the parallel montage, and the shot/reverse shot, which function in their purity (*presque à l'état pur*). Consequently, they lose their spatio-temporal identity and even their colloquial language, which, in this commercial structure and artificial context, strike a false note. Ironically, the filmmaker is obliged to get involved, personally, through

a "deus ex machina" technique, in order to save his protagonists from the dead end to which he has consigned them.

By way of conclusion, let me say that the hyphen between documentary and fiction is as strongly installed in our national cinema as it is in our own name, between French and Canadian, i.e., French-Canadian. So we probably should not call our cinema "the *québécois* cinema," but rather the "French-Canadian cinema."

When we explode our national hyphen, either we stay at home, nice and warm, "en québécoisie" (as in Perrault's documentaries), or we risk losing ourselves in Hollywood fiction. Still, it seems to me that the authenticity of our cinema stems from our fiction in search of our documentary and vice versa, or, to put it another way, from our own real language in search of our images. Our best films imply this very movement.

From this point of view, the film *Jacques et novembre* (1984) by François Bouvier and Jean Beaudry is remarkable. The filmmakers succeed in elaborating, deepening, rendering precisely, and finally, fictionalizing our "parlure," our particular, unique way of speaking. Simultaneously, they create our own images.

Laval University

NOTES

1. Keynote address given at the Michigan State University Symposium on "The Modern Québec Cinema," East Lansing, 7–9 April 1989. Portions of this text appeared in the *Revue Belge du Cinéma* 27 (Fall 1989).
2. *Le Cinema québécois à la recherche d'un publique* (Québec: Les Presses de l'Université Laval, 1982), 18.
3. "La Culture et le cinema au Québec," Memoire addressé au Premier Ministre René Lévesque par l'Association des réalisateurs des films du Québec (ARFQ), *Cinéma Québec* 53 (1978): 20.
4. *Image-mouvement, cinéma I* (Paris: Les Editions de minuit, 1983), 49.
5. Robert Sklar, *Movie Made America* (London: Chappell and Company, 1975).
6. *Le Signifiant imaginaire,* UGE, coll. "Dix-dix-huit" (Paris: 1977), 77.
7. *L'Avant-Scène du cinéma* 70 (May 1967): 11.
8. Paul Warren, *Le Secret du "star system" Américain* (Montréal: l'Hexagone, 1989), 187–200.
9. Pierre Perrault, *Caméramages* (Montréal: L'Hexagone, 1983).

2.

THE EMERGENCE OF QUEBEC CINEMA: A HISTORICAL OVERVIEW

Philip Reines

From its beginnings in the 1890s, the commercial film industry in Canada, apart from isolated, short-lived regional attempts, was almost totally dominated by the major film studios of Hollywood. Indeed, from 1920 through 1955, Hollywood was the single, dominant center of commercial feature film production in the world. It is no surprise, therefore, that its film studios, with their world-wide network of established theatres and their distribution monopoly, should wield enormous economic and political power beyond U.S. borders.[1]

American control of the Canadian market was attained during the First World War, largely because that conflict brought film production to a virtual halt in every involved country except the United States. In Canada, the Hollywood studios moved quickly to expand their already extensive theatre chains by the purchase of many locally operated outlets. Having increased its control of the market by adding distribution and exhibition to its production monopoly, Hollywood used political influence gained through foreign investment to persuade government officials in Canada to discourage any attempts to challenge this status quo.[2] Commenting on the dearth of any important film production in anglophone Canada during the years prior to the founding of the National Film Board in 1939, cinema historian Gerald Pratley wrote:

> Canada's early work in film-making is not important and there is little point in trying to pretend otherwise. Between the years 1896 when films as we know them were first projected in . . . [Canada] and 1939, when The National Film Board was formed, the production of motion pictures in Canada was often interesting, determined, usually well-intentioned . . . but in the end sadly insignificant, with little impact on audiences and containing little value for present-day study. . . .[3]

From the 1920s through 1939, with rare and isolated exceptions, English-language films exhibited in Canada were almost always either from Hollywood or England and, because of Hollywood domination of English cinema, the English product was, more often than not, a film made in an American studio in England, e.g., MGM-British. As a result of this monopoly, the feature-film industry in anglophone Canada remained nonexistent. Until the establishment of the National Film Board in 1939, film production in Canada was mostly confined to industrial, government, or educational short films made with small budgets and for limited distribution.[4] The only consistently creative and modestly successful independent production efforts were to be found in the Province of Quebec from 1937 to 1953. It was during this period that Quebec cinema began to grow.

Quebec, unlike the English-speaking Canadian provinces, was almost totally dominated by a francophone culture dating back to the sixteenth century and France's colonization of the New World. Separated from anglophone Canada by language, culture, and religion, the people of the province became even more protective of their separate identity after the French defeat in the mid-eighteenth century. Attachment to the land and spiritual ties to France and the French culture, together with the strong influence of the Catholic Church, created a cultural triumvirate that ensured the preservation of a separate *québécois* identity.

The exhibition throughout the province of French-language films imported from France beginning in the 1930s both built upon and enhanced the francophone character of Quebec. The freedom from monopolistic distribution of English-language films, which the success of this activity supposes, was an important factor in providing local francophone production companies a ready-made and willing audience when time and circumstance permitted. Prior to the move of the National Film Board to Montreal and the subsequent creation of the French language unit in 1959, francophone film studios barely subsisted; afterward, one finds a steady increase in number and in sophistication.[5] As such, the indigenous industry would reflect the momentous political and social changes in post-World War II Quebec that helped to shape it: at first as an uncertain hybrid, "French-Canadian Film," it would emerge after the turbulent sixties as the "cinéma québécois," made in the image of the "new" Quebec, reflecting cultural self-assurance and eager to test its creative capabilities.[6]

In order to understand the dramatic growth of independent francophone film production in Quebec, it is necessary to begin with the presence of the Catholic Church. From the beginning of colonization to the mid-twentieth century, the precepts of the Church dominated the social and cultural fabric of francophone Quebec. In 1907, it exercised a powerful moral influence and admonished its followers in the

province not to attend cinema showings on Sundays, and to avoid films in general because of their "corrupting influence." In 1912, strongly influenced by the Church, Quebec Province adopted a censorship law on motion pictures in order to "protect" further the people from the medium.[7] Fourteen years later in 1926, the censorship was considered so restrictive that major domestic and foreign distributing companies not only complained but threatened boycotts throughout the province, arguing that this law, if enforced, could severely threaten the exhibition of imported feature films in the Quebec theatres. Yet, while faced with a heavy loss of revenues, the American distributors ultimately relented, although complaints continued to be forwarded to the Quebec government. According to cinema archivist and historian Pierre Véronneau, the persistence of the Catholic Church in forbidding attendance at the cinema on Sundays, and its general disapproval of film lasted "until 1939 after which the Church will adopt a more conciliatory attitude."[8]

What little film production took place in Quebec from 1912 to 1936 is incidental to this study. However, it is appropriate to acknowledge that the first successful creative attempts in independent filmmaking began, ironically, with the individual efforts of two Catholic priests. First, Father Albert Tessier, utilizing his own funds and 16mm equipment, traveled Quebec from 1927 to 1960, and produced some seventy short films, which recorded a rural, traditional people, and the beauty of the landscape.[9] Father Maurice Proulx, in the period 1934 to 1961, produced thirty-seven 16mm films that also reflected the life and people of the Province. Most significant is the fact that his first two films were of feature-length, and that the first, *En Pays neufs/A New Country,* begun in 1934 and finished in 1937, is recognized as the first feature film made in Quebec.[10]

Like Father Tessier, Father Proulx traveled Quebec Province utilizing his own funds and equipment until his efforts were at length rewarded with government grants. Beginning in 1941, with the founding of *Le Service de Ciné-photographie* by the provincial government, Father Proulx was sponsored officially in his filmmaking endeavors. Commenting on the importance of these early independent film-makers, cinema scholar David Clanfield wrote:

> The films of both Tessier and Proulx bear witness to an era in the life of the province quite different from that of the NFB French team of the late fifties and early sixties. They might best be characterized as a "cinéma de la fidelité," committed to the preservation of the traditional rural way of life, based on the two intertwined institutions of the Catholic Church and a conservative government. They celebrate . . . the preservation of language, rural crafts, family . . . community and the Catholic religion. Nevertheless, by their overtly nationalistic concern with the definition of a cultural identity and their desire to project this image . . . they

anticipate the aims, intentions and methods of a [future] generation of Québec filmmakers. . . .[11]

Un Pays sans bon sens!

En Pays neufs, the first full-length film made in Quebec, set forth the advantages of colonizing the wilderness of the Northern Abitibi region of Quebec, and was clearly a form of propaganda sanctioned by the Church. The second, by Father Jean-Marie Poitevin, was entitled *A La Croisée des chemins/At the Crossroads* and was made in 1943, with actor Paul Geuvremont, and frankly advocated a missionary vocation theme. This film was also approved by the Church. Among these and other filmmakers of the period, Father Albert Tessier stands out as the most prolific and the best. His production of more than seventy 16mm documentary-style films, all silent and many in colour, singly and collectively, captured the wilderness beauty and vast spaces of Quebec. As such, they could be considered as early travelogue or nature films.[12]

These films, although moderately successful in Quebec, did not receive widespread distribution and were not considered popular entertainment. Nevertheless, although limited in subject and style, they must be

considered landmark symbols of the beginning of serious filmmaking in Quebec. It is important to note that, however limited, the influence of these films was sufficient to prod the government, in 1941, to consolidate its sprawling cinematic resources into one central coordinating department, Le Service de Ciné-photographie de la Province de Québec. Coincidentally, 1941 also saw the founding of the Odeon Theatre chain by showman N.L. Nathanson.[13]

As stated before, the cultural life in Quebec during the first sixty years of this century was dominated by the Catholic Church. As a result, most story-telling films made in Quebec during the twenty years of cinematic activity from 1930 to 1960 reflected this influence. The plots always stressed the importance of two major themes: (1) the major role of the Church in the everyday lives of the people, and (2) a priest or nun central character who provides solace and guidance to the people who depend on this leadership. Commenting on the inevitability of the Church's role in the cinema, critic Michel Houle provides some eye-opening statistics on the period:

> It is easy to explain why this theme [the Church as depicted in these films] in the forties and fifties was so powerful and permanent. It reflects the real influence of the Church in the social and cultural life of the Québec people. . . . In 1940 the Church in Québec numbered at least 25,000 clergymen, monks and nuns, and it supplied fifty-percent of the teachers to . . . colleges. It had almost complete and exclusive jurisdiction in the fields of social affairs. . . .[14]

To cope with a growing popular demand for francophone films in Quebec, two film production companies were established in 1944 and 1946. The first, Renaissance Films, was founded by Charles Philipp, and J. A. DeSève of France-Film. The company's first film, *Le Père Chopin,* was also Quebec's first 35mm feature film with sound. Director Fedor Ozep was imported from Hollywood to provide cinematic sophistication, and the film was released in Montreal on April 19, 1945, to packed houses during a four-week run. The film was an immediate success, because, for the first time, the public was able to watch *québécois* characters in Quebec, and to identify with them. With the success of this film, J. A. DeSève established Renaissance Films Distribution (RFD) in 1945, which in turn absorbed Renaissance Films. He soon built a studio comparable in size and sophistication to those of major foreign companies, and in 1949, renamed the company Les Productions renaissance.

In order to achieve his objectives, DeSève traveled to France where, with Catholic Church support, he conferred with Abbé Vachet, Executive Head of the Fiat-Film Studios, which produced films stressing Catholic values. Upon his return, he announced his intention to produce feature films of Catholic "ideological persuasion": Catholic cinema extolling, through its dramatic characters, the precepts of the Church.

Cinémathèque québécoise

La Petite Aurore l'enfant martyre

In describing his intent, DeSève stated: "Our aim is to create great artistic cinema which will call good-good, and evil-evil."[15] He also affirmed his desire to support an International Catholic Film Office in Montreal, as part of an international distribution company to ensure exhibition of his and Abbé Vachet's films in Canada and France. To this end, he solicited local Church leaders, through Abbé Vachét and others, to support the enterprise. With a studio under construction in Montréal, the company underwent corporate changes and began film production with *Le Gros Bill/Big Bill* and *Docteur Louise,* both of which were completed in 1949. In 1950, the fourth and last film, *Les Lumiéres de ma ville,* advertised as "entirely French Canadian," was released. Soon after, the company closed its doors and went bankrupt. The Catholic francophone film had not done well in Quebec.[16]

The second major company, Québec Productions Corporation, formed in 1946, avoided the mistake of the Renaissance philosophy and attempted a more sophisticated thematic approach in its francophone films. Founded by producers Paul L'Anglais and René Germain, the company built studios in the Montreal suburb of Saint Hyacinthe. The new company's first film in 1946 was an ambitious feature, shot

simultaneously in both French and English language versions. Titled respectively *La Fortresse* and *Whispering City,* both versions were directed by Hollywood director Fedor Ozep and starred three Hollywood actors: Paul Lukas, Mary Anderson, and Helmut Dantine. It did poorly at the box office, and so the company's production philosophy was modified to stress more local personalities and themes. As a result, the second feature film, *Un Homme et son péché/A Man and His Sin,* released in 1948, was a box office hit. A third film, *Le Curé de village* (1949), was also well received. Both films were adaptations of a well-known radio series in Quebec, and that in part accounted for their popularity. The dialect and the themes were, moreover, *québécois* and audiences readily identified with them.[17]

Flushed with success, the company in 1949 produced *Séraphin,* a sequel to *Le Curé de village,* which was also well received. The formula of these films mixed religion and ethnic values in an entertaining manner. *Le Curé de village* was awarded First Prize at the 1949 Canadian Film Awards. But, with the fifth film, *Le Rossignol et les cloches/The Nightingale and the Bells* (1951), Québec Productions Corporation suffered a resounding box office failure. Without adequate financial resources to rebound, this company was also forced out of business.[18]

Shortly after the demise of these two Quebec "majors," smaller companies, some with moderate success records, also folded. Among them were an English-language film company, Selkirk Productions, established by Richard Jarvis and Cecil Maiden. Others included Frontier Films, Excelsior, Carillon Pictures, and Alliance Films. All of these had achieved some small degree of success prior to encountering financial failure.[19] Collectively, in spite of their demise, they moved the film community closer to the realization that it was possible for a film industry to develop and survive in Quebec.[20]

From 1944 to 1953, film production had flourished somewhat sporadically but with only moderate success in Quebec. During this period a total of nineteen feature films were released throughout the province. This modest output was nonetheless in stark contrast to the mere two feature films completed and distributed during the thirty years prior to 1944: *En Pays neufs* (1937), and *A La Croisée des chemins* (1943). It is striking that with only nineteen films to its credit, francophone Quebec became the leading production center in Canada of feature-length films during this period.

Sadly, in 1953, a new medium called television began to contend with films for audience interest. The impact of television at first almost totally negated the small gains achieved in local film production, so that one by one the few remaining small studios in Quebec and Canada closed their doors. The triumph of the "small screen" of television over the "large Silver Screen" of movies temporarily ended Quebec's first

effort to establish a viable commercial film industry. Ironically, at the eleventh hour, in 1953, the industry produced one of the very best of the "early" feature films. *Tit Coq/The Cock,* a film based on the play by Gratien Gélinas and directed by René Delacroix, won the Grand Prize at the Canadian Film Awards. Unlike many others, this film, in French with English titles, received wide distribution not only in Quebec but throughout Canada. Moved to comment upon seeing it, René Lévesque, journalist, and later Prime Minister of Quebec, wrote: "with *Tit Coq* the Canadian [Québec] cinema emerges from the caverns."[21] Still, until the move of the National Film Board from Ottawa to Montreal in 1956, and the establishment of the French Production Unit shortly thereafter, no attempt at a revival of Quebec cinema would take place.[22] But when it did, a force of creative expression was released, which quickly elevated francophone Quebec cinema to world-class sophistication.

From this point until the decade of the 1960s and the Quiet Revolution, film production virtually exploded in the *Belle Province.* The next twenty years would mark the end of "French Canadian Film" and the transition from contemporary "Québec Film" to "Québécois Film." Some of the advocates of innovation working at the National Film Board were Fernand Dansereau, Louis Portugais, Bernard Develin, Léonard Forest, Clément Perron, Gilles Carle, Arthur Lamothe, Pierre Patry, Jacques Bobet, and Claude Jutra. They began to bring a new and dynamic creativity to francophone films in the areas of animation, documentary, and later, feature films. Others would follow and many independent companies would be started.

During the postwar expansion of the NFB into television, beginning in 1955, a successful attempt to initiate French-language production was achieved with two series. The first of these, *Passe-Partout* (1955–1957), a thirty-minute program, stressed the visual and cultural authenticity of traditional French life in Quebec, and, in so doing, sketched parameters for emerging *québécois* cinematic expression. *Passe-Partout* also utilized a combination of dramatic narrative and visual documentary to illustrate its themes. *Panoramique* (1957–1959), the second francophone format, presented a series of dramas not limited to the half-hour time limit. These television productions are significant, not only as cultural breakthroughs in a society dominated by English language and tradition, but also as legitimate vehicles that would permit emerging filmmakers, like Claude Jutra, Georges Dufaux, Gilles Groulx, Michel Brault, and Bernard Devlin, to hone their skills while exploring the nature of their francophone culture.[23]

In 1956, the NFB moved its studio to Montreal and, during the ensuing decade, further consolidated and refined the activities of its French Production Unit. Through the creative efforts of Fernand Dansereau, Jean-Pierre Lefebvre, Jacques Godbout, Gilles Groulx, Gilles Carle, Pierre

Patry, Claude Fournier, Michel Brault, Claude Jutra, and other Quebec filmmakers, the late 1950s and 1960s saw a surge of cinematic productions emanating not only from the NFB but also from independent sources. All of this activity, observes historian David Clanfield, provided "a vital nucleus for the [emerging] *cinéma d'auteur* which developed in Québec in the mid to late sixties. . . ."[24] The output of feature-length films that followed displayed the need for the contemporary *québécois* cineast to explore, in longer film formats, the emerging social and political milieu of the changing francophone population. Typical of this period was Claude Jutra's *A Tout Prendre/The Way It Goes* (1963). Produced independently for $60,000, this film won national and international notoriety and illustrated that dramatic French language feature films, independent of government support, could be produced successfully in Quebec. Other film-makers soon followed Jutra's lead and a new contemporary francophone Quebec cinema evolved, independent of Catholic Church and governmental rigidity, and contemporary in theme and techniques. The cinema of the *Québécois* was at last emerging.[25]

In 1960 and 1961, Michel Brault, working in France with cinematographers Jean Rouch and Mario Ruspole, produced films utilizing the technique of "cinéma direct," an intimate visual and sound style, usually associated with—but not limited to—documentary films. *Cinéma direct* was, in part, developed by Canadian filmmakers during the early NFB period from the 1940s through 1950s. As such, it became a vital element in the development of Quebec cinema and will be further discussed elsewhere in this essay.[26] Both Michel Brault and Pierre Perrault artfully displayed this technique in *Pour la suite du monde/Moontrap* (1963). This film placed visual and thematic documentary emphasis on the importance of "Tradition as an expression of the collective life and will of a people."[27] The film won many awards and critical acclaim for its frank and intimate perception of the complexities of ethnic life. As film critic Peter Morris writes: "It represented a major development in direct cinema away from simple observation to more immediate participation and a greater emphasis on the words of the people portrayed. . . ."[28]

According to film scholar Denyse Therrien, the period from 1960 to 1976, when the *Parti Québécois* was voted into power, was one of changes. French Canadians became *Québécois,* with an identity and a language: "*Joual* . . . the language of . . . the street." During these years the new *québécois* cinema became "increasingly virile, misogynous and violent," exploring themes and events heretofore ignored or avoided by francophone filmmakers.[29]

It must also be noted that during the 1950s *Le Bureau de film du Québec* was established. Also, the Quebec film-makers founded the

Connaissance du Film in 1963, which would become *La Cinémathéque Québécoise* in 1971.[30] In 1964, the year-old *Association Professionnelle des Cinéastes du Québec* presented a report to the governments of Quebec and Canada that detailed the necessity for allowing the Canadian and Quebec cinema, apart from the NFB, to develop without fear of censorship or interference. It also requested support from the government to aid in developing regional efforts in filmmaking. This report began the tradition of political lobbying by various cinema groups that continues to the present within Quebec Province.[31]

Throughout the 1960s, a period known as "The Quiet Revolution," francophone Quebec began to demand ethnic recognition and political, if not ideological self-determination, from the dominant Anglo-Canadian national majority. Acting in a more militant independent fashion, and less as a people defeated by Empire and separated from their European French roots, the Quebec Francophones, intellectuals, artists, and political elite began a new critical examination of all that had occurred heretofore. Leading this retrospective of the French-Canadian concerns was Quebec cinema. In the films produced during the years of The Quiet Revolution, no aspect, however minute or trivial, of traditional values, attitudes, and struggles was ignored. Individual discontent, group conflict, urban versus rural values, the changing roles of the Church, the economy, sex and love, and, in the midst of it all, the new dramatis personae, i.e., the francophone Canadians emerging at last as *Québécois*. The inevitable result of this collective looking inward was the eventual demand for political separatism and self-determination for Quebec.[32]

The period from 1960 through the 1980s saw the evolution and expansion of the Quebec cinema from a provincial expression of ethnic frustration into an articulate, cinematically cogent industry producing films of world-class stature. Accompanying these films were the highly individualistic statements made by a growing number of "auteurs" attempting to define their aesthetic parameters in dealing with the lives and environmental considerations of the *Québécois* in Canada.

In any discussion of Quebec cinema, both the concept of the *auteur* principle and the technique of *cinéma direct* are important, since so much of the basic identity of the industry was shaped and structured by these two elements. During the 1950s, there appeared in France a group of determined young film critics and directors who declared themselves anti-traditional. Their articles clamoring for a "new cinéma" first appeared in that country's leading film journal *Cahiers du Cinéma* founded by eminent critics André Bazin and Jacques D. Valcroze. Led by François Truffaut, Jean Luc-Godard, and Eric Rohmer, among others, the "New Wave" group advocated an end to impersonal cinematic styles and supported the *auteur* philosophy, which stressed artistic control,

expressive freedom, and personal style in direction, "independent of established industry practices."[33]

Although the movement gained great initial popularity and was responsible for some of the finest films made in France, by the mid-1960s it had peaked and begun to lose focus as many of its most ardent supporters explored different avenues of cinematic expression. Nevertheless, the impact of the New Wave Movement upon the international film industry was considerable. Especially among the emerging and evolving Quebec francophone filmmakers, the *auteur* philosophy was instantly accepted as one of the key principles of contemporary filmmaking.

The compatibility of the *auteur* principle allowed the emerging Quebec filmmakers to continue developing their own individual styles and forms of expression. Initially, for many this meant serving their apprenticeships at the National Film Board during the 1940s and 1950s, and later with the French Language Unit, where a wide degree of artistic freedom was encouraged. As such, they formed the essential cadre of *cinéastes* who would shape the emerging Quebec cinema and influence a new generation of filmmakers.

While development of *cinéma direct* has its roots in the traditional documentary image, born in the late nineteenth century, film historians locate its development in the late fifties:

> . . . when attempts to shatter the traditional framework of the documentary film were accompanied by work on the tools of filmmaking—the [portable] camera and [direct recording] sound equipment. . . . In addition, the craftsmen of what would turn into the "direct" met, showed their films to each other, exchanged ideas, gimmicks, experiences; in particular at the [Robert] Flaherty Seminar held in Santa Margarita [California] in 1959, where Michel Brault met Jean Rouch and Claude Fournier met Richard Leacock. . . .[34]

In Canada, the documentary, firmly established by John Grierson at the National Film Board in 1939, continues in the present to be a major element of the production schedule. During the 1940s and 1950s, under the guidance of executive producer Tom Daly of Unit B, and Guy Roberge, first francophone director of the NFB (1957–1965), the use of new portable equipment was encouraged, along with experimental techniques that ultimately led to the successful development and adoption of *cinéma direct* as one of the major cinematic techniques for both anglophone and francophone filmmakers. As such, it quickly became the primary tool by which Quebec filmmakers, such as Michel Brault, Pierre Perrault, Gilles Groulx, and Marcel Carriére, would project the reality of contemporary Quebec and its francophone culture to the world.[35]

The sound-oriented *cinéma direct* has been characterized by film scholar Paul Warren, as the perfect "tool for cinematic probing into the

changing cultural milieu of francophone society . . . [since] Québec Cinema is . . . real language in search of its images. . . ."[36] Prior to 1960 in Quebec, of course, the Catholic Church utilized both Latin and French to extol and reinforce traditional values centered in family and religion. During the 1960s, however, these values were displaced by the growing cultural discontent spreading through the province, known as the "Quiet Revolution."

Office national du film du Canada

Les Raquetteurs

It was during this time of discontent that Quebec francophone cinema became *québécois* and, while searching for cultural reality, began to exercise greater influence as a central icon in the search for ethnic identification. Using *Joual,* the contemporary francophone films reinforced the fact that the bonding of realistic images to an authentic common language was central to their society's cultural identity. Both the images presented, and the language spoken, confirmed this cultural reality and gave substance to it. In this way, the use of *cinéma direct* in Quebec films not only served as a reflection, but also as a stimulus to an emerging *québécois* society.

This self-searching quality, together with the growing artistic sophistication of the Quebec filmmakers, is evident in the films listed below, which represent a diversity of styles and themes. They range from short to feature-length documentary films utilizing the techniques of *cinéma*

direct, to the eclectic docu-drama, and the feature-length fiction film. All are considered important examples of the maturing Quebec cinema and have been exhibited within Canada. Only a very few have had any significant distribution outside of the country.

In the short documentary category are: Gilles Groulx's *Les Raquetteurs/ The Snowshoers* (1958), and *Golden Gloves* (1961); Michel Brault's *La Lutte/Wrestling* (1961); Jacques Godbout and Georges Dufaux's *A Saint-Henri le cinq septembre/Saint-Henri September 5* (1962); Clémont Perron's *Jour aprés jour/Day after Day* (1962); Arthur Lamothe's *Bûcherons de la Manouane/Manouane River Lumberjacks* (1962); Michel Brault's *Québec USA/Visit to Quebec* (1962); Jean Claude Labrecque's *La Visite du Général De Gaulle au Québec/The Visit of General De Gaulle to Quebec* (1967). Collectively and individually, these short films utilize the intimate style of *cinéma direct* to explore various conditions of *québécois* life. They usually, but not always, center upon the work and leisuretime activities of the average francophone citizens in the province.[37]

The longer and feature-length documentary allowed for a more detailed exposition of these themes. Some of the films in this group are:

Cinémathèque québécoise

La Visite du Général De Gaulle

Denys Arcand's *On est au coton/We Are in Cotton* (1970); Michel Brault and Pierre Perrault's *L'Acadie L'Acadie/Acadia, Acadia* (1971); Fernand Dansereau's *Faut Aller Parmi L'Monde pour le savoir/It is Necessary to be among the Peoples of the World to Know Them* (1971); Denys Arcand's *Québec: Duplessis et Après/Quebec: Duplessis and After* (1972), and *Le Confort et l'indifferénce/Comfort and Indifference* (1981).

A third cinematic style popular with Quebec filmmakers was the documentary-drama, an eclectic combination of realism of image and dramatic exposition of character. In both short and longer films, this style juxtaposes factual events with fictional or re-enacted dramatic segments. Some of the notable films are: Pierre Perrault's *Pour la suite du monde/Moon Trap* (1963); Gilles Groulx's *Le Chat dans le sac/The Cat in the Bag* (1964); Fernand Dansereau's *Le Festin des morts/Mission of Fear* (1965); Jean Claude Lord's *Bingo* (1974); and Michel Brault's *Les Ordres/The Orders* (1974).

The fourth and final category is the feature-length fiction film. These films may differ in theme and personal style, but all tell a story usually derived from an aspect of francophone literature. Some are original works, and some are adaptations, but all listed here are considered examples of the artful Quebec francophone feature film. They include: Claude Jutra's *A Tout Prendre/The Way It Goes* (1963); Gilles Carle's

Le Chat dans le sac

Office national du film du Canada

La Vie heureuse de Leopold Z/The Happy World of Leopold Z (1965);
Michel Brault's *Entre la mer at l'eau douce/Drifting Upstream* (1966);
Jean Pierre LeFebvre's *Il ne faut pas mourir pour ça/Don't Let It Kill
You* (1968); Paul Almond's *Isabel* (1968), and *L'Acte du coeur/Act of
the Heart* (1970); Jacques Leduc's *On est loin du soleil/We Are Far from
the Sun* (1970); Claude Jutra's *Mon Oncle Antoine/My Uncle Antoine*
(1971); Mirelle Dansereau's *La Vie rêvée/Dream Life* (1972)—this film
has the distinction of being the first fiction feature directed by a woman
in Quebec. Other feature-length films are Gilles Carle's *La Vraie Nature
de Bernadette/The True Nature of Bernadette* (1972); Claude Jutra's
Kamouraska (1973); Denys Arcand's *Réjeanne Padovani* (1973); Jean
Pierre LeFebvre's *Les Dernières Fiançailles/The Last Betrothal* (1973);
Jean Claude Labrecque's *Les Vautours/The Vultures* (1975); Denys
Arcand's *Gina* (1975); Jean Beaudin's *J. A. Martin Photographe/J. A.
Martin Photographer* (1977); Jean Pierre Lefebvre's *Le Vieux Pays où
Rimbaud est mort/The Old Country where Rimbaud Died* (1977); Gilles
Carle's *L'Ange et la femme/The Angel and the Woman* (1977), and *Les
Plouffe/The Plouffe Family* (1981); Francis Mankiewicz's *Les Bons
Débarras/Good Riddance* (1980); Léa Poole's *La Femme de l'hôtel/
Woman of the Hotel* (1984); Francois Bouvier and Jean Beaudry's
Jacques et novembre/Jacques and November (1984); Jean Beaudin's
Mario (1984); Jean Claude Labrecque's *Les Années de rêve/Years of
Dreams and Revolt* (1984); Micheline Lanctôt's *Sonatine* (1984); Justine
Heroux's *Le Matou/The Tom Cat* (1986); Jean Claude Lauzon's *Un Zoo
la nuit/Night Zoo* (1988); Denys Arcand's *Le Déclin de l'empire améri-
cain/The Decline of the American Empire* (1986); and *Jésus de Montréal/
Jesus of Montreal* (1990).

Commenting on the vitality, volume, and creativity of Quebec cinema,
historian Ian Lockerbie wrote: "What first astonishes the observer about
Quebec Cinema is its sheer quantity. In proportion to population, its
volume of production averaged out over the last twenty years [1967–
1987] must be the highest in the world."[38]

Notwithstanding increased recognition and financial support, the dis-
tribution problem of Canadian films in Canada has not appreciably
changed since 1987. The major problem is that the U.S.-controlled major
theatre chains in Canada still account for about 92 percent of the total
English language film revenues and 80 percent of the French box office.
As a result, over the years, only a small percentage of Canadian au-
diences have had access to the domestic cinema product. However, this
appears to be changing.[39]

In 1980, the Cineplex Odeon Corporation, a Canadian-owned theatre
chain under the leadership of Garth Drabinsky, began a policy of ex-
pansion that has placed it in a position of international importance in

Office national du film du Canada

Cordélia

the film exhibition industry. In 1986, the corporation purchased the Montreal-based France-Film Theatre chain and acquired twenty-six screens at fourteen Quebec locations, bringing the number of its theatres to ninety-five, in forty Quebec locations. In Montreal alone, Cineplex Odeon boasts forty-two screens in ten area theatres.[40]

More significant is the fact that the Cineplex Odeon Corporation, through its aggressive expansion policy, had achieved, as of 1988, the status of the largest movie theatre chain in North America, with 1,320 screens in 450 locations, within six Canadian provinces and nineteen states in the United States.[41] The company's first international release was *Le Déclin de l'empire américain,* which enjoyed lucrative world-wide distribution. Distributed in the United States, the *Déclin* not only earned a strong box office but was critically well received: an unprecedented success, not only for Director Denys Arcand, but for the Quebec film industry as well. In no small measure was this success attributable to the Cineplex Odeon Corporation's ability to market and distribute films not only in Canada, but on an international scale never before possible in Canadian or Quebec cinema history.[42]

On the immediate political horizon, Canada, in the context of the Free Trade Agreement, has sought a larger share of the American market for the Canadian film industry. Failure to achieve this result may lead

to restrictive legislation designed to eliminate American domination of film distribution in Canada.[43] The proposed law, *The National Film and Video Products Act,* now tabled, proposed in part that:

> The Govt. of Canada will regulate importation of film products into Canada in order to assure that Canada is accorded the status of a National Market for purposes of film distribution, and to encourage the development of a Canadian Distribution sector which is essential to a healthy Canadian Film Industry.[44]

Les Bons Débarras

More immediately significant for cinema in Quebec is the passage of the Quebec Cinema Act in 1988. Sections 104–105 of the Act specifically "prohibit independent foreign and Canadian Distributors from doing business in Québec if they are not based in the Province or fail to meet specific qualifications criteria."[45] The original intent of the Quebec Cinema Act was, of course, to encourage and protect the indigenous industry. In his support of this legislation, André Link, president of both L'Association québécoise des distributeurs et exportateurs de films et de vidéo and the Institut québécois du cinéma, stated:

> Québec is doing what must be done in order to protect its distribution
> industry. . . . If you cannot control your own market then you cannot have
> your own industry. . . . Québec has acted within its own jurisdiction. It
> is now up to the rest of Canada to act. . . . If the other provinces were
> to imitate Québec you would have reciprocity across the country and
> Canada would be protected and unified once again.[46]

The growing popularity of Canadian and Quebec films, not only in
Canada but also internationally, is succinctly reflected by the 1984
edition of the Toronto-based International Film Festival of Festivals
program. On September 6 through 15, the Festival showcased the
"largest retrospective of Canadian films ever assembled."[47] According
to Director of Programming, S. Wayne Clarkson, the Northern Lights
Program consisted of "more than 200 films covering the past 80 years
of production in this country ranging from silent classics . . . the new
Québec cinema of the 60's and 70's, right up to the achievements of
today."[48]

Also featured was the list of films voted Canada's Ten Best resulting
from ". . . votes cast by . . . leading journalists, lecturers and industry
representatives for the ten films deemed best in our history."[49] In the
Festival of Festivals Program, the following statement by Piers Handling,
Supervising Editor of Publications, explained, in part, the background
and reasons for this international survey:

> The occasion for the largest retrospective of Canadian films ever as-
> sembled seemed the right time to conduct this survey. It afforded us [the
> occasion] to take stock of what was the very best in Canadian cinema.
> We polled hundreds of critics . . . film professors and academics; a large
> number of our most eminent film makers; and a lot of people integral
> to the Canadian film scene. Most were Canadian but we also decided
> to . . . include the opinions of some of the best-known international critics
> who would regularly see and review Canadian films.
> The response was illuminating. There were no restrictions placed on the
> kinds of films . . . features, documentaries, experimental films, animation,
> short films were all eligible. When all the votes were tabulated the final
> list was established. We have decided to print the list of the top twenty-
> five films, which gives a broader picture of what was considered excellent.[50]

In a remarkable testament to the achievements of francophone cinema
since 1960, thirteen of twenty-seven nominations went to *québécois* films.
Of those, six placed within the top ten, including a first and a third place,
with another seven films in the eleven to twenty-five designations. In
the field of twenty-seven nominated films, Quebec *cinéastes* had
accounted for an astounding 50 percent of the number of total winners.[51]

In the four years since the survey and the subsequent successful tour
of Canada's Ten Best Films in the United States, filmmakers through-
out Canada, and especially in Quebec, continue to produce films at an

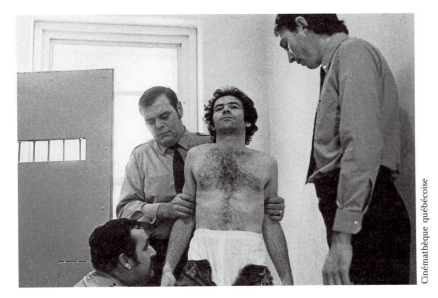

Les Ordres

astounding rate. It is possible that the newly implemented Free Trade Agreement between Canada and the United States may result in a more favorable redistribution of cinema screentime for Canadian and Quebec films in both Canada and the United States.

However, the future is still uncertain, as anglophone Canada and francophone Quebec continue to maintain an increasingly problematic association. Cultural values are at the heart of Quebec's differences with anglophone Canada, and Quebec filmmakers, in the search for cultural truth over the years, have been major contributors to this growing movement towards self-determination. The future will decide the ultimate outcome, but it is certain that the *cinéma québécois* continues to flourish in these uncertain and unsettling times. No doubt, now as in the past, it will continue to stimulate and to reflect the changing concerns of the people, whose vitality has given it life and substance.

SUNY College, Plattsburg

NOTES

1. Neal Gabler, *An Empire of Their Own* (New York: Doubleday Publishing Co., 1989), 1–7.
2. Gerald Pratley, *Torn Sprockets* (London and Toronto: Associated University Presses, 1987), 13–22.

3. Pratley, *Torn Sprockets,* 13; and Yves Lever, *Histoire Générale du cinéma au Québec* (Montréal: Les editions du Boréal, 1988), 27. Mr. Lever states that "On June 27, 1896, the first public projection [of motion pictures] on Canadian soil took place in Montreal at the Café-Concert Palace at 78 Rue Saint Laurent. . . ." This occurred six months after the Lumiére Brothers premiere showing in Paris on December 28, 1895.

4. Pratley, *Torn Sprockets,* 14–16. Two ninety-minute NFB documentary films, *Dream Land* (1975), and *Has Anyone Here Seen Canada* (1978), examine in detail the early cinema history in Canada from 1896 through to 1939 and the founding of the NFB. Both films were made by historians Peter Morris and Kirwin Cox.

5. Pierre Véronneau, "The First Wave of Québec Feature Films," in *Self Portrait,* ed. Pierre Véronneau and Piers Handling, (Ottawa: Canadian Film Institute, 1980), 54–63.

6. David Clandfield, "From the Picturesque to the Familiar: Films of the French Unit at the NFB (1958-1964)," in *Take Two: A Tribute to Film in Canada,* ed. Seth Feldman (Toronto: Irwin Publishing Co., 1984), 114.

7. Pierre Véronneau, "Chronology of Canadian and Quebec Cinema: 1896–1979," in *Self Portrait,* ed. Pierre Véronneau and Piers Handling, (Ottawa: Canadian Film Institute, 1980), 184–186.

8. Ibid., 183–84.

9. Peter Morris, *The Film Companion* (Toronto: Irwin Publishing Co., 1984), 292–93.

10. Ibid., 245.

11. Clanfield, "From the Picturesque to the Familiar," 114.

12. Morris, *The Film Companion,* 292; and Pratley, *Torn Sprockets,* 81.

13. Véronneau, "Chronology of Canadian and Quebec Cinema," 186; and Pratley, *Torn Sprockets,* 20–22.

14. Michel Houle, "Some Ideological and Thematic Aspects of the Québec Cinema," in *Self Portrait,* ed. Pierre Véronneau and Piers Handling, (Ottawa: Canadian Film Institute, 1980), 162–63.

15. Véronneau, "The First Wave of Québec Feature Films," 54–56.

16. Ibid., 54–63; and Pratley, *Torn Sprockets,* 81–95.

17. Pratley, *Torn Sprockets,* 81–82.

18. Ibid., 82–83; and Véronneau, "Chronology of Canadian and Quebec Cinema," 187–88.

19. Pratley, *Torn Sprockets,* 86.

20. Ibid., 86–96; and Véronneau, "The First Wave of Québec Feature Films," 62–63.

21. Véronneau, "The First Wave of Québec Feature Films," 63.

22. Michel Euvrard and Pierre Véronneau, "Direct Cinema," in *Self Portrait,* ed. Pierre Véronneau and Piers Handling, (Ottawa: Canadian Film Institute, 1980), 78.

23. Morris, *The Film Companion,* 228, 232.

24. Clanfield, "From the Picturesque to the Familiar," 113.

25. Houle, "Some Ideological and Thematic Aspects," 161–181.

26. Robert Daudelin, "The Encounter between Fiction and the Direct Cinema," in *Self Portrait,* ed. Pierre Véronneau and Piers Handling, (Ottawa: Canadian

Film Institute, 1980), 95–106; and Euvrard and Véronneau, "Direct Cinema," 76–93. Both essays discuss the various aspects of the Direct Cinema movement and its founders.

27. Morris, *The Film Companion*, 243–244; and Daudelin, "The Encounter between Fiction and the Direct Cinema," 99–100.

28. Morris, *The Film Companion*, 243.

29. Denyse Therrien, "Evolution du langage dans le cinéma québécois des années 60 à 80," in *Words and Moving Images*, ed. William C. Wees and Micheal Dorland (Montréal: Mediatexte Publications, Inc., 1984), 192.

30. Véronneau, "Chronology of Canadian and Quebec Cinema," 190. In 1961, the Service de Ciné-photographie de la province de Québec founded in 1941 changed its title to Le Bureau de Film du Québec.

31. Ibid., 190–91.

32. Clanfield, "From the Picturesque to the Familiar, " 122–23; and Houle, "Some Ideological and Thematic Aspects," 159–81.

33. James Monaco, *The New Wave* (New York: Oxford University Press, 1977), 3–12; see also Roy Armes, *French Cinema* (New York: Oxford University Press, 1985), 169–93.

34. Euvrard and Véronneau, "Direct Cinema," 79; and Armes, *French Cinema,* 186–87. At the 1959 Flaherty Seminar, the film *Les Raquetteurs* was shown by Michel Brault. The film's subsequent successful world-wide distribution provided encouragement to the francophone Quebec filmmakers.

35. Morris, *The Film Companion*, 78–81, 257.

36. Paul Warren, "Québec Cinéma and the Cultural Matrix," Keynote Address, The Modern Quebec Film: A Symposium (East Lansing, Michigan State University, 7 April 1989).

37. D. J. Turner, *Canadian Feature Film Index 1913–1985* (Ottawa: Moving Images and Sound Archives Division, 1985); and Connie Tadros, ed., *Cinema Canada* (Montréal: Cinema Canada Magazine Foundation, 1973 through 1990), Canada's foremost cinema periodical containing articles and critical reviews and interviews concerning all aspects of Canadian and Quebec film. Published monthly since 1973.

38. Ian Lockerbie, ed., *Image and Identity: Theatre and Cinema in Scotland and Québec* (Sterling: The John Grierson Archives, University of Sterling, 1988), 79. Ian Lockerbie is a professor at the University of Sterling and author of *Studies on French Literature and Cinema.*

39. *Cinema Canada* 146 (November 1987): 31. "Films made in Québec occupied 10 percent of the screen-time in the province . . . for the first time since 1974. As a result seven Québec . . . distributors of Québec films have shared a total of $150,000 from the Société générale du Québec as a result of its 'automatic aid' program."

40. *Cinema Canada* 134 (October 1986): 51.

41. Ibid.

42. *Cinema Canada* 159 (January 1989): 33. During 1988, Chairman Drabinsky has been forced to not only curtail expansion of Cineplex Odeon but to sell off a substantial part of the company's holdings in order to remain financially solvent. The financial problems seem to have been a result of too rapid an expansion.

43. *Cinema Canada* 152 (May 1988): 19–21.
44. *Cinema Canada* 157 (November 1988): 36. On October 3, 1987, the National Film and Video Products Act was tabled.
45. Ibid.
46. Ibid.
47. Piers Handling, Rena Polley, and Geoff Pevere, eds., *Festival of Festivals: Toronto International Film Festival Programme Guide* (Toronto: World Film Festival, Inc., 1984), 123. Presented from September 6–15, the program consisted of twelve film sections, galas, tributes, presentations, and a trade forum. Established in 1976, the Festival is an annual event.
48. S. Wayne Clarkson, "Festival Introduction," in *Festival of Festivals: Toronto International Film Festival Programme Guide,* ed. Piers Handling, Rena Polley, and Geoff Pevere (Toronto: World Film Festival, Inc., 1984), 17.
49. Ibid.
50. Piers Handling, "Canada's Ten Best," in *Festival of Festivals: Toronto International Film Festival Programme Guide,* ed. Piers Handling, Rena Polley, and Geoff Pevere (Toronto: World Film Festival, Inc., 1984), 123–27.
51. The complete list of winning films in order of place is as follows. In undisputed first place, *Mon Oncle Antoine* (1971). In second place was Don Shebib's *Goin Down the Road* (1970). *Les Bons Débarras* (1979), placed third. Fourth place was won by Ted Kotcheff's *The Apprenticeship of Duddy Kravitz* (1974). Philip Borsos's *The Grey Fox* (1982) and *Les Ordres* tied for fifth place, leaving the six place vacant. Two films, *J. A. Martin Photographe* (1976), and *Pour la suite du monde* (1963), tied for seventh place, leaving eighth place vacant. Two films tied for ninth place: Don Owen's *Nobody Waved Goodbye* (1964), and *La Vraie Nature de Bernadette* (1972), leaving tenth place vacant. *Les Plouffe* (1981), and *Réjeanne Padovani* (1973), were tied for eleventh place, leaving twelfth place vacant. Michael Snow's *Wave Length* (1967), and *Le Vieux Pays ou Rimbaud est mort* (1977), tied for thirteenth place, leaving fourteenth place vacant. Five films tied for fifteenth place: *Le Chat dans le sac* (1964), Don Shebib's *Between Friends* (1973), David Cronenberg's *Videodrome* (1982), Alan King's *Warrendale* (1966), and William Fruet's *Wedding in White* (1972). As a result, the sixteenth through nineteenth places were vacant. Four films tied for twentieth place: *Les Dernière Fiançailles* (1973), Wolf Koenig's *Lonely Boy* (1961), and Norman McLaren's two films *Neighbors* (1952), and *Pas de deux* (1967). Because of this tie, the next three places remained vacant. In twenty-fourth place, four films also tied, leaving the twenty-fifth and last place vacant: *Kamouraska* (1973), André Forcier's *Bar Salon* (1973), Richard Benner's *Outrageous!* (1977), and R.L. Thomas's *Ticket to Heaven* (1981).

3.

SCENARIO PREPARATION AND CREATIVITY IN QUEBEC CINEMA

Esther Pelletier

THE PLACE OF THE SCENARIO IN QUEBEC CINEMA

The important role that scenario writing has played for a number of years is gaining greater recognition in film production circles in Quebec. This increasingly generalized attention, within the network of government agencies that control and support the film industry,[1] has contributed to the perception of scenario writing as a virtually autonomous area of film production.

In 1984, with the imposition of Law 109 on cinema, this area had taken on such an importance that the *Institut québécois du cinéma* (IQC)[2] and the *Société général du cinéma du Québec* (SGCQ)[3] became, in 1988, the SOGIC, the *Société génerale des industries culturelles,* whose first priority was "to orient itself in particular toward [preproduction] development"[4] of film projects. Considered until then as only a minor step, as compared to the actual filmmaking process, preproduction development has rapidly expanded because of a greater willingness to finance scenario-based projects. Before reaching this high point, however, strong resistance had been encountered with regard to preproduction and the use of scenarios, especially during the sixties.

During those years, *cinéma direct* was expanding rapidly and was involved in almost all the films produced in Quebec.[5] *Cinéma direct* is characterized by two fundamental conditions: (a) an undetermined sequence in the events to be filmed, and (b) a certain type of participation in those events on the part of the production team. *Cinéma direct* thus avoids the process of scenario writing, since in practice neither the order of the events to be filmed, nor the actions and reactions of the protagonists in these events, whether in front of the camera or behind it, are known in advance. Moreover, the study of Quebec cinema

of this period shows clearly that social preoccupations dominated in the productions.[6] During the decade of the 1960s, the province of Quebec and its film industry were in a period of crisis: they were choking, aspiring to liberate themselves, and to assert an identity of their own. In that period, the scenario was not fixed in advance, either with regard to the future of society, or to the matter of creating films. The scenario had not yet claimed its proper place as a technical or artistic tool, much less recognition as an autonomous effort to explore and prepare film projects. The cinematography of the times did not require scenarios, since filmmaking aimed, above all, to be a tool for social and political intervention. Parallel to the efforts of the *engagé* filmmakers in *cinéma direct*, of course, others were attempting to lay the basis for the making of films based on fiction.

With the coming of the 1970s, the situation of Quebec filmmakers altered. *Cinéma direct* lost ground little by little, to be replaced by what was understood to be a truly Quebec film industry. In fact, in 1968, the Canadian government created an important governmental agency, long demanded by professional filmmakers across Canada. The mandate of this agency was to encourage the production of feature films in Canada. Thus, between 1968 and 1975, there was a period of important change characterized by the sudden appearance of a massive first wave of full-length fiction films on the movie screens of Quebec.[7]

It should be noted that during the course of these years, a number of filmmakers up to that time attached to the National Film Board (NFB),[8] a federal government agency that specialized in documentaries and animated films, left the NFB to join the ranks of the independents, working to make fiction films and to lay the foundations of a real film industry. However, the lack of private capital coupled with a limited market, eternal problems of the arts in Canada, and more particularly in Quebec, motivated the Canadian government to provide financial aid for the initiatives of the independents, a move that led to the creation of the Société de développement de l'industrie cinématographique canadienne (SDICC). From that time, the production of feature fiction films grew in the same measure that the documentary lost ground, little by little, and not without a struggle.

Two later periods would coincide with the *début* or reform of the government agencies concerned with the financing of the film industry.[9] The first period (1976–1984), coincided with the creation of the *Institute québécois du cinéma* (IQC), a government agency with a mandate "to promote and financially support, through its investments, the creation, production, distribution and marketing of films of quality," notably by its encouragement of the development of fiction films. The second period (1984 to the present), during which Law 109 on cinema came into force, also saw the creation of the *Société générale du cinéma du Québec* (SGCQ), which had as its aim the consolidation of the gains

made through the development of fiction films. In the future, the feature film would find itself in a privileged position in comparison to the documentary. Thus, guided by people working in the film industry—directors, producers, scenarists, distributors—this effort to free the Quebec film industry from the long tradition of documentary filmmaking has truly begun to bear fruit during the present decade.

Inevitably, in pursuing the objective of creating a film industry, the government agencies concerned in the financing of films, acting in concert with producers, sought to institute a standardized method of production traditionally associated with large film industries. This effort brought to the fore the preproduction specialists concerned with research and the creation of scenarios. Quebec film producers, however, principally trained in the documentary school, had almost never called for the collaboration of scenarists, even for the fiction films that had been made for years in Quebec. Already, between 1910 and 1930, some fiction films were produced here, but most were made in the period from the early 1940s up to the advent of television in the early 1950s, at which point production fell off. We could also point out the flourishing period of the *cinéma d'auteur,* with Groulx, Jutras, Lefebvre, Godbout, Carle;[10] or the period of the "yellow" films, the so-called "films de fesses," as well as the action films of Heroux, Fournier, and Lord.[11] But during all these periods, the writing of the scenario never had the same importance that it now has in the production system. Furthermore, the holdings of the *Fonds de la cinémathèque québécoise,* with respect to scenarios, are very revealing. For these earlier periods, the *Cinémathèque québécoise* can supply very few scenarios, compared to the quite impressive number preserved from the late 1970s through the 1980s. According to the individual responsible for the inventory of holdings, Mme Nicole Laurin, the *Cinémathèque québécoise* presently houses almost five thousand scenarios. It is evident from this fact, that from the moment government agencies were set up to direct and manage the production of films in Quebec, that is to say as of 1976, the writing of scenarios became the norm, and their numbers increased dramatically. So also, it goes without saying, have the numbers of professional scenarists in Quebec. As an example of this abrupt turnabout, in 1984–85 the SGCQ invested more than $1 million in the development of ninety-five fiction film projects (i.e., with scenario), of which sixty-four were feature films (including fourteen of medium length and seventeen shorts), while it invested just a little more than $150,000 on the development of fourteen documentary projects (i.e., without scenarios), including six full-length features, four of medium length, and four shorts.[12]

The possibility of finding new funding for the developmental stage of film production has encouraged producers, filmmakers, and scenarists to do research in preparation for eventual film projects, to write several

versions of the same scenario, or even to develop a number of different proposals for the filming of possible projects.

This growing interest in the writing of scenarios is spreading inside and outside of the profession. During the eighties, training courses in the preparation of the scenario were organized in a number of Quebec universities.[13] One can also attend seminars and debates on the importance of the scenario in film production.[14] This interest in the writing of scenarios, supported by a more substantial technical and economic infrastructure, has become, in some ways, the cornerstone of a certain renewal of the Quebec film industry.

A change in attitude toward the scenario is not unique to the Quebec film industry. Almost everywhere in the world, filmmaking regularly evolves, changing, according to its needs, the function of the scenario, and gives birth to new movements and new schools. A sophisticated scenario, stuffed with notes, technical indications and sketches, on the one hand, or a scenario consisting of several notes giving free rein to improvisation, on the other hand—each corresponds to a distinct era in the history of filmmaking.

In some cases, entire films were shot in studios according to a very precise outline (as in the early epoch of the film industry in the United States)[15] while in others, filmmakers deserted the studio and set to work on-location against a natural background, using only notes (the post-war Italian Neo-Realist films, the French New-Wave films, and the *cinéma direct* films of the 1960s). In his essay on the scenario, Jean-Paul Torök characterized the earlier mode:

> The industrialized Hollywood system—the purely narrative system—already relied essentially on the scenario during the era of the silent film. The coming of the talkies only confirmed and reinforced the fundamental role of the scenario. The conversion of the industry to sound techniques, which considerably increased the costs of production, and necessitated heavy investment, demanded careful planning of production methods. Advance preparation became imperative: it was necessary to prepare and organize the filming in the most rational and economical manner possible, in order to reduce time spent and to get the maximum return from work on the set. In this new arrangement, the scenario held the position of prime importance. It tended, in the course of successive "treatments" to present itself as the model, the simulation the mock-up, one might say of the film as it would finally be. In extreme cases, the filming, according to the wishes of the producers, was nothing more than the execution of a script elaborated beforehand down to the last detail. The reign of the scenario began: it lasted 30 years and only ended with the decline and fall of the Hollywood film Empire.[16]

According to the type of filming in vogue, the function of the scenario changes. The scenario of films made during the era of the "Majors" was

seen, above all, as a necessary technical tool, not only to the director, but also the numerous teams of technicians deployed in various areas about the set. However, the changes operating within the infrastructure of the post-war film industry, including the sixties, favored the *cinéma d'auteur*. As a result, there came about a reduction of technical teams, a decrease in production activity, while the scenario was often reduced to a certain number of indications concerning the basic intention of the author's project, or the general idea to be developed in the film. Such a reduction of information previously contained in the scenario allowed greater freedom to maneuver, not only to the directors, but also to the technical teams, and to the actors, who could improvise a good deal according to the inspiration of the moment and the situations they faced.

If some favored one or the other of these approaches with regard to the scenario, each approach had its advantages and disadvantages, and could not be considered a foolproof recipe for the success or failure of a film. Both have, in reality, contributed to the making of successful films, when one looks at the best and most influential examples in the history of film, but both have also contributed to the creation of mediocre films. Contemporary cinematic practice is, above all, the result of the coexistence of many different tendencies, especially since the cinema no longer belongs in particular to any European country or even to the United States.

THE SEARCH FOR SURE VALUES

Desirous of maximizing the profit from its investments, the Quebec film industry has been looking for the past ten years to utilize the scenario in such a way as to minimize the risks of underwriting possible productions. It is obvious that among all those projects proposed and put into production, many will be abandoned along the way from lack of interest and/or capital, without enormous sums having been invested at this level. Nevertheless, it is a well-known fact that all production, of whatever sort, always carries a risk factor. That is why novelty, invention, and originality do not always meet with acceptance on the part of investors. Also, at the beginning of the 1980s, after a relative slowdown in production, and despite the success of individual small-budget films, such as *Les Bons Debarras* by Francis Mankiewicz (1980), governmental agencies were forced to look for solid investments through the adaptation of literary works that had already enjoyed great popular success. That is why novels like *Maria Chapdelaine* by Louis Hémon (1916), *Bonheur d'occasion* by Gabrielle Roy (1945), and *Les Plouffe* by Roger Lemelin (1948) were seen, not only on the movie screen but also in the form of mini-series on television.

Cinémathèque québécoise

Bonheur d'occasion

The idea of reaching an audience already familiar with popular works was certainly attractive. However, the success of these films did not, perhaps, pay back at hoped-for levels, and, if at the time, the actual production constituted a positive return in the form of the continued functioning of the industry, it served elsewhere, in the longer term, concurrently to augment production costs considerably and artificially, without attracting new capital. In reality, these films were co-productions with French television, representing an investment of $6 to $7 million each. Once the co-production agreement had ended, the Quebec film industry was not able to maintain investment at that high a level. In addition, these films, while presenting an agreeable version of the past, introduced a very rigid concept of scenario writing, filming, and montage. We were still very far from having the original, dynamic, and up-to-date film production capacity for which we were looking. Finally, this type of production was only profitable in the short term and for a small number of producers and directors. It might be remembered that Gilles Carle directed both *Maria Chapdelaine* (1983) and *Les Plouffe* (1981), while Claude Fournier directed *Bonheur d'occasion* (1983) and Denys Arcand, *Le Crime d'Ovide Plouffe* (1984).

Cinémathèque québécoise

Les Plouffe

Without exactly changing course after this costly co-production adventure, the film industry found a return to the values of the past to be appropriate, as evidenced by *Le Frère André* (1987) directed by Jean-Claude Labrecque. The adaptation of works that had had some literary success continued as well to be an acceptable formula, like *Les Fous de Bassan* (1986) by Anne Hébert, directed by Yves Simoneau.[17] The government agencies, that is the SGCQ, decided in 1985 to restrict investment to about $3 million per production, thus leading to an investment level more in keeping with the realities of the Quebec market. While, obviously, some improvement has been obtained, the collection of policies in place still reflects a certain conservatism, which allows little room for innovation, or, for that matter, the work of young filmmakers.

A POORLY GUARANTEED CHANGING OF THE GUARD

The Quebec film industry was, in general, not interested in the training of young filmmakers until quite recently. Previously, the National Film Board had more or less filled this role. However, with the growth of private industry, the older generation of filmmakers had great

difficulty adapting to the new structures and especially in finding within these new structures the financial backing necessary to make films. Under these conditions, the government sought first and foremost to encourage the experienced filmmakers by giving them access to different financial aid programs. Even if, since the 1980s, government agencies have stated that they were interested in opening up access to these funds to newcomers, their policies have had, in fact, a tendency to restrict access to the latter. In the present context, it remains difficult for a young director to create a first work, because there exist almost no programs of aid for research and experimentation. By contrast, in 1984 and 1985 the SGCQ decided to set in motion two new aid programs to ensure continuity for scenarists and directors whose works had already been screened. *Téléfilm Canada,* on the other hand, offered to help regional filmmakers, while the National Film Board initiated the Women's Project: training programs for women between 19 and 25 years of age. If government agencies do not implement a genuine policy to support the development of projects by young filmmakers, must these latter rely completely on sporadic initiatives from agencies that, from time to time, give aid to placate their consciences? It would seem so: witness in 1981 a competition organized by ICQ and the television division of Radio Canada, which allowed four young filmmakers to produce, under professional conditions, short fiction films.[18] Of the four recipients, two later distinguished themselves—notably, Yves Simoneau, who would complete three feature films: *Pouvoir intime* (1985), *Les Fous de Bassan* (1986), and *Dans le ventre du Dragon* (1989); and Jean-Claude Lauzon, who directed *Un Zoo la nuit* (1987).[19]

It is impossible to speak of the new generation of filmmakers without mentioning the remarkable work of Léa Pool. After the success enjoyed by *La Femme de l'hôtel* in 1984, Léa Pool was quickly recognized as an "experienced" director by the financial institutions, which next supported her production of *Anne Trister* (1986) and *A Corps perdu* (1988), the second and third sections of her trilogy. Among the young filmmakers it is rare to find one who, like Simoneau or Pool, has succeeded in producing, in an acceptable time frame, a first feature fiction film. Jean Beaudry and François Bouvier are among the very small number who, by their ingenuity and their stubbornness vis-à-vis the agencies, were able to complete, in 1985, the gripping *Jacques en novembre,* and most recently in 1989, *Les Matins infidèles.*

The ranks of the new guard remain small in number, if one sets apart those in the 35–45 age group, who have filmed little and who have only a few feature films to their credit.[20] Behind this still active generation and the old-timers, the race for financing is very close, and there remains little for the young aspirants, who ask only to participate in the renewal of our "espace cinématographique." Certain individuals among

them get their chance by finding various sources of support within the existing professional milieu. Advised to do so by a director or better still, by a producer, government agencies sometimes agree to invest in their projects at the developmental stage.

IDEAS TO SELL

In the course of the coming years, one can hope that the efforts put forth during this decade to consolidate the Quebec film industry will allow it to expand, while not losing sight of the necessity of assuring itself of the means of stimulating and renewing its capacity for cinematic expression. Without renewal, the Quebec film industry, supported by a particular industrial framework, is in danger of having to mark time with variations and repetitions of old schemes, or else become imitative and follow blindly formulae for success. At the present time, the base on which it is established makes it fragile and dependent on government agencies. But the potential and the dynamism of the many individuals active in the film milieu certainly allow one to hope. Certain individuals have made it clear, through their own films, that the way is open for others. Daring and originality and dazzling ideas are not lacking, but they must be given ample opportunity to express themselves. What sort of future lies in store for us with *Téléfilm Canada* and the SOGIC, which has just set up an aid program for young creators between the ages of 18–35, or the yet-to-be-established school of cinema "soon" to be set up in Quebec? Time will tell.

<div align="right">Laval University</div>

NOTES

1. These government agencies have instituted a collection of constraints that orient the activities of those involved in the field of cinema. These constraints exercise influence on the methods of cinema production by determining cinematographic methods, amounts invested, and the fixing of norms regulating the entire process. See Jacques Dubois, *L'Institution de la littérature* (Paris: Natan, 1982).
2. In 1975, the government of Quebec, following the lead of the Canadian government, created a new law regulating the cinema and creating the Québec Cinema Institute (IQC), which has, among others, a mandate to "create and maintain financing, taking into account return on investment, creation, production, distribution, and marketing of quality films." The IQC exercised this mandate from 1976 to 1984 with a modest budget of $4 million a year.
3. In 1984, after a study commission on the film industry and numbers of public inquiries, the Parti Québécois Government reformed the IQC with the aim of strengthening the private film industry. Thus was born the Société générale du cinéma du Québec (SGCQ), which was provided with a budget of

$10 million and was mandated to "assure the production of a certain number of feature films, to maintain production of documentaries, to open access to funding; to encourage continuity for the most experienced filmmakers, to help film distributors resolve problems of undercapitalization, to renovate all movie theatres, and, generally, to remake the image of Quebec films and filmmaking."

4. Taken from a photocopied, unpaginated document, [S.I.] January 1984, preparatory to "Aid Plan 1984–1985" by the IOC approved by the Ministry of Cultural Affairs on 29 May 1984 (author's archives). We will return later to the notion of "development." Suffice it to say for now that the writing of a scenario constitutes the major element in the development process of a film project.

5. See Michel Coulombe and Marcel Jean, *Le Dictionnaire du cinéma québécois* (Montréal: Boréal, 1988); Yves Lever, *Histoire générale du cinéma au Québec* (Montréal: Boréal, 1988); and Giles Marsolais, *L'Aventure du cinéma direct* (Paris: Seghers, 1974).

6. See note *5 and also Yves Lever, *Cinéma et société québécoise* (Montréal: Editions du jour, 1972). Also see *En Collaboration, écritures de Pierre Perreault,* Actes du Colloque "Gens de Parole," 24–28 mars, 1982. Maison de la culture de La Rochelle, in *Les dossiers de la cinémathèque,* no. 11 (Montréal: Edilig, Cinémathèque québécoise/Musée du cinéma, 1983).

7. As examples see *Deux Femmes en or* by Claude Fournier (1970); *Valérie* (1968), and *L'Initiation* (1969) by Denis Héroux; *Les Mâles* by Gilles Carle (1970); *Les Colombes* (1972) and *Bingo* (1973) by Jean-Claude Lord.

8. The NFB (National Film Board), created in 1939 as a result of a report prepared by John Grierson, first Canadian government film commissioner, imposed his brand in the area of documentary during the war (1939–1945), when his production was very prolific. Shortly after the creation of the NFB, the celebrated Norman McLaren laid the foundation of the animated film section, which would assure the fame of this organization.

9. These government agencies, the IQC, the SGCQ, and the SOGIC (Société générale des industries culturelles) were created in 1988, following modifications made to the law on the cinema, and the law on the Société de dévelopement des industries de la culture et des communications. The SOGIC was created by the joining of the SDICC and the SGCQ, and consecrated a part of its activities to the film industry.

10. The names of a number of these *films d'auteur* are as follows: *Le Chat dans le sac* (1964) and *Où Etes-Vous donc?* (1968) by Gilles Groulx; *Les Mains nettes* (1958), *A Tout Prendre* (1963), and *Mon Oncle Antoine* (1971) by Claude Jutra; *Patricia et Jean-Baptiste* (1966), *Les Maudits Sauvages* (1971) and *Les Dernières Fiançailles* (1973) by Jean-Pierre Lefebvre; *Yul 871* (1966), *Kid Sentiment* (1968), and *IXE 13* (1971) by Jacques Godbout; *La Vie heureuse de Lépold Z* (1965) and *Le Viol d'une jeune fille douce* (1971) by Gilles Carle.

11. See note 7.

12. This information was taken from the *Annual Report of the SGCQ,* 1985.

13. In 1982 and 1983, *Association coopérative de productions audio-visualles* (ACPAV) and the *Institut québécois du cinéma* (IQC) organized courses in scenario writing with directors, scenarists, and fifteen participants (one of

which was attended by the author of this essay). In 1984, still under the aegis of the ACPAV and the IQC, a course was begun with the Italian scenarist, Enrico Modioli, Jean Gruault from France, and the American, Marshall Brickman. The theme of this training course was "Can there be a film industry without the scenarist?" Then it was the turn of the distribution firm, Parlimage, to begin giving training in scenario writing. In addition, the University of Quebec at Montreal, the University of Montreal, and Laval University offer courses in scenario writing, and the University of Quebec at Montreal proposes to offer a certificate in the subject.

14. It should be noted that in 1982, within the framework of the "Rendez-vous du cinéma québécois," an important debate on the role of the scenario in Quebec film was held, moderated by the director, Fernand Dansereau.

15. See Tino Balio, ed., *The American Film Industry* (Madison: University of Wisconsin Press, 1985), particularly chapter 7, "Blueprints for Feature Films: Hollywood's Continuity Scripts," by Janet Staiger, 73–194.

16. Jean-Paul Torök, *Les scénarios, l'art d'écrire un scénario* (Bruxelles: Éditions de l'Université de Bruxelles, 1986), 39–41.

17. Anne Hébert won the *Prix Fémina* for *Les Fous de Bassan* in 1982. The film appeared at the end of 1986.

18. *Dernier Voyage* by Yves Simoneau, *Elvis Gratton* by Julien Poulin, and *Pierre Falardeau and Piwi* by Jean-Claude Lauxon.

19. Julien Poulin and Pierre Falardeau also have directed two other short films about Elvis Gratton (*Les Vacances d'Elvis Gratton* and *Pas Encore Elvis Gratton*), which were put together to form a feature length film in 1985.

20. For example, Micheline Lanctôt, Jean-Guy Noël, or Mireille Dansereau.

PART II

FILMMAKERS ON FILM

1.

REFLEXIONS IMPERTINENTES SUR LA CREATION CINEMATOGRAPHIQUE

Pierre Perrault

Je plaide coupable. J'avoue, sans arrière-pensée, ma participation sincère et attentive à un colloque. Et qui plus est à un colloque sur la création cinématographique dans le cadre des Entretiens du centre Jacques Cartier à l'Institut Lumière de Lyon. *Si le cinéma est une invention sans avenir,* comme l'aurait affirmé, paraît-il, Louis Lumière lui-même, on doit admettre qu'il a déjà un certain passé, qu'il est désormais omniprésent, qu'il s'est érigé, comme le hockey, des Temples de la Renommée, des Institut Lumière à Lyon, des cinémathèques à Paris, à Montréal et ailleurs et qu'il tient des colloques savants à tout bout de champ où on pose toutes sortes de questions impertinentes qui reçoivent autant de réponses qu'il y a de participants.

En vérité j'ai bientôt retiré ma participation active et me suis réfugié dans l'observation curieuse pour ne pas tomber dans l'ennui mortel. Les échanges, je l'avoue, étaient brillants. De la haute-voltige. Mais j'avais l'impression de traverser la place de l'Étoile à pied à l'heure de pointe. *Venu nu de ma province.* Il y a plusieurs provinces dans l'écriture et dans le cinéma. Et chaque propos, sans le savoir, me renvoyait à mes vaches.

En vérité de quoi s'agissait-il? En somme de quoi s'agit-il? *De faire naître l'intempestif?* selon Michel Bouvier. *De donner le change?* d'après Paul Warren. *De filmer le paysage de dos?* affirme l'évangile selon Godard s'il faut en croire les Pères de l'Église dont Alain Bergala qui en fait son miel. Le cinéma est-il déjà révélé? *De se complaire dans la perversité?* surenchérit le même Bergala cherchant à nous consterner. Et il ajoute du même souffle pour nous confondre tout à fait: *Godard est un pervers plus polymorphe que Bresson.* Me voilà hors de combat. Relégué aux oubliettes. Bouche bée. Les oreilles béantes. Bergala navigue la haute mer. Son dire repose sur le *c'est-à-dire...* qui nous

Office national du film du Canada

Un Pays sans bon sens!

laisse mal en points de suspension. Il tire des bordées comme du canon. Il assume les contradictions. Je n'arrive pas à le suivre. Les contradictions me font défaut. Je navigue à vue. Il consulte les étoiles. Je n'ose pas prendre le large. J'écoute respectueusement. Quelque peu incrédule. Cherchant ma route. Dans la déroute.

Je dois cependent avouer mon sentiment. J'ai un peu l'impression que le discours sur le cinéma fictionne le cinéma comme le cinéma fictionne la réalité. Dans la mer du rêve toutes les directions sont dorées. En vérité on sublime l'inexplicable. Celui qui fréquente le sacré devient sacerdotal. L'auréole de l'imaginaire béatifie les propos. Le discours construit son temple autour de son objet. Le temple devient la démonstration du discours. Il auréole. Bergala pose le problème des *auréoles*. Il organize un espace pictural où il dispose les couronnes. Il alimente le regard. La mise en scène dispose du regard. Le regard est sollicité par la sainteté des convives. C'est la dernière Cène. Il ne reste rien à découvrir. Le spectateur constate. L'image est sainte. Ma perplexité est sans borne. Je sors du bois de la vérité simple. Je me trouve plongé dans la pénombre des révélations. C'est la Pentecôte. J'essaie de m'en sortir. Je me demande candidement s'il s'agit de disposer la réalité dans la fiction pour l'anéantir, pour la sanctifier . . . ou de disposer de la réalité dans le documentaire pour profaner le sanctuaire. J'ai conscience de mes sabots sur les dalles. Ma perversité n'est pas à la hauteur de l'enjeu.

J'avoue me préoccuper du réel. D'un certain réel que je nomme vécu. Je me dissocie de toutes les auréoles. Autant de la fiction qui mythifie, que du documentaire qui fait la zoologie de l'animal-homme le réduisant à un gestuelle surveillée par des spécialistes qui lui donnent du sens. Je suis impardonnable. Je n'ose faire un pas de plus. On me disculpe généreusement. On me tolère. Dans la marge. Pourvu que j'admette que j'auréole moi aussi comme on fait de la prose. Sans le savoir. Je me sens coupable *d'introduire une fiction*. On prétend que j'imagine la vie que je cherche à imager. L'image est-elle condamnée à l'imaginaire? Comme l'homme. C'est la maladie de l'homme. Irrémédiable! J'en arrive *à préméditer le naturel* selon la formule d'un autre participant. J'ai noté la formule sans retenir le nom de son auteur. Je plaide mon coupable. Personne ne m'entend. On a déjà proclamé mon innocence. En suis-je arrivé *à me trahir moi-même?* comme le déplore Dominque Nogez consterné par la France qui se laisse envahir par un autre langage. Autrement dit la France parlerait Hollywood comme je parle fiction. Sans le savoir. Prisonnier de l'image prépondérante. Incapable d'échapper au sillage. En dépit de mes véhémentes protestations. Où en suis-je? En pleine dérive? A les entendre j'alimente un *écran qui se fait territoire du fantasme* alors que je me croyais en assez bonne santé mentale, je constitue *une mémoire fictive* quand j'avais espéré enfin avoir rencontré l'instrument par excellence d'une mémoire totalement objective. Enfin on soupçonne *la création* pure dissimulée dans mes stratagèmes, on devine le *sacré* qui se drape subtilement dans le profane. Une odeur d'encens me monte au nez. Je constate que l'Institut Lumière est un sarcophage. Je crains la momification. Je me réfugie dans la prudence silencieuse. Je n'en pense pas moins, merci. Je suis à leur merci. Je me noie dans l'eau bénite. Je suis récupéré malgré moi.

En vérité je me rends compte qu'il n'est pas facile de se démarquer. On n'échappe pas à la cathédrale, comme on n'échappe pas aux Écritures totalitaires. Il est plus facile de renverser l'URSS que le cinéma. Dieu est inaliénable. Chacun trouve midi à sa porte. Le pouvoir est magique. La magie est pouvoir. Le cirque est universel. Je déteste l'universel. L'international. Je n'ai que faire de l'empire. J'aime mon village. Je reconnais l'autre. Je refuse de les confondre. Pour ne pas être confondu dans l'énorme et le pontifical. Le *biggest in the world* me paraît le fin mot de la décadence. Du déclin si on préfère. L'homme est toujours à recommencer. A l'innocence. Mais l'innocence est vulnérable aux images. Cul-de-sac!

La Bible est infatigable et n'a pas fini de m'étonner. De renaître. Car elle est représentation. Et toute représentation fait son nid dans la perception. Il ne suffit pas de chanter les psaumes de David. Encore faut-il les ériger. Les appareiller. Les éclairer. Les ornementer. Les envoûter. Leur donner un toit. Leur construire une voûte. Un temple. Un palais.

Un palais des sports. Un palais des festivals. Et des cérémonies. Autour de l'or. La palme d'or! L'oscar d'or! Le veau d'or! Et tout est en place. L'idole et l'adoration. Le dieu et ses fidèles. L'homme devenu fidèle. L'homme séduit par les auréoles. Et qui ne s'intéresse plus à son humanité.

Comment l'image agit-elle? Où trouve-t-elle sa force? Il n'y a pas d'image sans culte. Il n'y a pas de culte sans image. On n'adore pas un objet. Il faut encore y ajouter la présence. La présence réelle. L'incarnation. Le cinéma a entièrement renouvelé l'incarnation. Il l'a réinventée. De fond en comble. Depuis la voûte obscure des grottes préhistoriques jusqu'à l'envoûtement des parois cathodiques ou cinématographiques, l'image n'a pas renouvelé sa fonction. L'image n'a pas cherché d'autre objet que le culte. Ayant toute ma vie travaillé à désacraliser l'image, à la réaliser, à l'exorciser peut-être, à la vivre dans les fardoches de la chasse à l'orignal ou parmi les laminaires géantes au vent des harts grandiloquentes d'une pêche aux marsouins, je me rends compte que j'ai repoussé l'image hors de la croyance, que j'ai omis l'envoûtement, en sorte que personne n'ajoute foi à mes prétentions. J'ai découverte une Amérique. On m'attribue les Indes de la fable. On me confond à l'imaginaire. On débusque la présence réelle. On me prend pour Colomb. Un Colomb qui n'est pas sorcier. Un Colomb sans or ni paradis à la fin de la représentation. Je me sens récupéré par la théorie. La théorie me cherche des puces. Elle me découvre des auréoles.

Tout cela me déconcerte. J'écoute un discours cathédrale. Qui me revendique dans la mesure où le cinéma est universel comme la Sainte Église. Je résiste au sacerdoce. Je refuse les ornements. Je me réponds à bâtons rompus. Mes irrévérences ne sont pas préméditées. C'est le syndrôme du colloque. Je ne devrais pas fréquenter les temples. Je me résigne à garder le silence. Le silence me garde. Je prends des notes pour me rassurer. Un Paul Warren, pourtant exaspéré par mes impertinences mais qui résiste au *star system* sinon à l'envoûtement, me demande un article. J'accepte. Je mets de l'ordre dans mes notes. Sans trop prévoir où cela me mènera. A l'incohérence. A l'impertinence. Je poursuis mes contradictions. Usant de l'image et récusant l'image. Essayant de séparer l'ivraie. De distinguer entre l'image d'une réalité et celle d'une fiction. Cherchant à trouver place dans le discours qui englobe. Qui récupère. Sans y parvenir. Repoussé dans la marge par le triomphalisme. La vénération. L'envoûtement. La sorcellerie. Comment prendre place? Autant me taire. On parle de création. Abus de langage. Je n'arrive pas à me prendre pour un créateur. Tout au plus pour une créature si tant est qu'il y a un créateur. On abuse des mots. On fait de la surenchère. Est-ce le propre du cinéma? *En mettre plein la vue! Donner le change! Faire semblant!* Y a-t-il dans le cinéma un au-delà des apparences? Un au-delà de l'image? Une image qui ne se prend pas

pour une image? Qui ne se prend pas pour Dieu? Et un peintre d'icône que ne se prend pas pour un créateur? L'homme a créé Dieu, à son image. Encore l'image. Encore l'apparence. L'homme a créé Dieu dans la mesure où il n'existe pas et sans l'ombre du doute. Dans la mesure où l'homme existe on le met en doute. On l'écarte de sa pure et dure réalité. Où est l'homme? Chacun le cherche dans son imaginaire pour en faire une image. Un spectacle. Je ne récuse pas le spectacle. Je récuse le spectateur. Celui qui vénère l'image. Qui ne prend aucun souci de la réalité. Qui préfère l'image. Qui sacrifie sur l'autel de la vénération. Qui allume le cierge devant l'icône. Encore et toujours.

J'ai choisi, délibérément, de chercher l'homme et je le trouve partout ailleurs. Ailleurs que dans l'imaginaire. Ailleurs que dans le spectacle. Quelque part, humblement, dans la réalité. Mais la réalité ne fait pas spectacle même quand on en fait un film. La réalité n'a guère de spectateurs. Attentifs. Chaleureux. Il ne reste plus guère que des badauds sur cette terre de vénération. Le badaud court au spectaculaire. L'homme n'est pas spectaculaire. Heureusement pour lui d'ailleurs. Cependant tout se passe comme si les hommes étaient irrémédiablement changés en spectateurs par le spectacle. Tout se passe comme si les hommes vivaient au cinéma. De cinéma. Comme délogés du réel par l'image. Que font-ils dans la réalité? Est-ce qu'ils la vivent? Ou s'ils la rêvent? Peut-être a-t-elle été dévaluée, la vie réelle, par la vie rêvée. Par l'image. Les hommes vivent dans l'image. Je prétends réhabiliter la réalité. Dire aux hommes qu'ils valent la peine d'être vécus. En les regardant vivre. Est-ce du cinéma? Il est permis d'en douter. J'en doute. La théorie ne doute de rien. Elle me récupère en quelques mots, m'accusant de créer de l'imaginaire. Je proteste. En vain. J'ai tout fait pour faire autre chose que du cinéma. On m'accuse de cinéma.

Le spectaculaire n'est-il pas justement une perversion de la réalité? Une complaisance dans la perversion? Et la perversion est-elle innocente? Quel est son but? Elle trafique. Elle propose ses miroirs. Le spectateur se déplace. Il descend la rivière. Il se rend au poste de traite. Il va vendre sa fourrure. Pour des miroirs. *C'est l'aviron qui nous mène,* dit la chanson. Il va vers les lumières de la ville. Il consulte les affiches. Il se laisse séduire. Il va au cinéma. Par milliers. Chacun venant de son travail, de sa chasse, de sa course. De sa réalité. Les ballots pleins de fourrures. Il dépose ses fourrures au guichet. En échange des miroirs. En échange des mirages. Quelqu'un fait la traite. Il s'empare du labeur. Il paie en images. Il s'enrichit. Est-ce que le spectateur s'enrichit? C'est la traite des âmes. Le marché du rêve.

Et cette perversion dont on se vante comme d'un exploit, cette perversion ne semble préoccuper personne. N'inquiète personne. A les entendre c'est une sorte de sainteté. L'indigène bénéficie de la culture. On lui propose des créations. Spectaculaires. Encore les auréoles autour

de la cène. Comme les assiettes de Prévert. Autour de la table de Vinci tous les convives se prennent au sérieux. Ils sont en spectacle. Ils se donnent en spectacle. Dans l'image. Conscient de jouer un grand rôle. De jouer à l'image. Ils sont sages, comme une image. Ils ne savent pas qu'il neige dehors. A plein ciel. Ils sont au ciel. Ils se regardent les uns les autres. Ils s'admirent. Ils ne doutent pas de leur image. Ils sont dans l'image. *Et leur assiette se tient toute droite au-dessus de leur tête.* Je cite de mémoire l'impertinence de Prévert. Et je me dis que l'image se pose la question des auréoles. Que le cinéma se pose la questions des auréoles. La question de la sainteté. L'auréole dénonce l'idole. Aveu de perversité. L'image auréole. Choisit Judas. Choisit Jésus. L'image ne m'interroge pas. Elle répond du héros. Elle endosse. Elle prend parti. Elle vole au secours de l'image. Elle couronne l'image. Il y a plain d'as-siettes. Toute le monde applaudit. C'est la remise des *Oscars.*

Les écritures sont-elles innocentes? Les bisons d'Altamira sont-ils in-nocents? Peut-être est-ce la vénération qui est perverse? La foi endosse l'image. Elle en déduit la présence réelle. Elle lui donne une profondeur. La réalise. *Plus vrai que vrai,* dit le dicton. Bien sûr. A cause de l'auréole. Par ailleurs on dit que la réalité dépasse la fiction. Comment s'y retrouver? Je cherche le monde dans le monde. Se trouve-t-il dans l'image? Et quand la réalité dépasse la fiction quelqu'un achète les droits. Pour en faire une image. Pour la réduire en image. Est-ce la caméra qui pervertit? La religion? L'histoire? Pour changer un meurtrier en héros suffit-il de l'écrire. Peut-être est-il impossible d'échapper aux bisons d'Altamira? L'image dévore la réalité pour l'embellir. Elle fabrique des mirages. Des auréoles. La réalité appartient à l'image. Comment filmer la réalité? Comment échapper aux Ecritures qui pervertissent la réalité?

Les Ecritures, de la peinture rupestre aux Evangiles, m'épouvantent rétroactivement. Elles ont servi à explorer l'imaginaire. Peut-être les mages nous ont-ils appris à regarder les étoiles, les augures à explorer les causes. Mais comment ne pas constater qu'elles ont servi d'argu-ments pour nier l'évidence, pour contredire l'inconnu, pour condamner Galilée. Pour pervertir notre vision du monde en lui proposant les auréoles. Au départ l'Ecriture est une tentative d'explication de l'univers. A l'arrivée elle est l'univers. Révélation. Et l'homme me paraît toujours aussi vulnérable à l'image, même si les images changent. Perversion du discours qui devient *la voie, la vérité, la vie.* Les Ecritures ont imaginé l'univers pour se l'approprier, refusant de se rendre à l'évidence quand l'évidence est devenue accessible, possible. Les Ecritures ont imaginé les Indes pour nier l'Amérique. Pour atteindre le mirage des Indes. Colomb a voyagé dans les Ecritures. Il a fréquenté le mythe. L'Europe a cru Colomb. L'Europe a poursuivi l'or des Indes. L'Europe a préféré l'or à l'Amérique. Elle n'a pas découvert l'Amérique. Elle l'a conquise. Niant l'Amérindien. L'anéantissant. Pour justifier le mirage. J'entends

l'Europe admirer presque sans condition Hollywood, la négation de l'Amérique, et cela ne m'étonne guère. L'Amérique n'existe pas encore. Il n'existe qu'une image de l'Amérique. La preuve de l'image c'est la conquête. La preuve de l'Amérique reste à faire.

Je n'arrive pas à comprendre. A me comprendre. Je me réponds en secret aux questions que me pose un colloque. Je doute du cinéma. J'essaie de faire autre chose. Sans y parvenir. Je me sens récupéré. On nie sans hésitation mes prétentions. Le réel n'existe pas. Il n'est que fiction. Seule existe l'image. J'oppose mes doutes à leurs certitudes. Je tourne en rond. Je deviens de plus en plus improbable. Il me semble que le cinéma, plus encore que l'écriture, et que la fiction, plus encore que le cinéma, s'emploient comme les Ecritures elles-mêmes à substituer l'imaginaire à la réalité. Je reviens à Colomb qui voyait partout le paradis là où il rencontrait les plumes de l'Amérique. Il avait la foi. Merveilleusement. Il croyait à la merveille. Il ne réfléchissait pas sur les plumes de la réalité. Il rencontrait une image. Il naviguait les Ecritures. Il niait l'étrangeté, l'autre, l'amérindianité. Pour aller au cinéma il faut avoir la foi. Le cinéma propose les Indes. La merveille. Celui qui n'a pas la foi devine les plumes de la réalité. Il refuse la merveille. Croyez-en un incrédule. Un infâme incrédule qui préfère les perrroquets de l'Amérique aux Indes de Colomb. Colomb faisait du cinéma. Il proposait la merveille. Isabelle aimait le cinéma.

Ce qui m'étonne le plus c'est que le cinéma ne doute jamais du cinéma. Personne ne doute de l'image qui rapporte de l'or comme Colomb. Personne ne doute de Dieu qui construit des cathédrales. Même le mage ne doute pas de la magie. *La crédulité est un abîme,* murmure Jacques Godbout qui ne doute de rien. Pourtant dans l'Eglise il y a eu des hérésies. Au cinéma il y a de la surenchère. On parle d'Art majuscule! De création! Une incroyable inflation verbale. Le cinéma est apostolique. Il construit des cathédrales. Des Institut Lumière. Il est surtout apologétique. Le vocabulaire ecclésiastique lui va comme un gant. Il est aussi romain, c'est-à-dire impérialiste. Il tend vers l'universel. Si un jour le cinéma se mettait à douter de son infaillibilité? Devenait iconoclaste? Impensable, me direz-vous. C'est ce qu'il fallait démontrer. Le cinéma ne se pose pas vraiment de question sur lui-même. Comme l'empire. Il occupe le territoire. Il a supplanté la religion. Il sera remplacé par une autre paroi. Une autre image. Plus efficace. Plus tard. Un jour. Bientôt peut-être.

Paul Warren lui-même dans son livre sur *Le Secret du star system américain* se demande habilement comment agit le champ/contrechamp qu'il nomme fort justement le *reaction shot* (il ne m'étonne pas que ce mot soit intraduisible) pour opérer *l'arrimage de la salle à l'écran,* pour persuader, pour séduire. Il est témoin de la persuasion. Il ne dénonce pas la perversion. Il ne va pas si loin que de la sanctifier bien sûr. Parmi

tous les colloquants de Lyon il était peut-être le plus sceptique. J'aime le doute. Sans le doute il n'y a pas d'inconnu. Celui qui ne doute pas des Indes ne découvre pas l'Amérique. Il nie l'Amérique. Il la remplace par une image de l'Amérique. Disneyland après Hollywood. Mais se demande-t-il l'effet de la séduction sur les indigènes? Mesure-t-il les désastres de la traite des fourrures? A quoi sert l'image? A qui profite l'arme du cinéma? A quelles conquêtes de l'âme? A quelles justifications, de quelles dévastations? Les gens qui se nourrissent d'images souffrent d'ulcères de l'âme? Le savent-ils, les mages de cette magie? S'interrogent-ils sur les victimes de ces mitrailles de l'image et du son? Sur ces croisades des enfants pour conquérir quels paradis proposés par ces nouveaux Colomb? Le cinéma s'est substitué à l'église, à l'école et à la famille. Les parents sont toujours en retard d'une génération. Et dans quel but, pensez-vous, ce prosélytisme? Sinon celui d'enrichir l'argent qui arme le navire. J'entends les protestations indignées. L'artiste qui défend sa création. Sans soupçonner qu'il est lui-même séduit par la réussite. Le séducteur séduit. En faveur du Prince. On pourrait presque parler de proxénétisme, sorte de courtage qui s'adresse à l'âme. En passant par le corps. Car pour rentabiliser l'aventure il faut séduire le plus grand nombre. Par tous les moyens. En proposant *les créatures de rêve* dont parle non sans ironie un de mes amis qui ne déteste pas le cinéma. Je n'oublierai pas le grand hall du Palais des Festivals de Cannes. Et toutes ces *créatures de rêve* proposées par le cinéma sur les parois. Immenses photos de la séduction. Images. Peintures pariétales. Pour séduire les enfants. Le cinéma comme la drogue s'adresse de plus en plus aux enfants parce qu'ils sont les plus vulnérables. J'avoue que *ces créatures de rêve* ne me proposent même pas une image de la beauté. De la beauté de la femme. Au contraire. Je ne suis pas séduit. J'ai perdu mon âme d'enfant. C'est bien ailleurs que je trouve la beauté.

Bien sûr il reste, sur la planète, des fous généreux qui cherchent à détourner l'image vers autre chose que l'auréole, à constituer mémoire des disparus, trace des conquis, vestiges des assimilés, pour donner la parole à *l'homme du commun,* en dépit de l'Eglise, pendant que l'entreprise, l'industrie, le cinéma triomphant cherchent à mythologiser l'univers pour justifier l'Empire. Les Grecs et les Romains n'ont pas agi autrement. Le livre de pierre des cathédrales n'a pas agi autrement. Le cinéma cherche-t-il à libérer l'homme des images? de la magie? de l'idolâtrie? Les dieux n'ont jamais servie les hommes. Ils ont légitimé les rois. Les rois disparaissent. L'Empire succède à la Révolution. Et le jour où la République s'installe Paris-Match reconstruit les objets de vénération. Sur les ruines du temple. Quelque part, à la remorque des nouvelles divinités, sous une autre forme renaissent les rois, les princes, les *stars,* les riches. On consacre les vedettes comme les empereurs.

Les dieux sont-ils indispensables à la marche du monde? L'homme ne peut-il pas vivre sans adorer? Sans idole? Sans image? Peut-être bien que non. Mais peu m'importe. J'en voudrai toujours au veau d'or sous toutes ses formes. Sans les rois qu'on détrône, sans les statues qu'on brise, il n'y aurait pas d'histoire. Et sans la vénération, il n'y aurait pas de cathédrales si belles. Plus belles peut-être que le grand hall du Palais des Festivals de Cannes avec ces photos d'images peintes sur des corps de femmes déguisées en vamps. (Encore une sublime invention du langage hollywoodien que je me refuse à introduire dans ma langue sans dénoncer son origine.) C'est le long acheminement de l'homme à peine sorti de la caverne. Combien faudra-t-il saccager de palais, brûler de temple, proscrire d'idéologies pour libérer le peuple roumain? Les rois renaissent de ces cendres. L'homme se retrouve toujours assujetti à des vénérations. Images de paradis! J'essaie de m'y retrouver. A travers le cinéma. A l'encontre du cinéma! Le cinéma ne pourrait-il pas réduire le pouvoir de l'image? Ne pourrait-il pas devenir un révélateur de l'homme? Un découvreur d'inconnu? Tel n'est pas son intérêt peut-être.

En vérité à quoi sert de remplacer le marbre des dieux par la pellicule des idoles? Mais je me rends bien compte de l'énorme pouvoir entre les mains du cinéma. Comment résister au pouvoir? Ceauscescu n'a pas résisté à la magie du pouvoir? Peut-être, au départ, était-il un honnête homme. Il a été séduit par sa propre image. Séducteur séduit. Et ne voilà-t-il pas que nous avons en main toutes les couleurs, toutes les parois. L'homme n'a plus à se rendre dans la grotte ou le temple. La paroi de l'écran cathodique dans nos chambres. Comment rêver son propre rêve devant l'interminable bavardage de plus en plus intempestif? Avons-nous réussi à *faire naître l'intempestif?* Et à quel prix? On est loin du guerrier maori soufflant une chaux qu'il vient de pilonner pour décalquer l'empreinte de sa main sur la paroi. Nous sommes loin du tison éteint et de l'ocre broyée et de la torche fumante et des parois de Lascaux et des bisons d'Altamira. L'image n'est plus à proprement parler une image. Les iles ne sont plus de marbre. Traits subtils sur la pierre ou la toile. Mais à travers la transparence d'une lumière, torche diffusé par la lentille, un reflet mouvant, animé par une présence, révélant la chair des gros plans, la rougeur du sang sur les joues de la honte. L'auréole n'est plus au-dessus des têtes mais dans la transparence qui traduit autant les regards que les paroles, les gestes que la mort, la grandiloquence que les silences. Maquillage ou comédie. Plus encore. C'est l'incarnation en chair et en os. Sans passer par le subterfuge de la transsubstantiation. Tantôt incarnation d'un personnage par l'obscur comédien encore dissimulé dans les draperies de l'anonymat. Tantôt incarnation du comédien lui-même dans le personnage qui prête sa substance à la divinité. Le comédien devient le personnage. La crédibilité

repose sur la notoriété. La crédibilité repose sur la crédulité. Et inversement. Le personnage devient le comédien. Sur la rue les gens voient passer Jean-Paul Belleau, ou Belmondo, ils saluent Citizen Kane, ils reconnaissent Brutus et César. Le cinéma réussit dans tous les sens ce que le prêtre a tenté laborieusement de mettre en place; le mystère de l'Eucharistie. Par le comédien lui-même devenu dieu. Par le comédien qui se glisse dans le personnage, par le personnage que s'insinue dans le comédien, l'un et l'autre devenus sacrés l'un par l'autre. Dieu et sa doublure. Nous voilà condamné à l'adoration. Il n'y a plus de mystère. La magie est toujours la même. Et les dieux du cinéma ressemblent étrangement aux dieux de la mythologie. Tyranniques, capricieux, pervers. Pervertis par la magie. Ils en sont arrivés a *se complaire dans la perversité*. A force de jouer les dieux ils se prennent pour des dieux. Y a-t-il des exceptions? Elles comptent pour rien puisqu'on n'en parle pas. Le cinéma engraisse par le scandale. Et celles qui refusent de jouer le jeu sont éloignées des parois par la Metro Goldwyn Mayer. Lilian Gish qui refuse de jouer du scandale comme Greta Garbo. C'est rare comme vous savez.

Comment dès lors reconquérir notre humanité? Echapper aux images? S'agit-il de *vivre avec l'image* ou d'échapper aux images? Dans un monde où tout est image! Où l'image est partout! Les mages ont toujours fait reposer leur pouvoir sur l'image pour asservir les hommes. Depuis le premier roi sumérien. Depouis le premier chef de clan. Comment résister encore une fois? Renverser le tyran? J'entends la résistance. Elle est encore sourde. *Ami, entends-tu, les cris sourds du pays qu'on enchaîne.* Je songe à la France de l'occupation. A la Roumanie naissante. Au printemps de Prague. Au mur de Berlin. A l'Espagne de Franco. A l'Allemagne nazie. Tous ces pays prisonniers d'images fortes. Je songe au *Triomphe de la volonté* qui a tant contribué à l'image mythique du petit caporal. Très petit caporal. C'est le triomphe du mythe. La production d'image tend vers la production du mythe. Fatalement? Peut-être pas. Par goût du pouvoir. De la séduction. Et le mythe lui-même devient totalitaire. Car il règne sur les âmes. Autant celui de Hitler que celui de John Wayne. Et il tend vers l'uniformisation, l'universel, l'empire. Il n'y a de véritable image que celle de l'humilité. C'est la seule qui ne ment pas. Peut-être. Je cherche une issue. Il ne suffit pas de dénoncer le *reaction shot*. Il faut encore proposer une libération. Une marche des partisans. De ceux qui refusent d'appartenir à l'autre. Qui résistent au cinéma? J'ai l'impression que Paul Warren n'ose pas résister au cinéma. Même quand il en décrit les horreurs. Je me sens du côté de la résistance. De coeur. Pour écrire l'histoire. Pour l'empêcher de se prendre aux mailles de l'empire. De s'enliser dans l'empire. Qui osera utiliser le cinéma pour libérer les hommes de la magie? L'image pour se libérer de l'image. Est-ce possible? Je l'ai cru. On me dit que j'ai manqué le bateau. Qu'à mon tour j'ai créé des mythes. Je refuse de le croire.

D'ailleurs est-ce possible de vivre du cinéma et dans le cinéma sans satisfaire le Prince qui arme le navire? Et le prince de ce monde c'est l'argent. Et l'argent n'entend rien au monde et il ne comprend du cinéma que ce qu'il rapporte. Il ne comprend que lui-même. Il ne respecte que lui-même. C'est pourquoi il est prêt à tout profaner, même sa mère. Le riche n'achète pas un Picasso pour faire vivre Picasso. Il arrive quelquefois au Prince de se montrer bon prince. Rarement. L'argent jamais. Reste-t-il des Princes? L'ONF a été mon Prince. Je reconnais le privilège sans pareil. Je ne suis pas bien certain d'avoir été à la hauteur. Mais le cinéma dont je parle est ailleurs. Partout ailleurs. Au fond je ne fais que des films. Et non du cinéma. Mais le cinéma lui-même refuse de l'admettre. De me condamner. Il me pardonne mes dissidences. Il me tient en respect. Et même en estime. Pour ne pas se poser de questions. Pour ne pas se mettre en doute.

Il reste des contraintes. Innombrables. Et la plus dangereuse est peut-être l'argent. Même à l'ONF. L'argent n'est jamais gratuit. Et plus il y a d'argent, plus il y a de contraintes. Paradoxalement peut-être faut-il retourner au cinéma pauvre. Rêver à la *caméra stylo* dont on parlait il y a quelques années. Celle qui n'aurait pas besoin du Prince. Mais même le stylo de l'écriture a besoin du Prince. L'écriture prisonnière de la faveur. Je rêve de la *caméra en bois rond* imaginée par Bernard Gosselin. Une caméra de résistance. Mais le spectateur a vendu son âme au spectacle. Il est inaccessible. Et la critique . . . et la publicité . . . et même l'université se sont mises au service de la faveur. Les institutions parasitent le système. Et l'encouragent. Dans la mesure où elles en vivent. Mieux que bien des cinéastes d'ailleurs. Il y a plus d'enfants de choeur que de curés. Ce sont les courtisans.

Vaut-il mieux découvrir le cosmos grâce à la *caméra Imax* ou l'homme grâce à la *caméra en bois rond? C'est là, la question!* Le cosmos c'est la nouvelle conquête de l'Amérique américaine. L'homme c'est l'autre, le conquis de l'Amérique anéantie, négligée, méprisée, vaincue. L'Amérique amérindienne entre autres. Le *cow-boy* est en chômage. L'astronaute le remplace. L'Amérique européenne a recouvert l'Amérique amérindienne d'une couche d'Europe, de chrétienté, de conquête, de massacres, de génocides transformés en épopées par le cinéma *western*. Le tour est joué. Il ne reste plus au *cow-boy* qu'à se recycler en astronaute. Et la conquête se poursuit. Sans merci!

La navigation à compte d'auteur est-elle encore possible dans un monde médiatisé? Les antennes paraboliques implorant le Prince électronique. Sans se méfier. Qui se méfie du Prince? Le Prince aime bien les navires. Il accepte de financer le navire. Pour permettre une navigation. Mais qui va choisir la destination? Au début de la télévision, qui a définitivement transformé en marchandise le cinéma et même le journalisme, le cinéaste et le journaliste ont immédiatement occupé le champ

libre. Ils se sont emparés du discours. Sans méfiance. Réclamant des outils. Ambition légitime. Période faste. Pleine de maladresse et de générosité. Mais, petit à petit, le Prince a racheté le navire. A occupé la place. Le cinéaste est devenu capitaine. Il navigue désormais pour le compte du Prince. Il ne choisit plus la destination. Le Prince tient les comptes. Le cinéaste implore; épitres au roi, scénario, requêtes. Le Prince est un brasseur. Il est camouflé derrière toutes sortes d'instances. Il décide du sens au nom de la cote d'écoute. C'est le brasseur de bière qui décide de l'âme des spectateurs qu'il transforme irrémédiablement en buveurs de bière. Un brasseur de bière et un brasseur d'affaires. L'artiste sans s'en rendre compte est devenu mercenaire. Il lui faut gagner la guerre. La guerre des cotes d'écoute. La guerre des bières. La *Molson* contre la *Labatt*. Je simplifie à peine. La *Miller* contre la *Coors*. Et que dire de la *belle danoise?*

L'état de guerre est-il le lot de la condition humaine? Sommes-nous voués à cette lutte pour la vie dont parle les évolutionnistes pour expliquer la réussite de certaines espèces? Et l'humanité n'est-elle pas la forme animale la plus efficace, ayant réussi à s'allier toutes sortes de puissances, depuis le tranchant du silex jusau'au rayon laser, depuis la fronde de David jusqu'à la bombe d'Hiroshima? L'arme fait toute la différence entre l'homme et l'animal. Et surtout entre les hommes.

Derrière toutes les grandes cultures il y a une armée.

Et ceux qui se prétendent les créateurs vivent des miettes qui tombent de la table des puissants.

Mais aujourd'hui devant la difficulté d'utiliser l'arme ultime à cause du danger de ressac, l'homme, cet infatigable guerrier, a inventé l'arme la plus redoutable. Il a renouvelé l'image. Il a transformé l'image en marchandise. En objet de consommation. Produisant des divinités à la pelle. Il fallait 200 ans pour construire une cathédrale. Aujourd'hui, à Montréal, chaque semaine on a le choix de deux cents, oui, 200 long métrages dramatiques. *C'est une richesse extraordinaire à la portée de tous les yeux?* murmure Jacques Godbout. Je me permets d'en douter. L'image néglige la conquête du sol. C'est vrai. Mais elle s'en prend au territoire de l'âme. Sans consulter notre piété. Notre participation. C'est une cathédrale toute faite. Qui ne sollicite que notre faveur. Qui nous occupe comme un territoire, qui nous dépayse d'un pays qu'on n'a pas encore nommé, qui nous distrait de nous-mêmes. Ces trois mots m'effraient; occuper, dépayser, distraire. Ils sont la clef de notre civilisation de l'image intempestive. L'image nous tient lieu de tout. De réalité, de morale, de religion, de culture, de pays. Nous sommes irrémediablement dépaysés. Réinvestis dans l'empire. *C'est la génération Pepsi.* Et la publicité joue le même jeu que le cinéma. Revendiquant les dieux. Tous les dieux. Les dieux du stade et ceux du cinéma. Pour investir notre âme disponible à la divinité. Rachetant les héros mercenaires pour

nous vendre leur médiocrité *pepsi*. Les dieux sont à vendre. Les âmes aussi. Les dieux sont séduits par l'argent. Les âmes par la vénération. C'est la guerre totale. Universelle. Le triomphe de l'empire.

Je me sens coincé entre un colloque modeste et chaleureux réunissant critiques, penseurs, professeurs de cinématographie et quelques cinéastes abasourdis d'une part et *l'incontournable* présence de Hollywood symbolisée par la cérémonie pontificale de la remise des *Oscars* à grands déploiements (image presque moyenâgesque de sacre d'un empereur). Coincé entre ces deux extrêmes de la vénération, sinon de l'adoration, des mages à la remorque de l'étoile. Entre les catacombes à mots couverts d'un colloque et la place Saint-Pierre entourée par les colonnes du son du Saint-Siège cinématographique. Entre l'intelligence théorisante (il y a dieu quoiqu'on pense dans théorie) qui théologise sur la création et le pragmatisme triomphant du *showbiz* (mot que je refuse de considérer dans ma langue même si on le retrouve dans les dictionnaires de notre décadence) qui corrobore le *box office* (même remarque). Quelque part entre la chaire d'une critique presque clandestine qui vénère Godard comme si le cinéma n'avait rien de mieux à faire que de pratiquer la déconstruction systématique avec l'élégance d'un mauvais garçon de bonne famille qui pense que *les bourgeois c'est comme les cochons, plus ça devient vieux, plus ça devient bête* (et les cinéastes, eux?) et le trône impérial du *big show* des *Oscars* qui consacre le succès et ajoute inlassablement des niches à la cathédrale cinématographique pour loger les nouvelles idoles de ce Nouveau Testament.

D'un côté le sarcophage, le lieu de pélerinage, la châsse, le reliquaire, le mausolée, la pyramide, l'Institut Lumière et ses théologiens du cinéma, et l'un d'eux qui affirme le plus sérieusement du monde que *La Sortie de l'usine,* des frères Lumière, est une fiction et peut-être le plus grand film de l'histoire du cinéma (j'ai le sentiment d'être en danger de momification). De l'autre côté les grandes orgues, la cérémonie du sacre, les immortels, le Temple de la Renommée, la communion des saints, la théorie des demi-dieux, le grand défilé du *big show,* du *big business,* du *box office,* du *star system,* du *showbiz,* (et je me cherche une place parmi les gargouilles du grand livre d'or). Et je refuse le *Oscar* offert l'an dernier à l'Office national du film. Pour ma part. Et sans la moindre humilité.

Je ne résiste pas à la tentation de citer la belle formule de Jacques Godbout qui se cherche une âme des neiges dans une culture des livres et du cinéma.

Ma mère se nommait Hollywood. Mon père Saint-Germain-des-Prés. Les émotions fortes, le faste, l'aventure, l'exotisme, l'argent, la mort (celle des conquis, des méchants, des indiens, des nègres, des chicanos, des los tabarnacos, des bandits de toutes sortes je suppose) *venaient de Haute-Californie. L'intelligence critique, l'ironie, la vivacité, l'art, la poésie, la gloire, la vie, habitaient Paris.*

Il avoue que c'est ainsi qu'il se voyait à seize ans. Avec une âme empruntée à la littérature (le cinéma étant une province lointaine et, disons-le, mineure, de la littérature; quand je fais un film j'ai le sentiment d'écrire en utilisant un autre alphabet, genre bande dessinée). Autrement dit, à seize ans, Jacques Godbout avait appris à vivre en lisant. Peut-on échapper à cette confirmation, à ce baptême? Pour *apprendre à vivre en vivant!* La vie n'est pas dans l'écriture. Je ne méprise pas l'écriture. Ni même le cinéma. Mais une écriture pour être autre chose que de l'écriture se doit de prendre sa source ailleurs que dans l'écriture. Mettre au monde le réel. *Apprendre à vivre en vivant!* Est-ce encore possible dans un monde modelé, modifié par l'image? Par la mode de l'image? Par la vénération de l'image?

Le mort saisit le vif, proclame le vieux droit romain. Jamais en aucun temps la sépulture, la momification, l'embaumement n'ont été aussi précoce. On momifie les vivants. Il y a des coupoles où on habille en vert les immortels. On couronne. On palme d'or. On récompense. Comment vivre tranquillement une vie de cinéaste sans recevoir de prix; cela serait l'exploit. Peut-être suffit-il de ne pas les implorer. C'est le règne de *l'auréole.* On cite Godard comme les Ecritures. Hitchcock comme un Père de l'Eglise. Fellini comme un pape. C'est le vif qui s'empare du vif. Les procès de béatification en accéléré. La sainteté à l'âge de Rimbaud. L'immortalité, au premier long métrage. Le dictionnaire, au troisième. Je suis mal à l'aise parmi les déesses. Je refuse de baiser la bague des évêques. Je ne reconnais pas le maire de Montréal. Les célébrités m'agacent. Les immortels me font sourire. Les vedettes m'irritent. Autant Godard que Jane Fonda. Je n'ai aucun sens de la vénération. Je plaide coupable. Je suis iconoclaste. Je brise le veau d'or. Surtout quand il est de chair et de sang. J'ai horreur des *monstres sacrés.* (Encore un mot imaginé par la nouvelle religion.)

Je respecte mes personnages. Je les aime. Mais je refuse de vénérer. Le créateur vénère sa création. Celui qui se prétend créateur vénère ce qu'il prétend sa créature. Echange de bons procédés. Les demi-dieux se congratulent. Le créateur se pense plus grand que sa création, simple reflet de sa puissance. Et il en arrive à se vénérer lui-même dans la mesure où il a créé des divinités. Des idoles. Des *stars.* Des *superstars.* On va bientôt parler de *nova.* Et de *super-novas* (je refuse le pluriel latin). Mais vivre dans les images, n'est-ce pas réfuter les paysages. Et les dieux réfutent les hommes. S'incarner dans la fiction c'est récuser le quotidien, le petit à petit, le jour-le-jour, la vie en somme. C'est clubmédiatiser le réel. Très peu pour moi, merci!

Dans le direct, Dieu est créateur. Dans la fiction c'est le cinéaste, prétend, paraît-il, Hitchcock cité par Pascal Bonitzer, sorte de gardien sévère d'une orthodoxie vénérée. Ma transcription est approximative. La formule ne me déplaît pas, dans la mesure où je ne prétends pas être

créateur même si je ne sais pas très bien si Dieu existe. Bonitzer me repousse hors de l'église. Là où il n'y a point de salut. J'en suis fort aise. Pour une fois. Le reste du discours cherchant à me récupérer.

Je suis, ici, dans ce cénacle, le seul représentant de la réalité. Le seul en tout cas qui ose l'opposer à la fiction. Le seul enfin qui tire sa vanité de ne pas appartenir à l'Eglise. Qui redoute la fiction comme une sorcellerie. La sorcellerie ensorcelle. Envoûte. Le seul qui ne se prend pas pour un créateur. Quelle honte. Mais je suis bien trop orgueilleux pour me prendre pour un autre. Atom Egoyan, cinéaste d'origine arménienne, parle lui aussie de la création. Il décrit ce qu'on nomme pudiquement le direct, qui n'est rien d'autre qu'une façon de tourner, comme *une peinture naïve*. Je l'en remercie en coulisse. Il s'excuse, croyant m'avoir offensé. Il proteste. J'insiste. La naïveté d'ailleurs a sans doute produit les premières images. En toute innocence. Sans arrière-pensée. Comme avant la naissance de la divinité. Combien de temps s'est-il écoulé entre la première peinture rupestre et le début de la vénération? Et qui a le premier songé à construire un temple autour de la première image? Je fais des films qui réfutent la vénération. Je n'appartiens pas à la vénération. J'accuse mon impiété. Je suis iconoclaste. Naïvement. Je revendique la naïveté comme antérieure à la divinité.

Il n'est pas très confortable, quand on est impie, de se retrouver dans un festival ou un colloque. Je le reconnais. Et je m'évertue maladroitement et en secret à justifier un sentiment qui n'a rien d'une philosophie. Je constate ma naïveté. Je suis sans doute un primitif. Un peuple chasseur. Antérieur au grand mortier des religions qui accumule les temples sur les ruines de la première innocence. Il m'arrive de penser que les images nous plongent dans l'ignorance de l'essentiel dans la mesure où elles nous privent d'un rapport direct (justement!) avec la réalité pure et simple. Comme le T.G.V. ou l'avion. Car elles nous épargnent les dimensions de la vie, ces grands pôles de l'univers, en faisant abstraction de l'espace et du temps. La mythification ne serait peut-être pas autre chose. Bien sûr c'est la puissance de l'esprit. Cette capacité d'abstraire. J'en conviens. Mais on ne peut rien comprendre si on ne revient pas de temps à autre à la pomme. Celle de Newton. Celle de l'automne dans les arbres du premier gel. En deux heures le T.G.V. parcourt la distance Paris-Lyon. Trop vite pour le regard. Le paysage nous échappe. Les hommes sont invisibles. On n'entend pas le cri du coq. Le berger ne parle pas de sa chèvre et de son fromage. Tout devient fugace. On n'arrive pas à voir. Comment réfléchir? Le miroir ne voit que des traces de paysage. On omet le paysage quand on abolit l'espace et le temps. En deux heures, au cinéma, on parcourt toute une vie. Comment reconstituer le temps et l'espace? N'est-ce pas là l'illusion? Trop d'images nous tiennent lieu de géographie, de voyage, d'aventure. La géographie de l'âme est aussi un oeuvre pédestre. *Moi, mes souliers,* dit la chanson.

Notre sensibilité est multiple. Le pays n'est pas que cathédrale. Mais nous vivons en touriste. Sans parler au boulanger. L'image ne retient que le spectaculaire, simplification, qu'elle accumule. Que saurons-nous du monde en le parcourant à la vitesse du son dolby? Trop de poivre gâte la sauce. Trop de son l'entendement. Je respecte la flûte qui est musique d'homme à homme. La grande allure est conquérante. Elle est aussi omission. Elle omet le boulanger. Elle ressemble à Attila. Elle est Hollywood. On ne peut rien apprendre du monde en T.G.V. Dans l'énorme simplification de l'image. On ne s'abstrait du temps et de l'espace que dans la théorie sans odeur comme le cinéma. Je crois au goût de la farine. Au goût du pain. *Filmer le paysage de dos* ne constitue qu'une pirouette. J'aime bien Lausanne. J'aime aussi Freddy Buache; son nom ressemble à ses moustaches. Mais dans le film de Godard je ne connais ni l'un ni l'autre qui ne servent que de prétexte à Godard. Son film est un auto-portrait. L'auto-portrait d'un avant-gardiste déguisé en film. D'un clown qui se prend pour une pirouette. Mais il a le mérite de contester l'image. En même temps il redoute l'image, refusant de la réduire à la naïveté. Il ne me reste que la naïveté pour faire obstacle à la sainteté.

J'en arrive à l'anecdote. Dans une pensée il y a des bornes. Des façades derrière lesquelles se dissimulent du sens. Comme à Lyon, il faut emprunter les *traboules* (le mot n'est pas dans le dictionnaire que je consulte; les mots que je préfère ne sont pas dans les dictionnaires) et au fond de ces passages obscurs se dissimulent des palais. Lyon comme un secret bien gardé. Là où la splendeur est camouflée derrière les lézards des façades. Un colloque est-il un traboule au fond duquel se cache la pierre précieuse d'une compréhension, une façon de jeter des ponts sur les fleuves? De réunir. De concilier. Le cinéma comme une façade. Infranchissable sinon misérable. Je cherche un coeur qui bat. Quasimodo caché dans les combles. Qui veut entendre l'autre? Est-ce l'endroit? J'en arrive à l'anecdote.

Elle m'a été *racontée* par René Bonnière, cinéaste, originaire de Lyon avec lequel j'ai fait mes premières armes en cinéma. J'arrivais du magnétophone, de la parole brute, de l'homme sans médiateur, sans histoire pour ainsi dire. Il avait appris le cinéma dans les ciné-clubs, ces antichambres des colloques, et à l'ORTF, comme il se doit. Nous avons partagé un moment nos expériences pour faire une série de treize films que je n'ai pas oubliée. Ayant découvert pour autant que j'avais un pays et un fleuve depuis lors j'essaie de le mettre au monde. Mon pays n'est pas le cinéma mais un fleuve. On n'a plus jamais travaillé ensemble. Il est retourné au cinéma et à la télévision. J'ai repris le magnétophone jusqu'à l'imposer à la caméra. Durant cette belle année de tournage nous avons beaucoup discuté. De cinéma et de réalité. Du cinéma et des hommes. Et j'ai retenu l'anecdote suivante qui m'a beaucoup

impressionné. C'est une histoire de ciné-club, l'ancêtre des cinémas d'art et d'essai, là où on vénérait plus l'écriture que l'écrit, le style que l'histoire, le cinéaste que son film. Un jour donc dans une discussion au ciné-club qu'il fréquentait quelqu'un pour défendre une quelconque prétention a affirmé fièrement: J'ai vu *Le Cuirassé Potemkine*... Immédiatement, indigné, colloquialement, sentencieusement quelqu'un l'a interrompu en disant du haut de sa superbe: On ne voit pas *Le Cuirassé Potemkine!* On le revoit!

C'est ce que je nomme les Ecritures majuscules. *Est-ce ainsi que les hommes vivent?*, dirait Aragon. Est-ce ainsi que *le cinéma devient intempestif?*, ajouterait Michel Bouvier. Mal à propos! Innopportun! On est toujours l'intempestif de quelqu'un. Faut-il s'inquiéter outre-mesure des mots qui ne sont pas des mots. J'aime bien l'intempestif. Mais la vénération m'inquiète. L'Institut Lumière, le ciné-club, les colloques me rebutent pour autant qu'ils négligent la réalité au profit de l'image, qu'ils préfèrent l'écriture et le signifiant. Je n'ai pas revu pour vérifier mon désaccord *La Sortie de l'usine* des frères Lumière. Et je regrette quasiment d'avoir vu, un jour, sans trop le réaliser, *Le Cuirassé Potemkine.* J'ai certes vu un beau film. Plein d'emphasc! Mais je n'ai pas pensé à la Joconde. Et en voyant la Joconde je n'hésite pas à lui préférer les bisons d'Altamira. Je ne suis pas voué au culte mais je me sense agressé par ces façons de voir. D'élever sur les autels. Impérativement. Théoriquement pour ainsi dire. Il y a dieu dans théorie et il y a procession donc fidèle donc pélerin et pélerinage. Et Dieu, par mégarde. Et procession par inertie. Le langage est un long cheminement qui laisse des traces étranges. Comme une dénonciation. Le rebours des mots dénonce les mots. Ne s'agit-il pas, en somme, d'une façon bien française de croire en dieu? D'une façon bien française d'imposer dieu? Est-il possible d'en faire l'économie? Dieu est-il la seule nourriture de l'âme?

Quel est-il le projet véritable du spectacle spectaculaire? Le spectacle spectaculaire tient-il un discours parce qu'il a le projet de parler aux hommes? L'intention de révéler? De donner à connaître? De faire à savoir? Le cinéma en vérité n'est ni généreux ni gratuit. Comme on parle d'un geste gratuit. Et moins il est gratuit plus il est rentable. Plus il est rentable moins il est naïf. Le cinéma enrôle. Il lève une armée. Il se fait une clientèle dans le sens romain du mot. Le client est servi et il sert. Il sert à conquérir par imitation. Et insensiblement, de plein consentement et par consensus, par le jeu des réciprocités, des statistiques, du succès, le cinéma occupe un nouveau territoire. Usant de l'arme de la séduction il occupe le territoire de l'âme. Il persuade par le succès. Il devient incontestable. Infaillible. Il est conquérant. Il colonise. Il défriche. Il cultive. A son plus grand profit.

Cependant, habilement et sans même le vouloir, le cinéma fait écran. Il occupe la paroi. Il dissimule la sortie. Il bouche la vue. Imposant une

image du réel qui empêche de voir le réel. Je me revois dans la rue, sortant d'un film *western*, et j'entendais sonner mes éperons sur le trottoir. Le cinéma nous fabrique une âme d'emprunt. Une par semaine. Il s'en trouve pour aller au cinéma tous les jours. Une âme par jour. Surplus d'âme. Qui peut supporter autant d'âme? Et qu'advient-il de la petite âme individuelle de l'enfant qui s'apprête à naître au monde? Forcé par la persuasion à vivre par personne interposée. A vivre à Hollywood. A vivre à Saint-Germain-des-Prés. J'ai connnu il y a plus de 30 ans déjà, avec René Bonnière (a-t-il revu *le Potemkine*, comme il faut dire quand on est initié?), toutes sortes de beaux villages de la basse Côte-Nord du Saint-Laurent. Le Saint-Laurent c'est un fleuve encore à naître. Faute d'écriture. Faute de cinéma. Ni Hollywood, ni Saint-Germain-des-Prés ne s'intéressent à ce fleuve. Même si André Breton en a parlé. Qui donc va s'en charger? Quel poète, quel cinéaste dont la mère est Hollywood et le père André Breton ou Jean-Paul Sartre? Et ces gens de ce pays innommé me nommaient leur pays. Non pas dans l'écriture qui reste. Mais dans le verbal qui passe. Qui passait. Je n'avais pas encore tout à fait maîtrisé le magnétophone. Et maintenant il est déjà trop tard. Car ils ne parlent plus glace, mer, loup-marin, chasse, neige, dauphin, caribou, chiens, voisin; pays en somme. Je suis retourné à Tête-à-la-Baleine et on m'a raconté *Dallas, Los Angeles...*on m'a parlé *Dames de coeur* et Jean-Paul Belleau . . . on m'a parlé mémère Bouchard et *Le temps d'une paix*. Leur mère est savonneuse et leur père n'est pas même Juliette Greco. J'avoue n'avoir aucune parenté avec Hollywood. Je n'ai jamais vu Jane Fonda. Je suis un barbare. Un illetré. Au lieu de lire les films je lis les hommes. Au lieu de fréquenter les personnages de *Lance et compte* je navigue les voitures d'eau, je tends une pêche aux marsouins, je construis le Jean Richard, une dernière golette du fleuve, avec des mots qui ne sont pas dans les dictionnaires. J'avoue ma barbarie. Je ne suis pas autorisé à mettre en doute la nourriture spectaculaire. A douter de l'âme des fictions. Je me cherche une âme ailleurs. Dans les fardoches de la réalité. Qu'est-ce que j'ai à faire dans un colloque, un festival ou un ciné-club? Les gens que je connais existent ailleurs que sur les parois. Leur poésie a de la *glaise entre les orteils,* comme disait mon ami Didier Dufour. Mais, s'il fallait en croire la théorie, l'imaginaire nous tiendrait lieu de réalité. C'est du moins ce que j'ai cru comprendre. Et la réalité que je filme devient l'imaginaire que le spectateur contemple. Comme s'il refusait d'en croire ses yeux. En sorte qu'on pourrait, pour ne pas simplifier outre-mesure, prétendre que la légende n'est rien d'autre que la vision du monde de celui qui ignore le monde. De celui qui regarde le monde de loin. En étranger. En touriste. En spectateur. A travers le prisme des images. En plein arc-en-ciel. Mais le drame, pour moi, qui propose l'inverse du spectacle, c'est que l'ignorance (et rien n'est plus humain que l'ignorance sauf

erreur) s'obstine à regarder en légende ce que je propose en connaissance. Comme si j'étais le sorcier d'une sorcellerie et non le chroniqueur d'une réalité. Le témoin crédible de l'événement qui n'est pas le roman. Comme si notre vision du monde ne parvenait plus à échapper à l'image qui mystifie, qui simplifie. Pour nous faciliter l'apprentissage du monde. A contourner la Révélation des Ecritures ou les Ecritures de la Révélation. A regarder en face une autre substance, approximative, une autre image, objective, du monde. A détourner, enfin, l'image de la légende. A en faire un autre usage. A prendre connaissance. A remplacer l'astrologie par l'astronomie.

A preuve, l'imaginaire est séduisant. Il persuade. Il occupe le territoire de l'âme. L'âme de la foule. De la tourbe. Et il rapporte. Il grossit. Il enfle. Il s'élève. De plus en plus haut. Comme le gothique sur le roman jusqu'à Beauvais, cette cathédrale qui s'est écroulée un jour. Comme la grenouille de la fable. C'est la preuve du cinéma. Sa démonstration n'est pas ailleurs. Dans la logique du plus en plus gros. Et s'il me plaisait, à moi, d'être petit.

Mais l'imaginaire aliène aussi. Comme toutes séductions. Privant l'âme de son authenticité. Occupant toute la place. Aliéner, c'est rendre étranger. L'imaginaire nous rend étranger à nous-mêmes. Il conditionne. Il assujettit. Transformant l'homme en sujet... en fidèle... Le colonisant. L'induisant en tentation. En rêve.

En désir de paradis.

Mais le mot aliéner veut aussi dire dans un sens dérivé, et la dérive est facile, céder, disposer, donner, vendre. Vendre son âme. Ne plus se choisir, s'appartenir. Etre modelé. Cultivé comme un légume. La culture, bien sûr, il en faut. C'est un choix. On choisit son père et sa mère, en se rebellant. On est choisi par la force de séduction. Aliéné. Comment se rebeller? Résister au modèle? Recommencer le monde? Echapper au mythe réducteur?

Un mythe, c'est ce qui n'existe pas, dans la popularité du langage. La vieille sagesse des peuples l'a bien compris. Mais comment résister à l'envahisseur? Au conquérant qui pénètre dans toutes les âmes? Qui fait son nid dans la tête des enfants? En faveur du mage. Le mythe c'est l'arme de persuasion du mage qui propose ses mirages. La vie rendue facile par l'image. Le paradis de Colomb. C'est exactement le contraire de la connaissance. C'est ce qui précède l'histoire. C'est ce qui précède la connaissance.

Et tout se passe comme si l'homme souhaitait échapper à l'histoire pour retourner dans le ventre chaud du mythe maternel. Jamais dans son histoire l'humanité n'a produit autant de mythes. Comment les avaler? Allons-nous retourner au temps chaleureux où le mythe répliquait à l'univers, répondait de l'inconnu, rassurait notre petitesse en devinisant nos frayeurs. Le paradis serait-il de vivre dans un conte de

fées? Car le mythe fait l'économie du voyage. Il est l'enfance du monde. Les animaux parlent aux enfants dans le mythe. Dans la forêt les animaux nous fuient malgré notre désir de continuer la conversation. Il n'est pas facile de sortir de l'enfance. J'estime l'enfance dans l'enfance. Je ne propose pas l'enfance à l'adulte. Certes le métier d'adulte est difficile. Il consiste à sortir du mythe. A faire face à l'inconnu. A couper le cordon de la fable. A entreprendre la connaissance. Celle du monde et celle de l'autre. Le mythe propose un univers sans faille où tout baigne dans l'huile de l'intemporel. Hors du temps justement. Il réfute tous les inconnus. Il est dans les Ecritures. Il explore les images de l'univers. Il propose des solutions. Manichéenes. Réconfortantes. Et je sors du cinéma avec des éperons de gloire aux talons. Rassuré. Réconcilié. Satisfait. Ayant confirmé la possession tranquille de la vérité.

Tel est le cinéma *western*, entre autres, comme le modèle même du mythe en opération. Il réconcilie en éliminant. Adéquation de la force et de la raison. Il est divin. Il tire plus vite que son ombre. Magie. Il persuade non seulement le vainqueur mais aussi le vaincu. J'ai vu à Sept-Iles de jeunes indiens montagnais se disputer l'honneur d'incarner Buffalo Bill. Ils jouaient au *cow-boy*. Personne ne voulait jouer le sauvage. Aliénation.

Car *le bonheur c'est la victoire!* Rêve d'enfant! Qui n'est pas enfant? Qui a réussi à devenir tout à fait adulte? A se choisir. Le cinéma propose donc la victoire. Comme le sport professionnel qui est le plus séduisant des cinémas en vérité. Qui réussit à rejouer le même scénario cent fois par année devant les mêmes spectateurs entièrement séduits. Quel film y parviendrait en dépit de toutes les attractions; violence, sexe et le reste? Mais le cinéma a bien compris la leçon. Il produit de la victoire. Il satisfait le désir de victoire. Par tous les moyens. Il séduit même par sa propre victoire. Il élève des temples à son propre triomphe. Il se contemple. Nous voilà de nouveau à Hollywood. La remise des *Oscars* confirme la séduction. Dieu est la preuve de Dieu. Rambo est la preuve de Dieu.

En échange d'un mince bonheur éphémère (la victoire imaginaire), nous confirmons la puissance d'un système déjà puissant qui ne trouve de justification que dans la puissance. C'est l'empire en marche. L'empire des sens. Des sensations. L'âme de l'autre est à vendre. Sur le miel de l'imaginaire s'agglutinent les mouches de la vénération. A la queue comme des Polonais. La *star* ne tire son succès, sa brillance, que de la crédulité. Elle propose ses victoires, sa notoriété, à la vénération. La victoire est imaginaire. Le résultat est réel. Il se retrouve au *box office*.

Je reviens au *western*. Il m'obsède. Sa mécanique primaire est séduisante. Par son efficacité. Comme le miel pour les mouches. Et cette mécanique n'est pas nouvelle. Hollywood n'a rien inventé. Hollywood a seulement industrialisé le système. En le quantifiant. En le disqualifiant.

En effet toute légende justifie. Toute épopée magnifie. Tout récit propose la victoire. C'est vieux comme le monde. Il s'agit de fonder Rome. L'épopée ou la légende justifie le crime fondateur. La preuve du bien-fondé de la victoire c'est la victoire. Il ne reste plus qu'à décorer le héros. l'anoblir. Le brigand devient comte. L'assassin devient roi. Le voleur de chevaux est nommé shériff. L'exterminateur est conquérant. C'est le rêve américain. Il s'arrête au Pacifique! Pensez-vous? Il y a encore des barbares à persuader. L'épopée continue sa démonstration. L'empire ne s'arrête jamais. C'est une machine infernale. Romulus tue Remus. Il devient roi par le fait même du crime. Légitimé par la victoire. La mort de Remus justifie la royauté de Romulus. Et les dieux sont d'accord. Dieu est toujours victorieux. Et on dirait que Michel Serres est lui aussi d'accord avec ce fondement de la légitimité.

Le jour où un peuple est persuadé par l'épopée de l'autre, il est parfaitement conquis. On a fait l'économie du fil de l'épée. Et les uns ne travaillent plus qu'à enrichir les autres. Personne ne s'enrichit de son travail. C'est la traite des fourrures. L'histoire a opéré, l'histoire ancienne, en détruisant. Le cinéma opère en séduisant, en réduisant, en parasitant. Comme la douve du mouton. En parasitant le rêve.

Car les temps ont changé. Les armes sont à deux tranchants. L'exterminateur risque sa propre extermination. C'est la guerre froide. Guerre de mots. Guerre de symboles. Les armes s'accumulent aux frontières. Ridiculement inutiles. L'un propose le bonheur totalitaire: une idéologie mythique et généreuse. Presque naïve. Innocente au départ. Mais l'innocence ne résiste pas au pouvoir. L'autre propose la médiocrité. Celle des images. Toutes les médiocrités. Le génie des U.S.A. n'est pas ailleurs. Qui a compris qu'il est plus facile de vendre la médiocrité en image que le bonheur totalitaire en réalité? Faire la queue pour avoir du pain est moins convaincant que faire la queue pour acheter du rêve. Ils ont vendu le rêve au moyen duquel ils ont vendu la philosophie du rêve. Ils ont vendu la victoire par laquelle ils ont vaincu l'ennemi. C'est le cinéma. C'est le *Coca-Cola*. C'est le *MacDonald*. C'est la musique *rock*. C'est le *vidéo-clip*.

Le *clip* imaginé pour vendre la chanson est devenu la chanson. La publicité est dans la pomme, comme un ver.

Le mur de Berlin s'est peut-être effondré parce que les dieux U.S.A. ont fait l'assaut du bonheur totalitaire. Le mur de Berlin s'est effondré en partie parce que les Berlinois voulaient boire du *Coca-Cola* et acheter des *jeans*. Rêvaient de bonheur. Rêvaient de rêve. Les *jeans* sont l'uniforme de la médiocrité. Ils ont relayé le pas de l'oie du nationalisme exaspéré. Les *jeans* comme une âme d'emprunt. L'âme de la *Marlboro* pour faire fumer la France. La France fume cheval, lasso, *jeans*. La *Marlboro* n'offre que du rêve. Le vide du rêve est attirant. Le vide a précipité l'événement. L'Allemagne de l'Est n'a pas choisi la consommation

mais le rêve de la consommation. Bien sûr ils vivaient l'intolérable. Il leur reste à s'inventer une âme. Pour l'instant c'est la victoire des symboles. Les U.S.A. sont devenus les plus grands exportateurs de mythologie. C'est leur supériorité sur le papou. Pour l'instant. Mais les Japonais n'hésitent pas devant la médiocrité. Ils sont l'Empire du milieu ce qui n'est pas une vertu. Un jour nous deviendrons nippon.

Je retrouve par hasard en consultant un dictionnaire cette citation de Fustel de Coulanges qui a beaucoup réfléchi sur la *Cité antique.*

> *On reconnaissait le citoyen à ce qu'il avait part au culte de la cité, et c'était de cette participation que lui venaient tous ses droits civils et politiques.*

En ce sens nous sommes tous citoyens des U.S.A. et plus encore, il me semble, les Français que les Québécois, ce qui m'hallucine. Mais je n'ai pas la foi ce qui fait sans doute que je ne comprends rien à la religion.

Faut-il comprendre la vénération manifestée un peu partout dans le monde à l'égard des productions mythiques des U.S.A., comme un désir de participer à une citoyenneté transmise par les idoles? Bien sûr les U.S.A. produisent autre chose que des cow-boys pour vendre la *Marlboro.* Mais il y a derrière cette frénésie mythique l'énorme complicité des *cow-boys* à la recherche de la nouvelle frontière. Et personne ne l'admet. Comme il a fallu longtemps pour que l'Europe s'avise que l'esclavage et la colonisation étaient les armes de sa puissaance, les outils de sa richesse, la raison de sa domination. Les U.S.A. préfèrent se percevoir comme les vainqueurs d'un juste combat, des *winners* comme il disent non sans arrogance. Des *cow-boys* en vérité. Plutôt que d'admettre qu'ils sont des dominateurs. C'est le sens de l'épopée qui fabrique des dieux pour convertir les brigands en héros. Pour justifier la conquête.

En vérité l'histoire se répète inlassablement. Les temps changent. Les hommes demeurent. *L'economie est la continuation de la guerre par d'autres moyens,* affirme Michel Serres. Le cinéma est la continuation du mythe et de l'épopée par d'autres images, pourrait-on ajouter. L'économie nouvelle s'est empressée d'occuper le vide laissé dans l'âme par la disparition des religions.

Mais le mythe de l'un prive l'autre de son étrangeté, de sa singularité. Il méprise l'autre, cherchant à l'anéantir. Privé de cette étrangeté, l'autre succombe à l'ennui des cérémonies: la remise des *Oscars* ou le *Super-Bowl* comme réplique du veau d'or. Un jour Moïse reviendra. Et peut-être assisterons-nous à la naissance de *l'intempestif,* d'un nouveau cinéma qui ne résistera peut-être pas à son tour aux séductions du succès. Et renaîtront les vendeurs du temple. En attendant, le mythe triomphant continue inlassablement à nourrir sa puissance, à élever ses murailles, à bâtir ses tours. *L'essentiel me paraît que la tour soit découronnée,* affirme Michel Serres au début de son livre sur Rome.

Cependant l'humble petit cinéma québécois rêve d'être universel. Lui aussi. Il se modèle sur l'empire. Sur le triste *biggest*. Il se conforme tantôt à Hollywood et au veau d'or tantôt à Saint-Germain-des-Prés et la théorie. Comment exister sans naître au monde. Mais qui donc insiste pour nous rendre universel? Le cinéaste lui-même séduit par la séduction. Rien n'est plus vulnérable que la vanité de celui qui se prétend le créateur. De celui qui se compare au créateur. A celui qui aurait créé l'univers. Et il se paie avec le mot univers. Il n'envisage pas d'autre récompense. Il a créé dieu. Il a créé le veau d'or. Il n'espère rien de moins qu'un Oscar pour confirmer la création. Il espère la reconnaissance. Le producteur l'exige. Le Prince ne saurait se contenter de la belle réalité de l'Amérique. Il exige de l'or. Même s'il faut l'enlever aux oreilles de l'indigène.

Car, derrière le créateur, il y a presque toujours le tentateur. On reconnaît le producteur qui flatte le génie (voir *Jésus de Montréal*). Qui le compare à Dieu. Le marchand qui rêve lui aussi de veau d'or. De rejoindre l'universel. Pour faire du cinéma il faut devenir un *winner*. Il y a des recettes, des modèles. Pour réussir il faut solliciter la faveur, fréquenter la renommée, implorer les *Oscars*. Mais les *Oscars* ne couronnent que ce qui corrobore leur puissance, c'est-à-dire la soumission des autres au *Big Brother*. Il s'agit bien sûr de fabriquer des dieux mais sans oublier que *God is an American*. Comment résister à la tentation? Et le faut-il?

La tentation, c'est l'inertie en vérité. Se déclarer satisfait. S'en tenir à l'alouette de la chanson. Gentille alouette. La soumission, c'est prendre modèle. Imiter le gagnant. Et souvent en arriver à se mépriser soi-même. En vérité il n'est pas facile de changer de peau. Et dans tout film qui secoue les puces de son identité se dissimule la différence, l'indécrottable, l'authenticité, une rébellion secrète, un accent irrépressible, une barbarie en somme. Une Amérique réelle qui récuse l'Amérique du mythe. Sans le vouloir. C'est la preuve en vérité que l'aliénation galopante n'est pas totale malgré le désir secret. Nous resterons pour longtemps, dans l'Empire, une minorité visible pour les U.S.A., audible pour la France.

Il reste, bien sûr, l'avenue inconfortable de la résistance, de la rébellion qui repousse le cinéaste épris de lui-même dans les ruelles obscures de la clandestinité, dans le triste mâche-fer de l'enfance de l'art. Il reste bien sûr quelque part une Amérique amérindienne évacuée par le mythe U.S.A. Une Amérique (je me rends compte soudain qu'il y a le mot âme dans le mot Amérique), une Amérique québécoise qui cherche timidement à opposer la réalité de ses neiges aux sables pollués et insignifiants jusqu'à l'os de toutes les Floride et les Californie du mirage.

Toutes les clandestinités ne parviennent pas à renverser l'empire des mythes mais quel beau projet pour un cinéma qui refuserait l'esclavage,

qui revendiquerait le territoire de l'âme. Faute de mieux. Qui nommerait une certaine barbarie. En dehors du mythe si possible. Du moins en dehors du mythe des autres. En sa propre faveur.

Ce qui m'intéresse dans le cinéma québécois ce sont les films qui ne gagnent pas de prix. Je soupçonne Denis Arcand de rêver d'un *Oscar*. Comme s'il avait besoin de cette mascarade pour se faire confiance. Mais je lui dirais pour le rassurer (mais a-t-il besoin d'une aussi obscure reconnaissance) que ce que j'aime le plus dans ses films c'est ce côté rugueux, populaire, vulgaire . . . c'est tout ce pourquoi on ne lui a pas permis de passer sous le joug impérial qui remet les *Oscars* et corrobore le triomphe de César . . . une certaine barbarie réconfortante qui résiste tant bien que mal à l'empire. Presque sans s'en apercevoir.

Ceci dit, il n'est pas dit, il va sans dire, que Dieu n'existe pas. Mais c'est une toute autre affaire.

<div align="right">Québec, 1989</div>

2.

SNAPSHOTS FROM QUEBEC[1]

Jean-Pierre Lefebvre

Everything is a question of point of view: this is the inevitable realization of creators in a minority culture like ours in Quebec. In the same way, I discovered the "hugeness" of our pet Labrador when my 5-year-old son took a snapshot of the dog from his own angle of vision. To know the true nature of *québécois* cinema, then, one has to put oneself on the level of Quebec. It's regrettable that there has never been an American remake of a *québécois* film. Regrettable for theoretical study, that is! But one could make a comparative study of Godard's *A Bout de souffle* (1959) and its American remake, *Breathless* (1983).

One would be immediately struck by two antagonistic points of view: that of Godard, European, who vandalizes the form, then integrates it with the subject; and that of Jim McBride, American, who gives back to the form the academic conventions of spectacle.

Québécois cinema is situated somewhere between the two points of view and to speak to you frankly and subjectively about our cinema, I am sending you these "snapshots" from my own point of view.

IN ENGLISH ONLY

My mother was born in 1906 with, I do not know why, a passion for "les images" and music. (She was herself an accomplished musician.) She was 21 years old when talking pictures were born and she was carried away by the American films of the 1930s, especially the musicals, that filled our screens almost exclusively.

My mother, like the vast majority of *Québécois* of the period, neither spoke nor really understood English. Cinema was for her then a kind of waltz of sounds and images through a dream landscape. This was probably why she judged films on only one criterion: the film was good if it made her laugh or cry.

Cinémathèque québécoise

Laliberté

CENSORSHIP

Until 1968, one had to be 16 years of age to go to any cinema in Quebec, and the films were heavily censored to make them accessible to all—16 years and over, that is. *québécois* censorship went beyond the standards of prudery instilled in American cinema decades earlier. Either it was a total ban, for example: *The Wild One* by Laslo Benedek, *The Pilgrim* by Charlie Chaplin (because the film mocked religion), *A Bout de souffle* by Godard (which I personally saw in Syracuse, New York), or it was mutilation of sound and image (optical sound tracks were often perforated to eliminate vulgar or dangerous words: I believe the most famous case was *The Apartment* by Billy Wilder, where all references to Shirley MacLaine as "mistress" were systemically removed.) For young people under 16 years of age, there were only two kinds of opportunities for movie-going: (1) at Christmas, Easter, and All Saints Day, when commercial cinemas invariably presented a Walt Disney film preceded by an American cartoon (it was no doubt at one of these screenings that I fell in love with the work of Tex Avery) and perhaps a short film from the National Film Board of Canada, and (2)

Saturday afternoons throughout the year, in the basement of Catholic churches, where double features were presented—always American and always adventure or war films.

Being born in 1941, it wasn't until 1957 that I obtained the sacred right, as impatiently awaited as a first love, of going to the cinema. I can also publicly admit for the first time that cinema made me a great sinner. During Easter vacation, particularly, I would stick my nose into church for the afternoon service, just to see who was officiating, then I would cut out to the movie house a few streets away to catch the matinée.

DRIVE IN

But earlier on, in the 1950s, the Canadian dollar was worth 25 percent more than the American. This is why the *Québécois* descended en masse to "the States." And part of the trip was the sacred family ritual of the double feature at the drive-in.

Sometimes in my dreams I see again whole scenes from *Show Boat, An American in Paris, Annie Get Your Gun, Rose Marie, The Great Waltz,* and many others.

CULTURE AND ENTERTAINMENT

In 1951 I began my "classical education" in a Catholic boarding school. On rainy holiday afternoons they showed us films of the same genre as we had seen in the church basement: *Robin Hood, The Best Years of Our Lives, Court Jester, Joan of Arc, Lily, Mrs. Miniver,* and numerous westerns, among which those of John Ford left an indelible impression on me.

Obviously, the clergy saw cinema as pure and simple entertainment— much as politicians past and present have done—containing no cultural value, for, as our education and that of our teachers was "French" from "France," then real culture, it followed, must also be French—even if, for reasons of morality, they refused to show us French films! American films, however, were truly "moral," showing good conquering evil and married couples in twin beds . . . totally inoffensive, they believed. In consequence of this dichotomy between Culture and Entertainment, there was no question of recognizing ourselves, or our culture, in films. On the contrary, our teachers wanted to break us of our *québécois* language and accent.

But outside the halls of learning, where for ten months of the year, for eight years, they used so much energy to make us the elite of tomorrow, the times were changing—especially in the world of communication, with the incredible expansion of radio and television.

To keep up with the times, Canada opened its first English television station in Toronto, and its first French station in Montreal, in 1952.

In 1954, the National Film Board, still located in the nation's capital, Ottawa, decided to produce for television. Two years later it would relocate to Montreal.

THE OTHER CINEMA

Several film clubs were born in 1949, but they only began to proliferate, under the control of the Catholic church, in 1953. The church believed that it was time to combat the materialism of cinema in general, and American cinema in particular, by studying films that put forward more human and spiritual values.

The more notable among such films were *Ladri di Biciclette*; *Sciuscià*; and *Umberto D* by De Sica; *Roma, Città Aperta*; *Paisà*; *Germania, Anno Zero*; *Francesco, Giullare di Dio* by Rosselini; *La Strada* by Fellini; and *Jour de fête* by Tati.

For me, it was like suddenly perceiving the dark side of the moon— of life, of cinema, and of the world. Until then I had no idea of the existence of such alien cultures.

But that was not all: at the same time I made another great discovery through the first moving pictures that I saw of Quebec and *québécois*, both on television and at the film club of my college—the film club where I was passionately involved from the age of 14, deciding at 15 that I wanted only to make films. I remember the *coup de foudre* very well. Having seen my total devotion to the cause of "good cinema," the priest in charge of our club bestowed on me, one afternoon, an incredible, and fatal, honour: I was allowed to watch, alone in the chemistry lab, *Alexander Nevsky* by Eisenstein. We had been formally forbidden to watch any "communist" film, under pain of mortal sin. Only the "good priests," especially the philosophy teachers, screened such films, for "analysis."

The film impressed me as so many other foreign films had; but I also literally tore my hair out, wondering why they had forbidden this film, why it was a mortal sin to watch. I was astonished that this evil communist film even ended with a line from the Holy Bible: "Those who live by the sword, die by the sword" (you may remember that, by one of the ironies of history and propaganda, those are the same famous words that influence the hero of *Sergeant York* by Howard Hawks).

PROPAGANDA AND FOLKLORE

Until 1956, when the National Film Board moved to Montreal, to the heart of Quebec and the French-speaking population, the images we had of ourselves were of two sorts. First, there were those serving us propaganda, the *raison d'être* of the National Film Board, created in

1939 by the Scotsman John Grierson, at the request of the Canadian government, and second, images of folklore.

Two priests had explored on film the great landscapes, geographical, human, and religious of the *québécois* nation: Albert Tessier (1895–1976) and Maurice Proulx (1902–1988). Their documentaries were lyrically *pro patria,* showing the "true *Québécois,*" i.e., the peasants, who sweated blood to clear the harsh majestic country that God had so generously given them. This, incidentally, is the same Quebec that the National Film Board was trying to sell to immigrants from other countries.

Cinémathèque québécoise

La Petite Aurore l'enfant martyre

Also, beginning in 1944, around twenty independently produced, French language features appeared, all with heavy, melodramatic subjects. None have stood the test of time, except perhaps as documents, like *Petite Aurore l'enfant martyre* (1952), which recounts the horrific physical abuse of a young girl by her stepmother. Most of these films enjoyed great public success while taking advantage of a certain narrowly defined nationalism. But they constitute nonetheless an important step in the "Québécisation" (language and images) of our imagination, saturated as it was, and still is, by those of the United States.

HAPPY ENDINGS

To sum up thus far, one might say that the images my mother, I, and all the *Québécois* absorbed until 1956 were under the direct control of a number of "gods," each more inaccessible and paternalistic than the next: the god of Hollywood, the god of the Catholic Church, and the god of Canadian federalism, whose official voice was the National Film Board (which took twenty years to give its filmmakers the right to sign their own work, the real "author" heretofore being the NFB itself).

We were living in a kind of promised land of "happy endings": those of the American movies; those of French Culture with its rewards for the educated and privileged here on earth, heavenly rewards for the less privileged but faithful; and, finally, the happy, political endings of a confederated Canada, great and strong, completely dominated by an anglophone cultural industry rooted in the U.S.A.

Obviously, all of this left little room, if any, for the emancipation of our *québécois* culture, our language, our imagination . . . our identity, in other words.

CHANCE AND NECESSITY

How on earth then did we *Québécois*, dominated by these various gods, break our silence and begin to play with images and cinema, that inaccessible and expensive tool so long forbidden to the children we were? It was on one hand chance, and on the other, the necessity of communication.

By chance I mean a number of small events that came fortuitously together: the development of light cameras and portable sound equipment that "democratized" cinema; the demand created by television, which the NFB struggled to fill, becoming less and less able to censor its own product; and the arrival of new filmmakers, inexperienced and "naive," who gave freshness and audacity to their films.

By the necessity of communication, I mean that the clergy and the politicians could no longer keep out the rest of the world. Not even Maurice Duplessis, Quebec's little premier-dictator, who held the laws of God and man in his hands over a period of twenty years, between 1936 and 1959, could keep our minds imprisoned forever.

A personal example: for me it was the Algerian war that awakened my political conscience and knocked France and its culture off of its pedestal. Also, at the University of Montreal in 1960, just after the death of Duplessis and the beginning of Quebec's emancipation, we students soon realized that sometimes we knew more than our professors, whose teaching was restricted by tradition, for example, the famous "Index," which forbade, on pain of mortal sin, the reading of almost all of the major works of world literature.

Les Raquetteurs

CANDID EYE

From 1956 on, we witnessed a progressive reversal, on every level, of the gods that had dominated us.

How was that reflected in the world of cinema? It was as banal and as extraordinary as a love story: we noticed each other, we met, we were won over, we exchanged among ourselves, we changed, we dreamed, and sometimes we produced children. . . .

Having no intention of giving a history course, I will keep to the major moments and to the spirit that animated each step of our cinema's growth.

If the pot began to simmer in 1956, especially at the NFB, it was in 1958 that it boiled over with thirteen short films for the television series "Candid Eye" on the one hand, and the film *Les Raquetteurs* (17 min) shot by Gilles Groulx in collaboration with Michel Brault and Marcel Carrière on the other.

It is interesting to note that the series "Candid Eye" was essentially the work of anglophones at the NFB, while *Les Raquetteurs* was the work of a small group of francophones. Though both the series and the short film by Gilles Groulx originated in a candid and spontaneous observation of reality and people, only *Les Raquetteurs* came within an inch of being banned by the directors of the Film Board. Why? In my

opinion, because they sensed they were losing control of the way a people and its culture were represented with this film. The official reaction to the film—as to other later ones, such as *Cap d'espoir* (Jacques Leduc, 1967), *On est au coton* (Denys Arcand, 1971), and *24 Heures ou plus* (Gilles Groulx, 1976), all three of which were strictly banned—only served to reveal the intense fear Canada's "official voice" had of dirtying its hands and its films with "marginal" subjects, or subjective interpretations. I had a taste of the same medicine in 1968, when the NFB held up until 1970 the finishing of one of my films, *Mon Amie Pierrette*, for questions of "aesthetics." We had shot the film stressing the reds to give the impression of an 8-mm film; the young adolescent had bags under his eyes; the actors spoke in *québécois* about . . . nationalism. In short, it was too vulgar for the official voice of Canada to give it its imprimateur. (How may times has the word "vulgar" been attributed to the works most essential in the evolution of our culture?)

CINEMA DIRECT

So, with a candid eye and the global spirit that prevailed, we noticed each other, we met . . . and we were soon attracted to each other.

Until then, cinema had never gone into the streets; real people had never been able to reveal themselves, in word or image. But now a second stage began, called *cinéma direct.*

Once again, the most representative film of this period was by Gilles Groulx, *Golden Gloves* (1961, 28 min). Once again, the shooting was a collective effort, with Guy Borremans, Michel Brault, Claude Jutra, and Bernard Gosselin. What is more, since 1959, after much internal warfare at the NFB, a "French" team had come into existence and it enjoyed relative autonomy in the handling of its projects.

Cinéma direct for the first time gave a voice to those in front of the camera as well as to those behind it, as we sought to get to know each other. In many cases we spoke too much, but why not, it was so good to break our ancestral silence. (Julien Green has said that we create to speak for those who do not have the chance to speak themselves, or who have been reduced to silence.) The beginning of the "Quiet Revolution" in Quebec was sweetly euphoric when, in 1959, we began a new era with the death of Maurice Duplessis. The Liberal Party, under Jean Lesage, came to power in 1960, and within their ranks was René Lévesque.

SOUTH PACIFIC

Let's stop for a minute in 1961.

My father died in February, my mother in August, on the very day I was to interview François Truffaut for the independent magazine

Objectif, which we began in 1960 and abandoned in 1967, when most of us had become filmmakers ourselves.

A few months before her death, my mother, still crazy about the movies despite a serious illness of many years, asked to be taken to see *South Pacific* for the thirteenth time. . . .

If, along with my colleagues at *Objectif,* influenced no doubt by *Les Cahiers du cinéma,* I had rediscovered American cinema, *South Pacific* still represented for me the bottom of the barrel of "propaganda-spectacle." Could I then refuse my mother one of her few pleasures? Of course not, for I wasn't Marxist either!

It was the last time she would see a film on the big screen. . . .

I remember that from that day on I was haunted by the question: how could I tell my mother what I thought of this film, and what it represented?

I could come up with only one answer: to make films myself that spoke about her, about our country and our language, films that looked more and more like us, and that could offset perhaps the omnipresence of American culture.

The question, and the answer, have never disappeared: each of my films remains a kind of secret dialogue with my mother.

But at the time, with no film schools in Quebec or Canada for that matter, I studied French literature, until 1962. I then travelled to Paris, where, for a year, I watched, on average, four films a day. (In Quebec we had no *cinémathèque* either, though we worked through almost the entire repertoire of that of Rochester, New York.) That was my film school.

CINEMA VERITE[2]

On my return in 1963, I found two feature films had just changed the face of cinema in Quebec by combining the styles and methods then under experimentation: *Pour la suite du monde* by Pierre Perreault and Michel Brault, and *A Tout Prendre* by Claude Jutra. Both films were *cinéma-vérité.*

Looking back, we can see how logical this step was.

We had met and been "seduced" by the candid style; we began to exchange with *cinéma direct*; but we had to go further, to investigate the present and the past at the same time.

Between 1958 and 1960, Pierre Perreault had made a beautiful ethnographic inventory with the series *Au Pays de Neufve-France* (thirteen half-hours in collaboration with René Bonnière); in 1961, Michel Brault did the photography for *Chronique d'un été* shot in France by Jean Rouch and which we young filmmakers considered the manifesto of *cinéma-vérité.*

In *Pour la suite du monde,* the two filmmakers decided to place the people of l'Ile aux Couldres in the St. Lawrence River in a certain "situation": the return to porpoise fishing, which had been abandoned at the beginning of the century. For his part, Claude Jutra, who had participated in every step of the evolution of our cinema in the 1950s, turned the camera on himself, making *A Tout Prendre* both an autobiography and a psychological study.

We were a million miles from the gods that had dominated us: suddenly, everything was happening on the level of authentic testimony transmitted in words and images. As a consequence, aesthetics and all formal dictates, political or moral, became secondary. A new kind of aesthetic was born, and it was spreading, a little at a time, through the rest of the world of cinema.

TIME/MONEY

I watched all this from the outside, fascinated by all that had been undertaken since 1956, but a little skeptical at the concept of *cinéma-vérité—* maybe at any concept of "truth." I told myself that one day I too would have to stop being part of the audience and jump into the water.

It was in 1964 that I took the plunge.

In January and February I made a short of 24 minutes, with $300 and a Bolex borrowed from a friend.

In August, I came out of the Festival of Canadian Cinema in Montréal completely transformed by a viewing of *Le Chat dans le sac,* the first feature by Gilles Groulx—the same Gilles Groulx who this time had provided the missing link by bringing to a dramatic film the lessons of candid eye, *cinéma direct,* and *cinéma-vérité.* For the first time, watching a feature from here, I identified completely as a *Québécois* and as a budding filmmaker. So completely, that by the end of the year I attempted my first feature, *Le Revolutionnaire.*

We had to be crazy or naive or both.

We bought five hundred dollars worth of 16mm negative; one person had an Arriflex, another a Nagra; and the twenty-five people who took part in the shooting paid ten dollars each for food. We began shooting on Boxing Day,[3] and finished New Year's Eve.

We were shooting in the country, in the open, in the cold. The camera and the actors were freezing. . . . What to do?

Put the camera on the wood stove with the actors around it, and as soon as all thawed out, rush outside, start the camera and shoot . . . until everything froze again.

You can imagine the final result: long sequence shots, no reverse angles, no cutaways.

If I had shot in a studio, with lots of time and money, I would probably unconsciously have shot more conventionally, more American

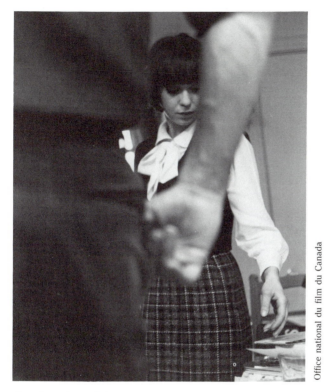

Office national du film du Canada

Le chat dans le soc

even (up to a certain point, because on the level of shooting style, I had always been an unreserved admirer of John Ford, the most "economic" of American directors).

During the editing, I realized I had been the victim of a series of imperatives—weather, time, money—that gave the film its own style, its "nationality," even its meaning, as my subject was the immobility of a group of intellectuals.

FORM/CONTENT

So it was chance, as well as the necessity of communication, that taught me and all *québécois* filmmakers our craft, that engendered a "quiet revolution" of form, because, paradoxically, the content was most important to us.

I saw *Golden Gloves,* by Gilles Groulx, once again several weeks ago. Today, television—for which it was made in 1961—would certainly

refuse to air the film for technical reasons: the high-contrast photography, the abrupt zooms. They, however, are part of the film's great beauty and authenticity. It's always a question of "point of view," isn't it?

In cinema, most directors do not want to cross the border of the figurative, especially American directors, who, as in the example of *Breathless,* prefer linear verbal stories rendered in beautiful images (that could explain in part the success of *The Decline of the American Empire* (1986) in the United States, since it consists almost only of filmed dialogue). I am neither for nor against this phenomenon: I simply point it out.

For my part, I believe that different cultures express themselves in different forms: that these different forms are an indelible mark of individual and collective identity. To give film, at any cost, the same grammar, a few recipes for scripts, a closed star system, in short the same form for every film, is to destroy the identity, the nationality of the work; to create a non-culture dominated by the economy, and profits. To destroy, finally, the emotion, which is, in my opinion, the source of all creation . . . that simple love story that determines the relation between the film and its creator. For example, I have a personal horror of shooting reverse angles, especially when we have a shoulder in the frame, because I become a "third" person—a voyeur instead of a participant, a passive spectator instead of an active one.

These are not abstract theories: they are simply the fruit of an "emotional" apprenticeship of our reality here in Quebec, which we had never seen except through the eyes of others.

WITHOUT MONEY

"Le cinéma québécois des origines," as we call it here, was as original as it was marginal, not only for the reasons I have stated, but also because we were not preoccupied by concerns of money or profit.

In the 1960s, the National Film Board and the Canadian Broadcasting Corporation-Radio-Canada were concerned only with cultural and political "profitability." In the private industry, which existed, just barely, and dependent on television, we had nothing. For example, my first feature *(Le Revolutionnaire)* had a budget of $16,000, my second, $14,000, my third, $35,000 . . . and these budgets included up to 50 percent of deferred salaries, which were never paid.

So our cinema wasn't born out of any tradition of spectacle or show business, despite our intoxication with American culture and the movies of Hollywood.

We must not forget that other cinemas, comparable to ours in Quebec, were being born at the same time. Many of us (except for the strict practitioners of *cinéma direct* and *cinéma-vérité*) met and exchanged ideas with these filmmakers at "Le Festival international du film de Montréal": Skolimowski of *Walkover,* Polanski of *The Knife in the Water,* Forman

of *Black Peter* and *The Loves of a Blonde,* Glauber Rocha of *Deus e o Diabo na Terra do Sol* and *Terra em Transe,* and many others. And some of our films began to travel, particularly in France, where they met with considerable critical success. Within less than six years (1963–69) we made concrete the abstract "literary" idea that people had of Quebec. For until then, it was the poets and writers—along with the songs of Félix Leclerc and others—that had represented us abroad and carried all our anxieties and *québécois* submission. Finally, the collective power of "le cinéma des origines" could help them in the work of our liberation.

ORTHODOXY

Is it necessary to speak of the other face of *québécois* cinema, which began to show itself in 1968, when the Federal Government decided to create the Canadian Film Development Corporation (now Telefilm Canada) to invest in, or lend money in support of, *québécois* and Canadian cinema?

It is a tale of a slow, and then—in the 1990s—a rapid move towards orthodoxy. Much the same as the one made by the filmmakers named above: Skolimowski, Polanski, Forman, Rocha.

Orthodoxy in the form, and so in the content, of "our" stories, that must resemble more and more those of other countries to have access to their markets.

If our cinema until 1968 garnered many cultural and political dividends, it was now necessary to "manage" it better.

We are still in the same position. More than ever.

Since 1975, Quebec has had its own financing body, *La Société générale des industries culturelles* (SOGIC), which pays more and more heed to the decisions of Telefilm Canada, because the cost of films keeps on climbing. Fifteen years ago, a feature film in Quebec cost between $150,000 and $300,000; now it is between $1.5 and $5 million.

The financial responsibilities have forced the majority of *québécois* films to choose subjects according to the demands of the market. Documentaries, *cinéma direct* and *cinéma-vérité* are almost rejected out of hand by television and investors. And the film schools thrust into the work place fifty times more people than our small industry is capable of absorbing.

In short, *québécois* cinema has evolved in much the same way as Quebec, conforming in spite of itself to economic imperatives, the direct and indirect pressures of the U.S.A. and their control of our distribution markets as well as prime-time television.

CONCLUSION

My closing is a little melancholy I'm afraid. But for the moment I cannot imagine a "happy ending," either in the long or short term.

The future of *québécois* cinema and Quebec culture depends both on the strong political will to hang on to our "marginal" history and language, and the passion of our creators to illuminate, once again, that political will.

But why must we survive, we sometimes ask. Why not follow the current and flow, body, soul, language, and imagination, into the immense whirlpool of American culture?

I do not know. That need to survive springs both from chance and necessity. Or simply the pleasure of being who you are, in the place were you were born. It springs from the pleasure of not seeing, feeling, or understanding the world in the same way as everyone else, and from the pleasure of exchanging that understanding with others—our different "points of view."

Finally, it is a need to continue my secret dialogue with my mother and, through my films, to let my children share that conversation too.

Quebec, 1989

NOTES

1. Translated by Barbara Easto.
2. *Cinéma vérité* differs from the other documentary technique mentioned by the author, *cinéma direct,* by its emphasis on interviewing and in general by the active involvement of the filmmaker. Both techniques were of course made possible by the development of light-weight cameras and recording equipment.
3. The first weekday after Christmas, a holiday in parts of the British Commonwealth, on which presents in boxes were distributed.

PART III

ESSAYS ON THEMES/DIRECTORS

1.

DEVIATED NARRATIVE IN THE EARLY FILMS OF LEA POOL[1]

Lucie Roy

> *. . . one cannot still silence.*[2]
>
> Pool

SILENCE: THE SIGNIFICANT MOMENT

Without charting a course through semiological debates on the question of cinematic language and its significant elements, it goes without saying that cinematography is a work of language.

It is specific to the power of cinema to conjugate space and time, and this specificity by itself deserves a semiological examination. Yet, by reinstating speech and silence within filmic enunciation, cinematography also implicitly imposes research relative to the linguistic contribution of its signification. To this extent, one cannot doubt that having proven the heterogeneous nature of the cinematographic code through the use of speech, cinematography *is* a language.

If each of the elements of film contributes in constituting the grounds from which meaning arises, and if, as a general rule, these elements are not situated inadvertently in the film, one can assume that silences are structurally integrated in the sequenced utterances. Because of this, it appears useful to examine their meaning, regardless of the fact that, traditionally, silence has mostly been considered as a kind of insignificant conglomerate of nothingness, or perceived as an accidental signification.

As a rule, research on silence as an utterance clue has not been an analytical preoccupation among scholars, despite the preliminary work undertaken by Freud and Lacan. Their work, of course, identifies only discursive reticence wherein speech has a tendency to be silent, the purpose being to express a conscious or unconscious refusal of the usual rules of symbolization. Yet underlying this logic is the idea that if speech

structures the unconscious mind, and if silence is a part of speech, then one has to accept that silence also structures the conscious mind as well.

Without unnecessarily pursuing a psychoanalytical approach to silence in the world of cinema, one can assume that if silence is present in filmic enunciation as discursive reticence, it must be expressing something.

In cinema as elsewhere, silence can constitute an acknowledgment of the impossibility of representing certain human states that refuse identification or the verbalization of awareness. Silence can also be the bearing of a memory in motion. It can also be the trace of a desire to focus the receptor's attention on the scriptor, rather than on a discursive statement that is approximative, because it is fragmentary.

Moving on, if we assume that silence is part of the whole range of speech, it cannot be denied that, from a sociological point of view, it can also be an instrument of moral formation. If silence is sober by nature, it is because we have, through habit, forced it to become representative of a quest, or perhaps of reprobation, or denial, or even death. Silence is often an utterance, ironically, of the unutterable, which finds in it the golden vessel able to carry the loftiest of sentiments and by which to express the paradox of the discursive presence-absence of the speaker or the scriptor.

Whether silence in cinematography is perceived within a framework of reticences, as a representation of human facts, or as an instrument of articulation between plans or sequences, we must more or less alter our concept of discourse to include sound and screen silences as elements of discourse, in order to assess their semantic, syntagmatic, and phenomenal implications.

THE SYNTAGMATIC

Research on silence in the field of cinematography must include studies of aural silences on the sound track as well as the use of visual silences (the empty screen) in filmic continuities. Screen silences can be viewed as a structural function pertaining to the spatial arrangement of objects in the image. They also have a temporal function in terms of the intervals they generate between shots and sequences by underlining their intrinsic differences and by accentuating their passage from one time period to another.

Within the paradigmatic and syntagmatic axes of cinematographic code exist voices and silences, full screens and blackouts. There are asequential syntagms marked by the spatial and temporal continuity of voids or screen silences whose purpose it is to destroy the linear sequence and in doing so to bring the film back to reality, back to its creative development, back to its organizing impulse.

The code of cinematic imaging, and even more importantly, of its sequencing, cannot be measured as simple sequential-temporal indicators,

because it is surely the interval and the silences that, as phenomena, mark the duration of the event in the filmic narrative and as such, mark temporal distances between sequence.

From the point of view of a syntactical analysis of film, one can imagine syntagms of sound and screen silences that, sharing their context with other film elements, would have different structural functions, including narrative. These syntagms might be inter-, intra-, or para-sequential.

Effectively, silences can be used as syntagms of articulation such as stopping points marked by the passing of one sequence to another—inter-sequential syntagms. They can also be part of a sequence of significant units—intra-sequential syntagms. And they can also be raised to an a-diegetic state to the degree that the use of silence leads to the denial of order and the succession of sequences—para-sequential syntagms.

The syntagm of objective silence plays the role of creating a kind of distancing from the unfolding drama. The rhythmical syntagm, essentially formal in nature, systematically opposes the length of the shots or the sequences. The formal articulation syntagm is used to join two shots, whereas the diegetic articulation syntagm connects two narrative segments presented as being disconnected. The tonic accent syntagm, as opposed to the objective silence syntagm, serves to punctuate the action with a kind of sombreness, whereas the psychological silence syntagm is an enunciative instrument, which this time belongs to the character. The poetic pause syntagm behaves as a tool of symbolization, which refers to a narrative system jointly present in the diegesis. Finally, the a-diegetic syntagm, by imposing important spatial-temporal ruptures, negates linear or sequential order.

Because the syntagm of poetic silence is more difficult to grasp, it is necessary to define it more extensively by specifying that it acts as a narrative pause, as a gap, which constantly underlines the discursive concept used. In this instance, silence evokes the overlapping of two jointly present systems acting within the same diegetic course. The last two syntagms, poetic and a-diegetic, therefore, seek to question the enunciative process rather than revive the fiction.

Throughout the taxonomy of sound and screen silences, one notices that both forms of silence serve either to link the diegetic or fictional writing, or to thwart the diegesis in affirming the scripturality.

Finally, silences are not to be taken only for palimpsests, i.e., silences wherein to insert speech. To write silences in words or in story lines is, above all, to create a presence. Likewise, to write silences in the spatial and temporal dimensions of fiction is an attempt to portray silence as gesture and writing. It is to impose scripturally a certain vision of visible consciousness through the judicious use of the scriptor and of patterns of enunciation.

THE PRACTICE OF A CERTAIN REALITY

It is essential to look at cinematography as a bringing into play of a thought that directly conjugates space and time. Therefore, through the use of certain types of silences in cinema, the scriptor often acknowledges screen patterns of grasped reality and, consequently, he can also stimulate scripturality and, thereby, the fascination of the spectator. Nevertheless, by prolonging sound and screen silences, the scriptor can channel the spectator's attention back to his own reality by interrupting the fascination that the filmic narration had exercised over him.

Cinematography, and more particularly films, impose a point of view, a certain intentionality, a purpose of awareness that silence evidences. Between the image and the voice, there exists, therefore, a kind of gap, which might represent thought in motion. It is also possible that the discursive gaps between different recitations presented in the film might be, in themselves, representative of this thought in motion and this vision of scripturalized conscience.

In cinematography, if thought lends itself to being transparent through the conjugation of space and time, it also sometimes allows itself to emerge from within the very silences.

In studying silence and the ruptures that it creates in the narrative, cinematography can only be perceived as a form of the orientation of space and time; it can likewise be considered as an object reflecting a certain point of transparent consciousness that orchestrates the fiction.

LEA POOL: AN ESSAY ON APPLICATION

It is our intention in this essay summarily to engage in the study of the filmic achievements of Léa Pool from the perspective of silence. Because sampling each case of screen and sound silence syntagm appears useless, we shall not consider a systematic study. We shall, however, emphasize the analytical pertinence of certain scenes where sound and screen silences are used in a particular fashion.

Following chronologically the art of Léa Pool, we shall tackle, one at a time, *Strass café* (1980) and *La Femme de l'hôtel* (1984), while leaving for another occasion her later films, *Anne Trister* (1986) and *A Corps perdu* (1988).

> She looks at the words, the light, she hears the noises from without, the cries from within, doesn't know what else to do. She hears the noises from without, the cries from within. Between them, there exists a wall, the wall of silence, the wall of solitude.[3]

Strass café by Léa Pool, along with *L'Année dernière à Marienbad* (Resnais, Robbe-Grillet), *Dialogue de Rome,* and *India Song* (Duras) belongs to the tradition of "dysnarrative" films, which seek to divert the

narrative and, as a result, interrupt the fascination that a classical narrative could hold over the spectator.

In many respects, *Strass café* resembles the works of Marguerite Duras: an insistent music that returns as a strange leitmotif, the same slow editing, the same tendency in the immobility of shots and sometimes the mobility of the camera, the same monochromatic tone of the narrators and, finally, the same stigmatized narrative-representative spaces between image and sound. Taken separately, the image and the voice tend to try to escape significance. If, at times, voice reawakens space in a narrative or thematic sense, the camera remains fixed and distant from the scene of action. The image manages to take up space without ever letting fiction penetrate into it.

In Léa Pool's movie *Strass café*, which I shall approach here in more detail, empty screens do not serve to make the objects stand out within the image. Rather, their purpose is to hide space in the density and obscurity of empty, silent screens. The emptiness so created tends to silence the semanticity of space in order to allow voice expression. Even though they deliver the narrative, the voices of the two narrators present in the film remain silent for long moments at a time.

Lengthy shots emptied by systematized obscurity, coupled with the hammering of a voice throughout the moments of silence, abolish the coherence of the diegetic structure. Anonymous settings—the station, the port, the hotel room, the lane, the Strass café bar—in fact, constitute the motives or pretexts for using the voice to affirm the writing concept as a filmic genre.

The characters are held at a distance in space, so impenetrable and uninhabitable that the space itself is obscure. If the characters are momentarily or accidentally present in the image, they are reduced to helplessness by the shadow that, in long strides, seems to want to drive them as well into the density of the emptiness and the silence. The characters are therefore only presented on the screen in order to accentuate their dissolution, their dislocation, or their disappearance.

They are portrayed as insubstantial objects, without words or action. In fact, throughout the narrative, neither of the two characters is allowed to speak. Held outside the diegesis, they are summoned only to become engulfed in the voices that the two narrators impose.

The film at this moment appears to be a spatial-temporal surface, as such neutral, on which the voices and, even more so, the silences, are printed.

The film, however, seems to want to relate the existence of a woman in exile who has neither name nor age, and whom "we call 'she' for the sake of convenience." This woman in exile, seeks a place to dwell, "a station whose doors lead to all directions," a place where she can evade her nocturnal fears. Despite the fact that we have never seen them

together, it appears she has met an androgynous man who, like her, sings at the Strass café; we see him only toward the end of the film. They never manage to reach out to each other across their absences and lengthy moments of silence. Characters of pain, they can love each other only because they are separated, exiled. "She leaves him without ever having reached him and she goes on pursuing her exile. In her mind, she wanders through oblivion in a quest of void, in a quest of memory of void. She is full of barriers."

Léa Pool constantly plays on a slow scale, out of silence and the unrepresentable. The screen easily passes to obscurity, the voice to silence. Léa Pool uses sound and screen silences by having them assume functions of an a-diegetic nature. Through the structural use of silence and screen emptiness, stretched on the surface of the narrative, she succeeds in dismantling the habitual diegetic instrument by denying the sequential order and destroying the story time frame in order to emphasize the time of the thought process.

The intervals and, even more so, the sound and screen silences, contaminate the film to the point of deviating the narrative, heard as a story told by characters bearing ideas and actions and swept up in a conflict they are perhaps intended to resolve. In *Strass café,* there are no intervals; nor are articulative syntagms used, formal or diegetic, to the point that clearly cut sequences are nonexistent, with the result that silences are charged with ambiguity. Sequences are constantly annihilated by syntagms of a-diegetic silences that never cease to interrupt the order of a possible sequential enunciation.

The silence of the voices, of the music, even of the screen, appear as a kind of scriptural downfall, like the hint of a thought seeking to be written. A thought that seems to be constantly attracted elsewhere, dispersed in the absolute of a nameless, illusive, impenetrable agitation, and thus insolvable.

To a certain extent, by asserting semantic connections of silence and screen voids, Léa Pool, through excessive usage, plays on the paradox of semantic absence decreed as a fictional presence voluntarily indecipherable. Moreover, by slipping behind silences, the voice asserts its refusal to follow the rules of symbolization and nevertheless throws us into the decoding of a discourse whose signification remains opaque. By writing the story of "she" with the help of sound and screen silences, the author continuously insists on the nonrepresentational quality of her story, the terrible nostalgia that haunts the images of the film. Ultimately, she never ceases to decree the invincibility of the writing of silence and voice over that of image and the fiction, and the fascination that they might have exercised. Silence affirms the hegemony of thought as act, and writing, relative to space and time, by deviating their habitual semantic and fictional possibilities.

In terms of the thematic plane, Léa Pool shares the preoccupations of Marguerite Duras: exile, absence, torn love, the cry of silence, and the atemporality of existence are the cornerstones of a deviated narration, which insists, as such, on the sentiment of a perpetual quest.

> We would have very much preferred to stifle all this story, never talk about it. Day after day, silence lets itself be heard, one cannot still silence.[4]

La Femme de l'hôtel

The opening scene in *La Femme de l'hôtel* uses approximately the same processes as those resorted to in the film *Strass café:* a music sufficiently repetitive, a lengthy panoramic view of a city, and a voice-over activated and punctuated by lengthy pauses, hold the fiction at a distance. The voice tells the story of a producer in search of places in which she feels like a stranger and where she wishes to shoot her film.

> Montréal, at the start of November. It rains. It snows. It's cold. I have been here for three days now. I have been looking at and listening to a city in which I have lived for eighteen years. It's odd, I feel as though I were in a foreign city. A stranger in a hotel somewhere. I used to say that here I was home, but I'm not home. Here no more than elsewhere. Maybe it's the reason why I've chosen to shoot my film here, to discover the stranger I have become.[5]

One could momentarily believe that here Léa Pool pursues the same thematic quest as that undertaken in the aforementioned film. Indeed,

the slowness and the inexpressible seem to want to engage in similar diegetic themes: the wandering, the feeling of being a stranger, the anxiety, the exile, the quest, the elusiveness. The music reinforces their semantic intensity to the extent that it evokes sufficient nostalgia, a kind of sentiment of expectation and emptiness that is repeated endlessly, musically.

During the opening scene, which a slow pan expands, the voice-off accentuates the distance of the view relative to the setting of the fiction by directly taking charge of this part of the narrative, rather than making the diegetic composition of time, space, and characters signify what the voice expresses.

The voice-off accentuates the gap between the scriptural and the diegetic, which the music and silences punctuate and accentuate.

In *La Femme de l'hôtel,* the subject reaches the representative narrative by playing on two narrative modes that are sufficient to focus the scripturality and its thematic scope as filmic facts, rather than bringing forth a fiction as a fact of representation and as an object of fascination.

The fascination sustained here is situated in the network of two narrative profiles and in the gap into which the sound and screen voids prod themselves.

In the following sequence of the film, the voice-off takes on the aspect of a producer, included in the fiction, whose husband leaves her after a lengthy silence. Another woman, Estelle, silently packs her baggage and sits down. She then walks to a station empty of noise. Footsteps resonate. She buys a ticket for Toronto. She retraces her steps and gets into a taxi. The same music that was played at the beginning of the movie accompanies and accentuates this erring impression to pursue. A snowy park. A hotel. A waiting room. Silence. The first encounter between Estelle and Andréa. A question. A lengthy silence.

In a hotel room, Estelle is sitting by the side of the bed and remains silent. She can hear people applauding in the days when she entertained. The camera executes a lengthy pan and fixes the white-surfaced wall. This silent screen space along with the venetian blind, which once again has been closed and which appears at the very end of the shot, act as a diegetic articulation. The following shot, a lengthy aerial pan of the port of Montreal, accompanied by the same music, acts as a formal and diegetic motive, which brings into focus the scriptural process used.

The voice-off of the producer runs through a series of representative shots of the places to be included in the film.

A street, a theatre, a city. They never look like what we had imagined them to be, even less through the memories we held of them. I had everything to rediscover. I had to forget and start all over. I wandered through the city from one end to the other. It's strange these streets never lead

—98—

to the river. And yet, Montréal is an island. She too is looking for the river without ever finding it. She will wander on without end. She is the character.[6]

The settings, still anonymous, find themselves ritualized and brought back to the fiction to be shot. The territory of the assumed reality and that of the fiction will be the same. In a similar fashion, contrary to the anonymity presented in *Strass café*, "she" here is a double character, that of the fiction and that of the assumed reality.

The film relates the story of Estelle (Louise Marleau), a former singer, disappointed and wearied by the fatigue of existence. One morning, as Andréa Richler (Paule Baillargeon), the producer within the movie remarks, "She possesses the strength to let herself fall apart to discover just how far she can go." She wanders on, is arrested and placed in a convalescent home from which she escapes to pursue her wandering. The groundwork for the movie is laid. Andréa, the producer, is seeking a song, a voice, a face, and places with which to attempt to materialize the fiction. She meets Estelle, by whom she is inspired and fascinated, and who compels her to reflect upon the life that she has stolen in the name of fiction. In fact, Andréa is inspired by Estelle's life to put into images the broken life of a singer:

> She is what I want to show. But there you are, she isn't a character I have invented, her life belongs to her.[7]

Narratives within a narrative, Léa Pool plays on a double register. She handles Estelle's life as a kind of documentary by accrediting it with the seal of reality and thereby reinforcing the believability of the character. Andréa, the producer, plays the part of a mediator between the assumed reality or the documented one and the fiction to come. The fiction, the life of a singer (Marthe Turgeon) acts as the reflection of Estelle's life. The originality of the film lies precisely in the fact of lining the fiction with a reality assumed and reinserted within the film by bringing out the paradox of cinematography itself: the reality of enunciations or of the narrative intention and the unreality of the borrowed process.

This paradox is indeed taken up again in the composition of the film itself. By proceeding in this way, the author allows herself formal digressions endlessly accentuated. The film seems to be structured in tiny paragraphs or very short scenes articulated among themselves through sound and screen silences, which make the action pass from one narrative profile to another.

The narrative and formal processes of the film are intentionally laid out in the open. The sequences or the shots are highly fragmentized; the background music is strongly marked by quick passages of voices to silence, from music to voices or once again to silence, without necessarily being coherently presented with regard to the images. The sound

track haunts the movie; certain silences as well as the musical motif encroach at times on the shots or the subsequent sequences by bringing forth the scriptural space between the narrative systems used, and the thematic intention that runs through them.

Likewise, the presence of the music in the film constantly comes back to accentuate the overlapping of the diegetic motifs by intrinsically reflecting upon each one of them the presence of the other narrative system. This musical leitmotif has become a scriptural realm present in the diegesis as a whole.

Throughout the narrative, the lengthy pans bring forth the scripturality as screen facts, which the music and the silences reinforce and overqualify by referring the spectator to the semanticity of the narrative plateaus proposed.

In terms of form, *La Femme de l'hôtel* by Léa Pool, therefore, constantly asserts cinematographical scripturality through the use of systematized silence and music, as instruments of cinematographic language as well as instruments focusing on the language used. The writing of silence in cinematography acts as the relay and the interrogation of reality or of a certain reality: despair.

On the semiological plane, Léa Pool uses screen and sound silences as psychological and poetic ends, as well as formal and diegetic articulations that punctuate, once again, the film as a whole.

In *La Femme de l'hôtel*, the poetic interval is present throughout the whole textual surface as though it consisted of a meta-syntagm distinct from the a-diegesis, as it does not deny the diegesis, but multiplies the levels of meaning. This meta-syntagm is dispersed throughout the whole filmic surface in the dual presence or the overlapping of the two narrative themes where one serves as a referent to the other. To a certain extent, the sequences would therefore be symbolic realms whose implicit purpose is to evoke the initial or second narrative plateau that the silences articulate.

In other words, in the case where the writing of sound silences and screen voids refers to the second narrative background, we are in the presence of a poetic pause syntagm; in the case where they serve to put forth the passing of a plan to another, these silences are formal syntagms of articulation. Formal in the sense that they act more as filmic plasticity, or points of passage from one shot to another, rather than the narrative structure of the story. Diegetic in the case where they serve to mark the passage of one narrative movement to another. However, it is important to note that the syntagms of formal or diegetic articulations can, at the present time, have a poetic function.

This having been said, on the other hand, the absence of sound silences and screen voids between shots or sequences are sufficient to indicate that, if a formal or diegetic articulation is marked by a sound

silence or screen void, there exists a certain intention to signify some-thing or amplify a signification to come through the anticipation there-by created.

Blended into the darkness (syntagm of diegetic and poetic articula-tion), the music is heard, Estelle walks into the theatre with Andréa. Their dialogue is highly punctuated with lengthy silences (psychologi-cal syntagm). Estelle walks toward the front of the set "light." The camera pans to dark (formal articulation syntagm) to the point when Estelle appears in a close-up in the frame.

> A brightness (silence). A soft light, a soft light of a rainy day by the sea (silence, the room is empty). There is a decor, a window. It's raining. One intuits the presence of the sea. One hears the sea (silence). It's strange, it's frightening (silence, the room is empty, Marthe Turgeon, the actress, is there standing at the far right corner of the frame). I'll have a large room with shutters at the windows. It will be a rainy season, with rain. I'll be so weary from the city that it won't bother me always hearing the rain. I'll be ever so quiet. Wrinkles will disappear from my face. I won't have any friends (silence). Maybe once in a while, I'll go to the movies. I'll sit in the back of the hall, darkness all around me (silence) and the immobile faces won't be aware of me. Imaginary faces. People like we see in stories. And then I'll walk out to the promenade. I'll walk alone and the violent wind will blow on me to the point where I become slight, even slighter, just up to the point (silence) where my body no longer exists. (Estelle's face is superimposed on a parking lot covered with a heavy blanket of snow that the wind tears away and is gradually substituted by her face). Right up until the wind wraps me in its cold white arms and brings me with it forever.[8]

As the excerpt from Léa Pool's film reveals, the author continually uses the semantic and structural connections of silence and screen empti-ness either to substantiate the psychology of the character, or to bring forth the formal and diegetic articulations of the story.

As a final brief analysis of Léa Pool's two achievements, we have seen that silences and screen voids are present in *Strass Café* and *La Femme de l'hôtel*. They participate in filmic writing, either as a structural func-tion narratively denied (a-diegetic syntagms), or as a structural func-tion integrated within the sequential enunciative process of the film (formally articulated, diegetic and poetic syntagms).

By way of comparison, silences and screen voids in *Strass Café* seek to annihilate the story; in *La Femme de l'hôtel* they are used for both discursive and diegetic ends. In the latter film, silences and screen voids serve to bring forth the scripturality of the recital as initial enunciative projections rather than giving prominence to the fiction. Far from want-ing to attenuate the temporal ruptures imposed by the succession of filmic sequences, Léa Pool applies herself to putting them into relief by leaving silences and screen voids through the surface of the recital,

thereby punctuating the passing of one shot or sequence to another and the passing from one narrative plateau to another.

In terms of filmic analysis, one cannot exclude the intervals, by blending and losing them in the sequences, without beforehand recognizing the articulatory traces they display through the sequential order and without verifying their a-sequential function; and, this having been done, without seeing them as one of the scriptural processes.

Screen silences or voids appear to be one of the initial spatio-temporal determinisms of the diegetic continuity. They not only allude to the differential and temporal writing of the filmic flow, but they also allow its organization inscription and, therefore, its conceptual use. Emptiness qualifies space and time by temporalizing them and by temporalizing thought. We believe that emptiness of the screen, like temporal or sequential emptiness, indicates in reality presences, and that they constitute one of the fundamental elements of the filmic flow.

Within various degrees, in *Strass Café* and *La Femme de l'hôtel*, Léa Pool, by interrupting the temporal and narrative thread of the diegesis, manages to bring back the filmic fact to reality, where thought lets itself be overtaken in organizing and apprehending space and time, in order to reconjugate them. Fascination is maintained here in the successive unveiling of a kind of "unrepresentativeness," that of poetized emotion through the enunciative slowness and the shaping of silent writing as interstices of thought.[9]

Laval University

NOTES

1. Translated from the French by Mary Lellbach and Robert Turner.
2. Léa Pool, *Strass Café*.
3. Ibid. Short in text quotes in this section are also from *Strass Café*.
4. Ibid.
5. Léa Pool, *Femme de l'hôtel*.
6. Ibid.
7. Ibid.
8. Ibid. Lea Pool's inspiration comes from a theater piece by Tennessee Williams, *Talk to Me Like the Rain and Let Me Listen*.
9. These reflections are more or less the results of semiological, psychoanalytical, and phenomenological research on silence in cinematography that culminated in a master's and doctoral thesis.

2.

PIERRE PERRAULT AND THE QUEBEC DOCUMENTARY: "FOR THE CONTINUITY OF HUMANITY"

Cedric May

At the March 1989 Oscar Award Ceremony in Hollywood, an Oscar was given to the National Film Board of Canada to celebrate fifty years of sustained achievement. The press hardly mentioned this award. The quiet but solid success over fifty years of a semi-governmental agency sits uneasily with the glamour and razzmatazz of the movie industry and the star system. The presentation of the award by Donald and Keifer Sutherland reminds us of the drain of Canadian talent to the United States entertainment industry. (According to the *Canadian Encyclopedia,* Michael J. Fox was born in Edmonton in 1961 and emigrated to Los Angeles in 1979, while retaining Canadian citizenship.) The Oscar awarded to the NFB was received by Marcellé Masse for the Film Board and the Federal Government and he was accompanied at the presentation by the Quebec feminist and moviemaker Anne-Claire Poirier, best known for her documentary on rape entitled *Mourir à tue-tête* (1979), a title that combines dying with screaming at the top of one's voice. The award came after fifty-two previous nominations and eight previous Oscars awarded the Board, whose first Oscar in 1941 was also the first Oscar ever awarded to a documentary.

The citation mentioned most accurately the three areas of Canadian achievement with the NFB—animation (we think at once of Norman McLaren), documentary cinema, and, thirdly, innovation with the hand-held camera. The orientation of the Board's programme goes back to its early days. The NFB was founded in 1939 by a Scot, John Grierson. His ambition and energy built it up into one of the world's largest studios with a staff of 787 when he retired in 1945. Space problems dictated in part the move of the NFB to Montreal in 1956 and the Board benefited from the impetus given to the Arts following the publication of the Massey Report in 1951. In the early years, the NFB was content

—103—

with a French version of selected English-language films, but the move to Montreal led to the hiring of many *Québécois,* the appointment of Guy Roberge, the first francophone President, and the separation of the Board's programmes on linguistic lines in 1964. Later there came the creation of a separate women's section in French, on the model of Kathleen Shannon's Studio D. The NFB also bowed to pressure when faced with criticism from Canada's native peoples about the condescending image presented of them. They were brought in to produce programmes such as *Challenge for Change* in the late 1960s.

Pierre Perrault, 1976

Cinémathèque québécoise

"Cinéma direct"/direct cinema is the term given to the NFB's most notable innovation. Thomas Cullen Daly is usually credited with the first sustained use of lightweight equipment to obviate the need for large crews, tripods, and elaborate planning. The result was a fluid, spontaneous style of interview. Tom Daly was a key figure at the NFB during his 40 years there; he retired in 1985. He was in charge of the famed unit B from 1950 to 1964 and responsible for *Universe* (1960), *Lonely Boy* (1962), and the multi-screen *Labyrinth* for Expo '67 among many others. Tom Daly's name appears on the production team of *Un Pays sans bon sens!* (1970, scenario published in 1972), a film I shall mention again when discussing the work of Pierre Perrault, its producer. Perrault early applied the techniques learned from Daly. *Cinéma direct* was

essential to his cinematographic technique based on interviews where the interviewer is as unobtrusive as possible.

The NFB played an important role in Quebec's Quiet Revolution through the investigative documentary on the cinema screen, but also on television. Quebec consumed television with prodigious avidity from its introduction in 1952, finding in it satisfaction of the nation's need to discover and define itself. Denis Arcand's *On est au coton* (1969) examined the fate of the workers exploited in the textile industry. Bernard Gosselin and Marcel Carrière produced a delicious tongue-in-cheek, gentle send-up of the Quebec uniformed organization, "Les Zouaves pontificaux" in *Avec Tambours et trompettes*. Gosselin and Labrecque with *La Visite du Général De Gaulle au Québec* (1967) demonstrated, as Pierre Perrault has remarked, that the word "freedom" could not be pronounced in Quebec. The Quebec documentary chronicles the rapidly growing sophistication, maturity, and self-awareness of the Quebec people in the past thirty years. Ian Lockerbie in *Image and Identity* puts it succinctly: "What the early documentaries did was to hold a mirror up to Québec life and create a national self-portrait of thc Québec people."[1]

The feature-length documentary grows naturally out of the *court-métrage* and becomes a new genre into which almost any Quebec feature film one cares to think of can be fitted. In Quebec films such as Jean Beaudin's *J. A. Martin, photographe* (1977), *Cordélia* (1979)—and an anti-hanging film, *Mario* (1984); Jean-Pierre Lefebvre's *Les Fleurs sauvages* (1982), Francis Mankiewicz's *Le Temps d'une chasse* (1972), Michel Brault's *Les Ordres* (1974), André Forcier's *Bar-Salon* (1974), Claude Jutra's *Mon Oncle Antoine* (1971), the human interest is strong, an element of fictionalization is always present, but plot, rarely given a high priority, is frequently neglected. Long films such as Anne-Claire Poirier's *Mourir à tue-tête* (1979), and Jacques Leduc's and Roger Frappier's *Le Dernier Glacier* (1984), are unashamedly didactic. Their producers' sure touch in isolating and treating boldly essential modern issues—rape, the care of the elderly, and the human consequences of economic recession—allow them to attain a level of universality while remaining resolutely local in idiom. The long documentary, with the theatre of Gélinas, Dubée, Languirand, Barbeau, and Tremblay, is the servant of the process of the honest, uncompromising social evaluation that is at the heart of the Quiet Revolution.

There is a second distinct strand to the development of Quebec documentary during the 1960s and 1970s, one which goes back to the work of a native of Michigan, Robert Joseph Flaherty (1884-1951), who, born in Iron Mountain, grew up in Canada and is best known for his *Nanook of the North* (1922). Pierre Perrault belongs to this tradition, producing long, slow-paced movies that celebate Quebec's inheritance.

The Quiet Revolution, to a certain extent, had to turn its back on the past in its haste to modernize Quebec society, its politics, its education, its economy, but there will always be room in the heart of the Quebec people for an appeal to the traditional values and the themes of *appartenance*, faithfulness to their French North American heritage. This explains the appeal of the immensely popular Gilles Vigneault, whose songs often recall the fortitude of the pioneer, with at times an environmentalist message, and the foibles of small town life.

Pierre Perrault is an ethnographer and a poet. He has a passionate love for people and for words, the two inseparably linked. He is a man of great personal charm, a good talker and a good listener, and his work combines ethnographical films and work for TV and radio with plays, poetry, and essays. His beautifully handwritten letters to friends are indistinguishable from his poems. Pierre Perrault is all of a piece, a man whose ideological standpoint and whose professional strategy make him thoroughly comfortable with who he is and what he is doing. He constantly annotates his own cinema in essays, interviews, and in the long parentheses that intersperse the printed scenarios of his films. Much of this fascinating reflexion on his work is contained in these scenarios, especially *Un Pays sans bon sens!*, (Montreal, Editions Lidec, 1972), in *Caméramages* (Hexagone, 1983) and in *De la parole aux actes: essais* (Hexagone, 1985). The first volume of a new work, inspired by the film of a sea voyage in which he traced with Michel Garneau the journeys of Jacques Cartier from St. Malo to the St. Lawrence, has just been published under the title *La Grande Allure*. To read one of these film scenarios is to see how much more these are than the simple "book of the film."

His work as a filmmaker falls loosely into three cycles, one on Quebec's Indians, a second on the survival of francophone Canada (*Un Pays sans bon sens!* [1970]—perhaps his most complete film as it embraces the other themes—and *L'Acadie, l'Acadie* [1970]), and the third recording for posterity the fast-disappearing traditional cultures of the Abitibi region and the Ile-aux-Coudres. This last contains what might be considered a fourth cycle devoted to his beloved St. Lawrence and the memory of Jacques Cartier. His most accessible film, *Le Beau Plaisir/Beluga Days*), is a 20-minute documentary about the beluga hunt made in 1969 in the style of the celebrated *Pour la suite du monde* (1963).

Perrault must have exerted considerable personal charm to persuade Tom Daly to let him take equipment and a crew 300 miles down river in 1962 to make a documentary on the tiny island community of fishermen and "caboteurs" on the Ile-aux-Coudres. The light-weight equipment certainly made this project more feasible and helped Perrault get close to his subjects. The ethnographer has a notorious difficulty in

getting authentic, natural interviews. Interviewees are cagey and suspicious, tend to say the obvious, invent things, have great difficulty in being unselfconscious and articulate. Perrault has a gift for drawing people out, but his real breakthrough came in realising that memory survives best in the hands and muscles that performed for decades routine tasks, in the feel of the wind on the cheek of the sailor—essential to the navigator, in the aesthetic delight in the forms of ships and waterborne craft of all kinds and in "le beau plaisir," the joys and pains of community and shared toil. Perrault got his interlocutors to relive physically important social events—building a boat, recreating the beluga hunt, visiting France, and killing a pig—and this "remembrance of time past" triggered the involuntary memory lingering in bone and muscle, in ear and eye, in instinct and reflex. The strategy of the poet Perrault works like a dream.

Of course, he manipulates his subjects. They would not voluntarily have conjured up the figure of Jacques Cartier. They were the ones, I argued (at a conference in Rennes, France in 1984, 350 years after Cartier's first trip), and in this I was following Perrault closely, entitled to evaluate the skill of Cartier as a navigator who in three trips to the St. Lawrence never put a ship aground in those notoriously treacherous channels.

Perrault has been criticised for the length and slow pace of his films, for the linguistic difficulties of the text, and, curiously, for working with "primitive" and often inarticulate people (this last from some of his French critics—see *Caméramages* [1983]). Such critics have failed to see that Perrault's aims are to denounce the sick hurry imposed by the cult of efficiency and productivity and to demonstrate and validate the riches of the French language, its inventiveness, its appropriateness in traditional communities, a heritage tragically impoverished by urbanization. He also wishes to demonstrate the symbiosis between the hunter and his victim, man and his environment, and man and his work in traditional society, values that are destroyed by the dehumanising effects of urbanization and the capitalist exploitation of labour and concentration of economic power. Above all, he wants to bring out and celebrate the wisdom, wit, and dexterity of Quebec's native peoples and the despised remnants of a culture fast disappearing. As an urban *Québécois,* he marvels at his wife Yolande's ability to give all the flowers of the St. Lawrence lowlands their common name, not a skill that would mean much to the "Arvune" (the Irvings), oil magnates of the Eastern St. Lawrence and the Gulf. But there is not an ounce of sentimentality or romanticism in all this. Pierre Perrault has the physique and the style of a man who has fished and hunted and sailed and toiled, laughed and cried, eaten and drunk, suffered heat, cold, mosquitoes and physical hardship, alongside those people to whom he has endeared himself.

Office national du film du Canada

Pour la suite du monde

This gives him his credibility and the right to get to the heart of the matter. He is to be admired for his courage in pursuing the unfashionable and pinning his faith on the despised and ignored, the "laissés pour compte" of his films. There is an elegiac note in much of his work, images of abandoned homesteads, burning goélettes, the faces of the old and the very old (including a 99-year-old Indian portageur). This tendency is very effectively countered by the zest for life in the occasional musical accompaniment of an accordion, harmonica, and fiddle, the animation of his interlocutors, some of whom become veritable stars and by the ludic quality of Perrault's use of language.

Some of this can be detected in his titles—*Chouennes, Caméramages, Gélivures, Pour la Suite du monde, Le Beau Plaisir, Portulan, Les Voitures d'eau, Un Pays sans bon sens!, La Grande Allure,* and *Toutes Isles,* words and phrases taken from the picturesque, enthusiastic speech of his informants, from the playful neologisms and exotic specific terms of the vocabulary of the tradition he is documenting, or from the récits and the toponymy of Jacques Cartier. *Chouennes* are tall tales, *Caméramages* his distinctive cinematic techniques, *Gélivures* a neologism that eloquently evokes the climate and mythology of the North, the next two titles are from the colourful speech of one of his principal actors on the Ile-aux-Coudres as is *Les Voitures d'eau* (the old wooden riverboats of the St. Lawrence). *Toutes Isles,* title of a collection of prose poems, is the name

Cartier gave curiously to a single island. *Un Pays sans bon sens!*, contrary to what we might imagine, does not describe Quebec as a "crazy," impossible land, but, rather, a country that is loved beyond all reason, that is, excessively. Quebec is the "way-out" land, the subject and the rhetoric of Perrault's work.

Here are some of the aims of Perrault in his own words: "nous avons essayé de rendre la parole et son honneur aux gens de parole."[2] "Tout un peuple est tiraillé par son propre échec. Il manque d'images et dévore l'univers."[3] "En ce qui nous concerne, humainement, nous n'avons pas réussi à distinguer Xavier du mercier de Dol, Meavenn de Chaillot, le marin breton du bûcheron, l'Indien du Québécois: et nous les avons trouvés *'magnifiques au nom de l'humanité'* " dirait Didier. . . . Ils ont eu la chance énorme, Yolande et Didier, de naître dans du beau pays, de la belle étoffe, dans du tangible et de l'admirable et du cohérent."[4]

Office national du film du Canada

Pour la suite du monde

"J'ai vérifié le mot village pour avoir fait à rebours tout le voyage des découvrances . . . avoir en partie découvert le lieu de mes appartenances."[5] Perrault wants to give images, he calls them an "album," to the rootless urban waifs, without a village, without soil in which to grow, whose greedy gaze scours the skies, who have not had his wife Yolande's great good fortune to be born in the tangible and coherent world of things. Perrault the city dweller has given himself an identity

by retracing the discovery of the land of his allegiance and by redis-covering Jacques Cartier in the skills and in the values of the people of the St. Lawrence.

The documentary was the cradle of Quebec cinema, not only at the NFB, but also at the Office du Film du Québec and on television. It has been one of the instruments of Quebec's growing self-discovery.

It could be argued that the arts are excessively subsidized in Canada and that this support has at times an adverse effect on Canadian artistic production. There is certainly a great amount of state patronage. Pierre Perrault has enjoyed the considerable freedoms and resources provided by the NFB. He has tended to produce the films he wanted to make rather than films assured of commercial viability. He has taken con-siderable risks, particularly in his extensive use of nonprofessional actors, risks that haven't always paid off. But box-office appeal is not an im-portant criterion. Perrault is not "popular," because his cinema is at odds with the materialism and urban lifestyle of modern Quebec. What he is creating is a rich and varied archive of lasting importance. His films have, too, a lyrical, plaintive quality that is an acquired taste but which grows on the spectator.

Pierre Perrault, by his intelligent experiments with technique and long reflexion on his art, has played a central role in the history of Quebec film. For him, the documentary is not a mirror to a people. When it is not sounding a warning note, it is rather the "supplément d'âme" for which our age seems to long, a tribute to forgotten people, an album of essential images, a therapeutic vision "for the continuity of humanity."

University of Birmingham

NOTES

1. Ian Lockerbie, *Image and Identity: Theatre and Cinema in Scotland and Que-bec* (Sterling: University of Sterling, 1988), 81.
2. *Un Pays sans bon sens!* (Montréal: LIDEC, 1972). ["We have attempted to return the word and its honor to people of the word."]
3. Ibid., 12. ["A whole people is torn by its own defeat. It lacks images and it devours the world."]
4. Ibid., 98. ["And what concerns us in human terms is that we have been un-able to distinguish Xavier from the cloth merchant of Dol, Meavenn from Chaillot, the Breton sailor from the wood cutter, the Indian from the *Québécois*: and we found them 'magnificent in the name of humanity' as Didier would put it. . . . They had the enormous luck, Yolande and Didier, to be born in a beautiful country, made of good stuff, amidst the tangible, the admirable and the coherent."]
5. Ibid., 99. ["I verified the word village' in order to have made the entire voyage of discovery backwards . . . to have in part discovered the place where I belonged."]

3.

LEA POOL'S GYNEFILMS
Janis L. Pallister

PRELIMINARY CONSIDERATIONS

From a wide range of excellent films recently emerged from Quebec, Léa Pool's films are outstanding as works whose visual structures and ideological, albeit minimal "stories" fuse to present gynepathetic themes, sometimes in terms of a specific geometry. These films are not culturally based or bound, as *Mon Oncle Antoine* or *Les Bons Débarras* might be said to be. Of course, since Pool is of Swiss origin, her use of Quebec cultural materials is in a sense minimal, even though the skyline of Montreal and other views of the city serve as a backdrop in her works. The symbolism and the geometry of her films reflect Jewish and feminist concerns, not social or political concerns pertaining uniquely to Canada or to any of its regions; and, as we shall see, this is particularly true of her film *Anne Trister*.

Neither is Léa Pool making an ethical statement in her films, as *Le Déclin de l'empire américain* can be shown to be doing; nor are they presenting a predetermined narrative, as the beautiful *Fous de Bassan* halfway intends.[1] Her pictures are not subverting the violent American crime story, as *Pouvoir intime* is in part attempting. None of these things is Pool doing in quite the same way as other directors in Quebec, if she is doing them at all.[2]

Rather, one may with confidence contend that Pool's work, along with that of certain other women directors, clearly marks the entrance of the Quebec cinema into worldwide feminist cinematic iconography. But Pool, among these women filmmakers, seems to have an uncommon gift. Even so, her accomplishments to date, like those of other women directors, will probably not reach mass audiences; the analytical nature of her art will cause it to remain somewhat special. Of course, many

Cinémathèque québécoise

Pouvoir intime

new Canadian talents are presently coming to the fore in this field, and that is surely a true index of the extent to which Quebec cinema will forge ahead in new and different patterns. Mireille Dansereau was something of a pioneer in women's films; Nicole Brossard followed her, as did Louise Carré and Anne-Claire Poirier; but Léa Pool carves out new terrain: she comes closer to a complete understanding of the medium and its own unique characteristics than most other Canadian women directors (except perhaps Patricia Rozema in the anglophone domain).

Like most feminist works of art, Pool's films present the woman's cosmos; men are characteristically marginal to the story line or to the visual preoccupations of the work. (The role of men in *Anne Trister* can, however, be said to be more ambiguous than is the case in *La Femme de l'hôtel.*) *La Femme de l'hôtel* captivates the viewer more for its atmosphere than for its photographic impact—though this is certainly not negligible. It is a gynefilm concerned with the haunting of one woman by another (not an uncommon scenario in feminist films, after all). But more importantly, it is devoted to speculation on the art of film; this film, like Fellini's *8½,* concerns the making of a film, the problems of making a film, the emotional involvement of the director in making a film—here a woman's film, moreover.[3]

Simply stated, *La Femme* (87 min. 1984) emerges as a highly compact and a highly visual film. Interestingly enough, in *Anne Trister* Pool

again uses the talents of Louise Marleau, who had appeared—along with Paule Baillargeon (Andrea)—as Estelle or La Femme in *La Femme de l'hôtel.* Baillargeon will be the spectacular "Curator" in Patricia Rozema's excellent, prize-winning anglophone feminist film *I've Heard the Mermaids Singing* (1987). And it may be of some interest to point out in passing that Louise Marleau had in 1980 starred in Mireille Dansereau's *L'Arrachecoeur,* another film by a woman director in which fantasy and relationships between women are studied: in it, a young married woman tries to escape the domination of her mother.

LA FEMME WANDERING AND
THE PRISON OF THE SELF

But it remains to be seen whether *La Femme* is really a "fantasy," as has sometimes been asserted; it certainly is not built upon a "subversion," as feminist critics seem bent on proving. Nor is Estelle, the elusive and mysterious woman who haunts Andrea the filmmaker, an allusion to Woman, or *la femme fatale,* as portrayed in *film noir,* as has also been contended.[4] On the contrary, Andrea's desire for the mysterious woman, whom she "needs," whom she desires and loves, is a reappropriation, it seems to me, of the Garbo type, reflected through a reconfiguration of "stereotypical" symbols, just as the triangle, used in *Anne Trister,* might be thought to be standard or conventional in its signification, although in both cases the symbol is unexpectedly applied, and with considerable freshness, to the homoerotic experience.

In *La Femme* (so aptly called *Woman in Transit* in English), Pool introduces many scenes that reflect transition, eternal restlessness, homelessness, and alienation, especially as it applies to the "Wandering Jew," a concept that will be heavily at play in *Anne Trister.* Andrea imagines the main character in her film: "une étrangère dans un hôtel, . . . un lieu de passage" ("a foreign woman, a stranger, in a hotel, [which is] a temporary dwelling place"). Suddenly she applies all this to her own situation: "je ne suis pas chez moi, pas plus ici qu'ailleurs" (I am not at home; no more here than elsewhere) . . . ; "here" is Montréal, or Québec City, as the case may be. But the floating geography, and especially the interchangeability of "here" and "elsewhere" or "there" (*là-bas; ailleurs*) are insisted upon throughout the film, whether that vagueness of place applies to the situation of Andrea, to that of Andrea's character, or to that of Estelle. Estelle is the woman in transit, a "star" who dreams of the sea, of walking on the esplanades, of escaping, of "closing up" (the theater, life), of ceasing to do what others want, but who, also, as her name suggests, thinks, as she examines the empty theater, of the *lumière douce* (soft light), which, in her melancholy, is imagined as being suffused with rain. She, perhaps an actress of the

theater, comes to be not only the actress Andrea sought, for her film, but also the very woman who is her obsession, her love object ("Je vous cherchais," or "I was looking for you").

Estelle is, in fact, such a love object as Andrea could not recognize in her previous male lover, from whom she is separating at the very outstart of the film, for, she tells him, she realizes "it" is impossible (bisexual, heterosexual love, the accomplishment of the film?), to which he responds angrily by saying that they were merely ships that passed in the night, anyway ("on s'est croisé seulement"). In *Anne Trister,* we will see the main female character also dismissing her male lover, this time clearly in favor of a woman. But ironically (and also as in *Anne Trister*), the relationship with Estelle, the woman, is of a transitory nature, like the episode with her male lover, or "man" as he is called in the credits, because Estelle, like Andrea, is fundamentally homeless, and restless. Her first appearance in the film shows her starting to catch a train—to go from East to West—in fact, then changing her mind and taking a taxi to "a hotel"; and her last scene shows her again, this time really catching that train, which in both instances is West-bound. This East-West trajectory will be repeated, along with many of the other symbols of *La Femme de l'hôtel,* in *Anne Trister.* In conjunction with this, we should also note that in *La Femme de l'hôtel* there are endless symbols of this transitoriness and wandering: train stations, hotels, airports, one-way tickets, highways with traffic coming and going, subway trains, taxis, automobiles, etc. The theme of departure is echoed in Andrea's film, the film within the film, where an older woman (a mother) reads to a younger woman, who is about to "leave," from Marie-Claire Blais's *David Stern;* the passage in question restates Estelle's voiced longing for the sea. These symbols of homelessness and separation, along with the airport as a key addition for scenes of good-bye, will recur in *Anne Trister.* In *La Femme* we also have the introduction of allusions to the desert, the wasteland, which one also only "crosses," or passes through; the desert, too, will reappear in *Anne Trister.*

In *La Femme de l'hôtel* the key visual image, as important as those scenes evoking voyage, appears to be the image of rails, doors, and windows. Rails on the bedsteads, bars on the windows, are used in quite conventional ways to suggest that Estelle, as well as the main character in the film being made, is trapped, or in a prison. Curiously enough, the characters nonetheless pass back and forth through doors, often with glass and/or grillwork attached, or go up and down stairs. The aimlessness of this constant coming and going forces one to conclude that even though doors ought to provide an "exit," in this case the exit itself is part of the pattern in which these three women—Estelle, Andrea, and her film character—are trapped. Andrea's film character is, incidentally, a *comédienne-chanteuse* (played by Marthe Turgeon), who is

imagined as "someone fragile, who wanders about without knowing who she is, half-dead, half-mad." While each of these three women is an individual, in a very real sense, and through a process of *dédoublement* common to Pool's strategies—as we shall again observe in *Anne Trister*—all three women can also be said to represent one woman, as in Bergman's *Persona*.[5]

Moreover, even though Pool is known for her unusual photography of Montreal, in reality these compositions are little more than establishing shots, for she is, in truth, fixed on (urban) interiors. The characters go in and out of doors, yet the prime space of these women—reflecting the habitual space of women—is indoors. They may walk in the streets, but more often they are looking through the windows out into those streets; more often they are looking through glass on doors, or restaurant windows, or through blinds upon a world they seem unable to enter; more often they are seen in bedrooms, studios, editing rooms, restaurants, bars, theaters. They are trapped by their space, as they are trapped by their restlessness, for the space is only appropriated. None of it really belongs to them. (Andrea even bunks with her homosexual brother, Simon, who tends to watch Italian films on TV, the clips of these affording yet another allusion to [art] film, as well as to director and spectator. And, as we have seen, the presence of Fellini is felt elsewhere in *La Femme*).

Even more tellingly, in Andrea's film the *chanteuse* is placed in an asylum. As Andrea explains to the actress portraying the *chanteuse*, the *chanteuse* finally gets out of the asylum. But Andrea then reforms her idea, saying that the *chanteuse* does not really get out; for part of the experience of being mad, of being in a madhouse, will always go with her. The notion of "no exit"—here, from eternal exit—pervades this film, as perhaps also *Anne Trister*. Thus, like the characters in *Waiting for Godot,* these women are forever "exiting" from their trap, but they may not exit and therefore perpetually begin the journey over again. This must be the reverse of Tristan and Iseult whose love story was typified by Cocteau as *L'Eternel Retour*: here we have the converse story of *L'Eternel Départ*. Hence, it is not easy to understand why it is sometimes said that the two women in *La femme* are better off for their encounter. Estelle has, after all, resumed her travels—as will Anne Trister—whereas Andrea, although she has made the film, weeps and searches still for Estelle. Andrea says, at the end, that the meeting has perhaps made everything "possible" again, which takes us back to the beginning, where she has told her male lover that "it" is impossible. But, if this applies to her film, the same cannot be said of Estelle, that other nonartistic, nonsexual part of Andrea.

The claustrophobia experienced by the Poolian character gives her kinship with the women of Anne Hébert's novels (and of the film

Kamouraska, rather ably brought to the screen by Claude Jutra). This kind of entrapment also occurs in Marguerite Duras's novels and films. Indeed, Pool's films have been said to be "Durasian." But this is as if to glorify them, when in fact the films of Pool stand on their own, and, besides, have little standing in the Durasian world. Indeed, the analogy, which should include the autobiographical inclinations of both artists, must remain very superficial, because Duras sets her films, and her "foreigners," against the strife of war and the pain of colonialism, and upon occasion even against the holocaust. Then, too, Duras's films are often interminably long and sometimes rather wordy, hardly the cosmos of Pool! Though Pool's films may have an application far beyond Quebec, in a sense we shall see later, her characters are fighting a set of battles unknown to the Durasian character: in Pool, the problems of art and lesbianism spring to the fore in ways unknown to the field of concerns found in Duras. Moreover, I find the motion pictures of Pool to be much more filmic than those of Duras. (Of course, here I leave aside *Hiroshima mon amour,* which she did not direct but only helped to script.)

THE MAJOR THEME: GARBO, THE FILM, AND *LE REGARD*

If alienation and homelessness, if marginality as woman and as Jew are the lot of these women,[6] even so, the major theme of the *La Femme de l'hôtel* is not that, really. It is, rather, the making and viewing of film; therefore, the creativity and the suffering of the artist are sub-considerations here, as they also will be in *Anne Trister*. The focus, it seems to me, is on the glance, *le regard*. Whereas in the traditional film the spectator looks upon the woman through the eyes of the hero, in a sort of scopophilia, here the spectator looks upon the mysterious woman through the eyes of a woman. Thus Estelle's role does not represent a subversion (of the *femme fatale* sometimes found in *film noir,* and, for that matter in many films), but, rather, an invasion of the myth of the mysterious woman—the unknowable woman characterized by exoticism and having an unmatchable mystique—who was in part created by the film industry; for Estelle is Garbo-like in her dark-clothed glamour. She is, also, to some extent, androgynous, as is also the viewer, Andrea. Estelle is the dark lady of the sonnets. Still, the more Andrea observes Estelle, the closer she comes to understanding her character, and, in the final scenes, herself. Andrea reformulates Garbo's famous line, as she explains to the actress how to portray the *chanteuse* in the film they are making: Andrea says to the actress, in French: "She needs solitude, as others need air. It is not that she wants to be alone, but that she wants to be left alone" ("qu'on la laisse seule"). Then Andrea translates into English: "I want to be left alone." (The shifting of pronouns is a whole other question; it involves the assumption of one personhood

by another, as well reflecting the types of fusion and fragmentation that are found in Monique Wittig's *Le Corps lesbien,* to which the script of our film is singularly comparable.) Filmmaker, actor, and spectator are interlocked here. Andrea and Estelle reset the Garbo-Stiller combination; the famous couple was sometimes referred to as "Pygmalion and Galatea." To the extent that Estelle is the embodiment of the woman Andrea seeks for her film, her model, her dream woman and her alter ego, Estelle, the elusive woman "star"—reminiscent of the stellar Greta Garbo or the androgynous Marlene Dietrich—is not only a refashioning (rather than a subversion) of a stereotype, with its accompanying myth and mystique, but also, and even more significantly, the restatement of a prototype, this time with a woman director and a woman spectator. And as director-editor, Andrea (not André or Andrée, but Andrea [Eng., f.; It., m.!], the Andr-ogynous), Andrea has the power to undo her art, or modify it, just as Anne Trister will be seen to do. Moreover, the use of the television reinforces these ideas: on two occasions we find Andrea so plunged in her obsessive preoccupations that time for viewing the picture has literally run out: the television screen projects nothing but snow in the late, dark night.

One cannot insist too much upon the importance of this regard and its role, which inevitably remind us of the formulations of Foucault, both on glance (in *Birth of the Clinic*) and on picture or icon, about which he says (in particular in *Madness and Civilization*) that the image remains in our minds, and ultimately presents only an enigmatic face, so that its power is no longer to teach but to fascinate. If we were speaking of emblematic art/literature, we might then assert that our impression upon first viewing the *res pictura* could linger and lose its connection with the *inscriptio* or *subscriptio*. My application of that formula here substitutes film for *pictura* and dialogue for *inscriptio* and *subscriptio*, so that the atmosphere provided by the shape and shadow of Estelle along with the imagery of the doors and windows will be the lasting impressions carried away from our viewing. Similarly, from *Anne Trister* we will retain above all the image of the obsessional triangle and its symbolism. It is not too extreme to claim that within its mediation on the film *La Femme* is predominantly concerned with the glance, and indeed, in a more specific sense, with the professional filmmaker's *regard,* which Andrea casts about her, just as the clinician or physician does in his or her own way. The important text from René Char given at the start of the film tells us through its extraordinary use of synesthesia that "Les yeux seuls sont encore capables de pousser un cri." The quote is not to be overlooked.

La Femme de l'hôtel: Gerald Pratley aptly says of it: "A film of frosty beauty and introspective despair concerning a filmmaker and her encounter with an older woman."[7] Despair that is echoed in *Anne Trister,*

I believe, despair that frustrates, indeed prevents, the achievement of *jouissance,* said by modern feminist critics (Annie Leclerc, etc.) to have been denied to women—lovers, readers, spectators, and so forth—for eons, a denial that was (is) expressly intended by the patriarchal structures of civilization. *La Femme de l'hôtel*: a gynefilm, centered on woman's experience, on essential longings: "touch me, touch me" cries the pivotal song of the film and of the film-within-the-film. This film does not, however, promise bliss in the face of the castrated or absent male. It is about homosexual problems, to which Pool will return in *Anne Trister.*

ANNE TRISTER
THE ALPHA AND THE OMEGA; THE TRIANGLE

Now, granted, *Anne Trister*'s (homosexual) story line is as thin as that of *La Femme*; but *Anne Trister* also provides a feminist meditation on triangle, on the letter A as Alpha, Anne, Alix, Art; on the Wandering Jew—marginalized, Alienated, Orphaned (the Omega). Almost beyond the reach of language, this film has little to do with the theories promulgated by the European structuralists, deconstructionists, post-modernists, and the like. I will not, therefore, be concerned in my analysis of *Anne Trister* with "reconstructing the object in such a way as to manifest the rules of its functioning"—for the film is not strictly speaking an object, and it does not function by rules. And, although I recognize it to be an authentic gynefilm, like *La Femme,* one should reject jargon-laden descriptors, and eschew such nonsensical claims such as Léa Pool's films "privilege the inscription of the feminine" (as I have heard asserted in a paper on her *Femme de l'hôtel*). For in the final analysis, inscription is not a word that applies very well to Pool's films anyway.

It is, however, appropriate to analyze recurrent tropes in this film, with an eye to seeing how certain visual structures and the portrayal of certain relationships (friend to friend, mother to daughter, man to woman, woman to woman, daughter to father) reinforce Pool's themes of alienation and artistic failure, or of art *per se,* threatened by contemporary concepts of "progress." The Alpha is Amour and Art; the Omega is Oneirism and the Oblivion and Obliteration of the person and the creator, Outcast and levelled, by Western civilization at least, if not on a cosmic scale. The journey of the protagonist is one from Israel to the West and back again; it is the quest for another—a(m)other—country, a quest that fails in the end. Although in *Maclean's* we read that Léa Pool's *Anne Trister* created a sensation at the Berlin film festival due to the fact that Pool announced herself in it as "telling stories more powerfully" (though the comparative is incomplete), this "story" is not "told," but portrayed, and therein lies the essence of Pool's power.[8]

ANNE TRISTER THE ALPHA AND THE OMEGA

The video catalogue (from Polyglot, to be exact) describes the film *Anne Trister*—made in 1986 by Pool, and starring Albane Guilhe, Louise Marleau, and Lucie Laurier—as telling the story of a young woman whose father has just died. The text concludes with the statement that: "She leaves her male lover to go to Québec where she wants to become an artist, and where she falls in Love with Alix."

But this is to say little, because the very point is not that the young woman falls in love with Alix, a female psychiatrist, nor that she wants to become an artist—"wanting" is not the issue anyway, since she is an artist—but that the quest, which is a quest for another, for a(m)other country, for acceptance of one's art, for absolute love, appears to fail. The onset of the quest is not so much stimulated by the father's death, as by desire. Departure is the Alpha, the beginning of the film; return after failure is the Omega, or, in one sense, the end; but the Omega is also representative of an eternal search, of a search reinitiated. Thus, the return to Israel may not be so much that of the prodigal daughter to the motherland, as of repositioning, prior to new departures we cannot know of, since we are really only privy here to a small segment of infinity.

Office national du film du Canada

Anne Trister

The trajectory of the film—from Israel to Canada to Israel—is told in terms of a battery of triangles and triangular motifs. We must bear in mind that the triangle has infinite variations; and also that the circle implicit in the Omega is infinite, as the search is infinite. This is the visual geometry of the film, as well as the pattern of the protagonist's social and sexual relationships, and the triangle does not allow for artistic and sexual resolution. A text in *Spirales* published at the time of Suzanne Lamy's death replicates a conversation in which Lamy declared to her friend Andrée Yanacopoulo that they would never be *comme ça* (not like *Anne Trister*) tells us still more: resolution, like death and burial in the Portuguese Jewish cemetery on the Côte Sainte-Catherine in Montreal, would end the quest, of course; but failure at art and love also ends the quest.[9] Or was Lamy referring to the nature of her relationship to Andrée Yanacopoulo? In the context of this conversation between Lamy and friend, the expression "comme ça" is ambiguous, to say the least. We know its double meaning. But Lamy's statement tells us, also, that to some extent the film represents a "true story," and that, in spite of the ending of the film, *Anne Trister* returned to Montreal where she finally died.

TRIANGLES IN THE PLOT: SOME EXAMPLES

In order to see how these triangles function, let us speak first of the relationships in the film, perceived as shifting sands of the desert, ever changing their pattern, but always in a triangular mode.

At the beginning of the film, just after her father's funeral, which is portrayed without dialogue but which emphasizes the shifting sand that falls into his tomb in that desert locale, Anne (Albane Guilhe) embarks for North America. She must depart, following the trauma and devastation of her father's death; she must also depart, as she explains to her lover, because she feels "blocked by frames," by all that is standard, and, I dare say, "square." In one of the earliest scenes of the film she is in the Tel Aviv (?) airport with her boyfriend Pierre (Hugues Quester) who has refused to accompany her, claiming he cannot just up and leave his job. After her departure, Pierre and Anne's mother take a drink together, and Anne's mother confesses she has never given Anne the love that she expected of her. A revelation for us, too.

Arriving in Montreal, Anne looks up an old friend of the family, Simon Levy (Navit Ozdrogru), a Jewish bistro proprietor, who helps her to find her studio and to get established in this new environment. He appears to be a father replacement for her. But more importantly she soon looks up Alix (Louise Marleau), a psychiatrist, who is also clearly symbolic of the rescuer, the healer and the mother whom Anne seeks. We readily see that the first major triangle of the play involves Anne, Alix, and Anne's male lover in Israel, with whom she remains in contact, and

who is later to arrive in Montreal for a brief and failed visit. However, Alix herself has an Italian lover, Thomas (Guy Tauvette). This, then, is the second major triangle of the film. Lesbian love is as a consequence pitted against heterosexual love, and one is curious to know which can win out, if either. Adding to the complexities, Alix has as a difficult patient, a young girl named Sarah (Lucie Laurier); she is a source of some unexpressed jealousy for Anne, establishing therefore a third triangular relationship.

But there are greater complexities than this, as I have hinted at above. Anne, who in some respects projects a replica of the theme of the wandering Jew, has to relate to two fathers: her own dead one and the friendly Montreal barman. She must relate to two mothers, too: her own and Alix. She must relate to two strong macho men: Alix's lover Thomas, who seems interested in Alix predominantly as a sex object, and her own male lover, Pierre, who, when he arrives in Montreal, is informed by Anne that she loves Alix now, even though Alix cannot love her in the same way. After this confession on the part of Anne, Pierre returns to Israel completely baffled and crushed. Moreover, Anne must relate to her own childhood, which is represented by Sarah, the difficult, rebellious and troubled patient of Alix. Sarah, too, is in search of the mother. The relationships are, then, convoluted indeed, but seem invariably to take on ever more complex and subtle emotional responses to one another. Nevertheless, I will insist that a triangular configuration of the relationships is the dominant theme of the film, and is reinforced more powerfully by its visual content than by any amount of the dialogue.

VISUAL REINFORCEMENT OF THE TRIANGLE

We should begin our analysis of the visual content of *A.T.* by considering the names of the principals: both Alix and Anne have names that begin with A, a letter which, of course, contains at least one triangle. As our heroine becomes more and more obsessed with Alix as mother-figure in another—a(m)other—land, and as a potential lover besides, and as she paints endless designs on the walls of the studio, which has become her chief Artistic preoccupation, we cannot help but to notice that these designs revolve around the letter A. Moreover, these A's seem to be conjoined, to be a sort of constellation that figures and even consummates—vicariously—Anne's desire for Alix.

Prior to this, however, we have a scene in which Anne and Alix are preparing a model of the studio. The two women are seated on the floor, in the living room of the "A"partment that Anne and Alix are sharing. Behind them, in the background, is Thomas, watching a game on television. The composition of the scene is very telling! It forms a perfect triangle, in fact, if not also the letter A (Figure 1).

Figure 1. Anne, Alix and Thomas

Within this scene two important things occur: one is visual, one aural. In preparing the above-mentioned model of her studio, Anne is using a large triangle; she also makes the observation to Alix that they are like two little girls playing with their doll house. The statement is rife with significance: it highlights the mother-daughter relationship, the maternal drives of Alix, the sub-theme of Sarah and Alix, who together act out Sarah's longings for maternal sponsorship, and so forth.

In the next several scenes showing Anne working in her studio, we have a multiplication of these triangular patterns, borne out by the scaffolding and the ladders she is using, and a straight chair, the rungs of which play in the conceptualization of the designs she is putting on the walls of her studio, the studio itself having become both an objet d'art and a space wherein other art works are to be realized. Shadows on the walls and on the floor carry out the triangles. The ladder of the scaffolding, for example, throws off a shadow that reiterates the image (Figure 2).

As we have already said, Anne, obsessed with the desire for Alix, draws large, merging A's against the moresco background on one wall of the studio (Figure 3).

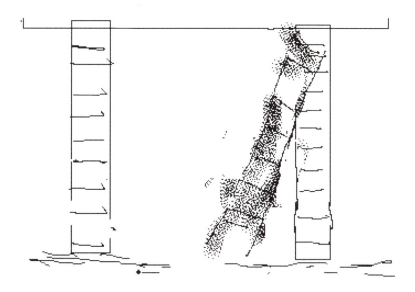

Figure 2. Scaffolding & Ladder

Figure 3. Conjoined A's

Lying on her back, as, like Michelangelo, she paints on the ceiling, the scaffolding and her back, propped by a triangular device, join together to make still another triangle (Figure 4).

Figure 4. Anne on Back

Ultimately beside herself, Anne makes advances toward Alix, who can give maternal responses (by making Anne some eggs, giving her a grapefruit, bringing her pizza and wine, wrapping her in a towel, comforting her over her lost art), but not sexual ones. Frustrated and in despair Anne, in the gesture of an editor, smears white paint over the conjoined A's (Figure 5), but is interrupted by Simon, who arrives to tell her that an artist cannot make judgments about a work that is being produced. The overlapping of life and art in the scene go unnoticed by Simon, of course. Anne, Alix and Art all three—another triangle— are obliterated, at least momentarily, by Anne's gesture. Still a few scenes later we will find that she has restored the two conjoining letter A's (Figure 6).

Figure 5. A's Obliterated

Figure 6. Re-Conjoined A's

Now, echoes of the triangular patterns are to be found in almost every scene in the body of the film. One may notice them in the V-neck shirts, the collars of sweaters and jackets, and in the scenes depicting the struggle between Alix—the psychiatrist—and her seemingly one and only patient Sarah, a very disturbed little girl who wants to maim her teddy bear, who seeks to fondle Alix's breasts, and who is clearly the *dédoublement* of Anne. For example, one scene in Alix's interview room shows Alix and Sarah with a tripod in the background (Figure 7), the function of which is not stated. (Professor Donohoe, during discussion at the Québec Film Symposium, suggested that the tripod, representing stability, indicates to the viewer that sessions with Sarah are being filmed.) But one should add that the tripod also alludes obliquely to the art of film and photography, which recurs at the end of *Anne Trister,* and which therefore affords a highly significant link with the preoccupations of *La Femme de l'hôtel.* It is to be noted, moreover, that the composition of the scene presents the same kind of arrangement we had with Alix and Anne preparing the studio model. And in yet another scene on the wall surface between and behind Sarah and Alix, a child's drawing of a rabbit with sharp triangular ears and a sharp triangular mouth occupies the central plane of the frame (Figure 8).

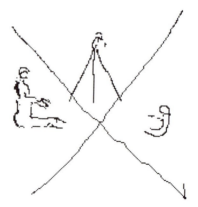

Figure 7. Alix, Sarah, Tripod

Figure 8. Rabbit drawing

 As I have said, when the camera shifts once more to her studio, we find Anne has restored the A's on the wall, and is continuing her work. In still another scene, she has gone to sleep, and a dove, which has gotten trapped in the studio, flies frantically about and then comes to rest on the paint-pot: the symbolism is clear, and the oneiric content begins to penetrate the film at this point. In subsequent scenes we may again pick up the triangular patterns in the bend of a leg or the arch of a knee, but they are especially evident in a car scene in which the two women struggle with their attraction for one another, while the ladder and triangle motifs are carried out behind their heads by the traversins or head-rests that loom large, while through the rear window one catches a glimpse of Montreal (Figure 9).

Figure 9. Car Scene

COMMENTARY ON THE TRIANGLE IN *A. T.*

The triangle, then, already announced as an earthly trinity, a three-in-one fusion of film star, director-artist, and the incarnate object of the glance—or the *regard*—in *La Femme de l'hôtel*, has by now become the subject of an intense meditation by Léa Pool, in this film about love and art. So much so is this the case that we are inevitably reminded of the fine Canadian animated short entitled *Notes on a Triangle,* and having reviewed this brief but elegant piece, we inevitably recall that the square, too, leads to the triangle when intersected. Can we conclude that in the scene where Thomas and Alix argue about Anne, the background, made up entirely of squares, conveys the message that the heterosexual love for which he argues is extremely "square"? One must leave this in the realm of speculation. Still, it is certainly of significance that all triangles and squares disappear into the background, as the two women decide to return to their male mates. Perhaps they do not have the strength to love beyond their fear. Alix makes clear to Anne that she is not prepared to commit herself to a lesbian lifestyle. That Anne settles for compromise and the Omega (what is the final stance—failed art, failed love and return, perhaps to errancy, certainly to circular patterns) is also clear.

Let us briefly explore that return. In the course of her stay in Montreal, Anne has been receiving tapes from Pierre. On one of them he tells

the story of Tom Thumb who, he says, moves back, through the ruins he makes, to his mother's womb. The story is, of course, assimilated to the story of Sarah, a type of Anne-as-child, who finally opts for a whole teddy bear, and to Anne herself, whose return to Israel, to the desert, follows an accident in which she falls and is hospitalized. (The fall itself can be taken on a symbolic level: already in *La Femme de l'hôtel* we encountered a strange piece of dialogue in which Andrea said, "You have the strength to fall, to live despair like the only hope that is still possible.") Does Anne have this kind of strength? this kind of despair? She is dismissed from the hospital, only to return to a decimated studio, which has been destroyed, to be replaced by condominiums, as a hallmark of urban progress and of the whole of Western civilization's triumph over personal, and especially women's art. Devastated at the loss of this work, Anne is comforted by Alix, who for once appears to respond to Anne's hungers, and even to her eroticism. Yet Anne decides to leave Montreal and Alix. (In some ways, we might contend that the question of lesbianism remains unresolved here, just as it does in *La Femme de l'hôtel,* as well as in *I've Heard the Mermaids Singing* and even in *Desert Hearts.* This lack of resolution might, it seems, be regarded as a hesitancy on the part of the woman director; but more likely it is simply a matter of mimesis, ambivalence in such sexual conflicts often being characteristic of true-life experiences.[10])

Anne's return to Israel, to the Orient, and to Pierre, who during his short visit to Montreal has been discouraged, but not permanently, by Anne's confession of her love for Alix, suggests that her search for a mother, as for another—a(m)other—land has either been completed or else has failed, and the latter is the more likely: the odds have been against her, both as an artist and as a would-be lesbian lover. More fundamentally, her return to Israel, like Tom Thumb's, is a return to the "mother's womb"—to the place of birth, to an earlier mother and to an earlier love (Pierre), and (it would seem) to a place where the sands and suns of the desert may heal the wintery landscape of Montreal. She is now filled with a relentless depression following these failures. The father's death has been digested, the search for feminine affection somewhat satisfied, or at least adjourned. Or is it? For she remains in contact with Alix, and sends her back off-center films of herself, and a bag of sand from the desert, which Alix has named as something she loves and craves. The desert is the new space of their understanding, no doubt. While the sexual square is re-introduced, a new, an ultimate triangle is nevertheless established, with the desert stretching between two motherlands; the desert, a space to be crossed, a place of healing, but also a place of sterility and loss. Will our heroine

resume her search and her travelling? Has she already? For even though she smiles from the frame, suggesting that she has successfully passed over the desert, has adjusted to her homelessness and despair, she is nonetheless now blocked by the frame—locked in the frame she abhorred and which was at least temporarily subverted by the triangle. She seems now to be the trapped dove of an earlier sequence, that dove being a symbol of the trapped madwoman we saw through the *chanteuse,* who in the film-within-the-film mirrors the equally caged existence of Estelle in *La Femme de l'hôtel.*

And, besides, we do not know who is taking those pictures sent back to Alix, nor what the real locus of their origin is. We do not know whose *regard* or glance is fixed upon her; we do not know who the spectator is. We do not know if Anne has conquered her longings for the mother figure, the mother substitute, "the older woman," Alix, but we must assume not. Certainly in *La Femme de l'hôtel* her counterpart Andrea does not forget "the older woman" Estelle, perhaps her alter ego, perhaps a mother figure, but, if so, one she conversely seeks to nurture at times. ("Have you eaten?" she asks her.) Role playing and role reversals abound in these two films.

This is the note upon which the film ends: the Orphaned, Alienated, ever-wandering, unappreciated woman Artist and the mother-hunter has reached Omega, which is circular, never ending, womb-shaped, ever reinitiated, and which ironically is, as it were, also Alpha—the Alpha and the Omega being, in the final reckoning, undifferentiated because indistinguishable. Anne Trister, ever Triste, *Anne artiste, Anne Triste erre* (ever errs or wanders), Anne Triste, *Femme errante . . . Juive errante.*[11]

Still this departure on my part into ludic linguistic fields is not legitimate, for having established at the outset of my segment on *Anne Trister* that the film was above all a visual work, we must abide by that assertion here.

CONCLUSION

By way of a conclusion to this long discussion of Pool's gynefilms, we might say that *La Femme de l'hôtel,* a film about the making of a film, shows us not only how the myth has invaded the sign, a danger to the art film, according to Johnston,[12] but also how the icon or the sign invades the myth and even becomes preeminent, just as it does also, and even more forcefully, in *Anne Trister.* And be it also said that these films are no more innocent of the workings of myth than are the films of Agnès Varda, though Johnston, in her fine article on Lois Weber and Dorothy Arzner, has mistakenly claimed that Varda's films—especially *Sans toit ni loi*—are so.[13] In either of the two pictures by Pool explored in this paper, the narrative and its incarnation through the

characters, e.g, the mythic content, are less important in and of them-
selves than the far more singular fact that woman, not man, is the visual
center, as well as the mythic center of the film universe; and in either
film the love object, as well as the lover-spectator, also, is woman. The
substitution of woman as spectator reshapes all stereotypes, and infuses
them with new and creative blood. Both films insist, then, on woman's
centrality; and both show the traces of the *auteur(e)* or director-marked,
director-controlled tradition: one supposes both films are based on per-
sonal experience, perhaps the same experience, which provided the same
thin plot and the same portrayal of an almost solipsistic despair present
in the two films. Both are heavily gender-marked. Both are what Johnston
calls "counter-cinemas." Both are films manipulated by a woman who
has considered stereotypes and rejects them. Above all, Andrea, like Pool,
is in the position of power: she may prohibit the camera from freezing
woman in stereotypical images; or she may instead exploit the stereo-
types of the mysterious, unknown and unknowable woman ("Qui es-tu;
d'où viens-tu?" asks Andrea; and she might have switched the pronoun
and asked: "Qui est-elle?") Andrea, like Pool, might introduce the fixed
symbols of train, door and triangle, but arrange them or apply them in
unfamiliar ways that have undergone reshaping, or better, redirection,
rather than, as some would say, subversion.

The conclusion of *La Femme* postulates the proposition that reality
is stronger than the imagination: Estelle, the woman Andrea meets in
the hotel, is the embodiment of her creative efforts ("Elle est ce que
j'ai voulu montrer"). And for Estelle, Andrea's assumption of her most
intimate person by and into Andrea's creativity constitutes a theft. But
what a blessed theft! For the centrality of woman in Pool's art world
and the internal criticism of, as well as the refashioning of, stereotypi-
cal states and symbols that her films contain make of these two films
superb (but not necessarily entertaining) gynefilms, films for, by and
about women; films that reach beyond the scene of Quebec to strike
a chord of recognition in women everywhere. Nor has Pool found it
necessary to include a cat in either of these films in order to make this
so.[14] With her portrayal of the intimate through script and through
camera, she will remain in the vanguard of international feminist film-
makers for some time to come.[15]

<div align="right">Bowling Green State University</div>

NOTES

1. This film does, incidentally, portray the wings of desire better than Anne
 Hébert's somewhat sordid and certainly conventional novel upon which
 it is based, perhaps because of interspliced clips of the stunning *morus bas-
 sanus,* or northern gannet, shown in positions of flight, or with beak up-
 ward as it seeks the currents and poises to take flight.

2. Léa Pool's filmography includes an earlier avant-garde film, *Strass Café* (1979), which has not been considered in this paper.

 Pool is, as I note in my text, not a native *Québécoise*. She is from Switzerland, and so the final departure of the heroine in *Anne Trister* for a trip to Switzerland, where she will be reunited with her boyfriend, may, like other factors in the film, be somewhat autobiographical. Her lack of *québécois* content has been the focus of some criticism; yet we may call this a *québécois* film, since many if not most of the collaborators on Pool's film are *Québécois*—and by now she herself is, as well, a citizen, in deed if not in fact, of that province. In another sense, we might call any of her works made in Québec "French" films, since they are made in the French language, and "international feminist films" in the way that Nelly Kaplan's film, *Néa*, filmed in Switzerland in the French language by a French Jewess, and dealing with similar identity crises, could be called "international."

3. In view of the preoccupation with film that *La Femme* offers, it is important to note Léa Pool's claim, in her interview with Aaron Bor (relayed at the Québec Film Symposium in East Lansing, and later published *Québec Studies* 9 [Fall-Winter 1990]: 63–68), that American film has not influenced her. Clearly, she could not avoid such influence, if only subconscious. But even more telling are the marks of the Garbo tradition on *La Femme*: the mysterious woman whom Andrea seeks to show in her film is even supposed to cherish her solitude in true Garbo fashion, as I have shown in my text.

4. Specifically by Mary Jean Green in a paper at ACQS (1987) in Québec City (later published in *Québec Studies* 9 [Fall 1989: 49–62]). In this paper she also argues for the "inscription" theory, discussed at a later point in my text. Unless otherwise noted, citations within the text refer to the film under discussion.

5. Léa Pool herself maintained this in an interview she conducted with Suzanne Gaulin ("Pool's Splash", *Cinema Canada* [October 1984]: 8). Here she is quoted as having said: "The three women, in my view, make up a fourth, who is the woman." Then, among other things, *La Femme de l'hôtel* represents an effort to define woman, the essence of woman, and this effort to define woman is continued in *Anne Trister*, where, as will be seen, there are similar *dédoublements* of the three main female characters.

6. The themes of marginality and alienation as Jew and as a woman are more strongly underlined in *Anne Trister* than in *La Femme*. Even though Estelle says to Andrea (Richler): "Vous êtes juive?" the fact of the question tends more to function as a moment of "recognition," than to draw attention to a "marginality." Put another way, the question established a common ground between the two women, so that their difference—from the majority of other *Québécoises*—is shared. The place of Jewish beauty in the history of film is of prime bearing here as elsewhere and the exquisite face of the Viennese Hedy Lamarr (Hedwig Eva Maria Kiesler), whose acting abilities were somewhat limited, may serve as one example among many. Curiously enough, the external spectator—unlike Andrea—may not always be aware of this ethnicity, but only of an aura of exoticism. Consequently, this ignorance liberates his/her scopophilia from any religious/racial taboos or

prejudices. Andrea Dworkin and others have studied the fate of the Jewish beauty in society and in art at great length and with some very revealing results; their studies include the particular victimization of her by the Germans during the holocaust.

7. *Torn Sprockets,* 264.
8. *Macleans* (September 15, 1986): 44.
9. *Spirales* (Summer 1987): 8.
10. This lack of resolution regarding the lesbian issue raised by *I've Heard the Mermaids Singing* appears to be a condition of the film that disconcerts Cameron Bailey. See his review in *Cinema Canada* (November 1987): 25.
11. Not too surprisingly, expatriot sentiment and the strong sense of exile are not unusual themes in feminist films. Particularly in the *Québécoise* Marilú Mallet's *Journal inachevé* (1983), exile is the primary theme that links all the stories and substories to all of the characters, who are faced with the problem of choosing a "place" in which to "settle down" or "put down their roots." In this picture we also have the theme of the woman filmmaker, seen in *La Femme de l'hôtel.* Mallet's depiction of the theme has the arresting dimension of portraying husband and wife, both of whom are moviemakers, in conflict not only on the gender level, but also on the level of art: they are, so to speak, going in opposite directions. Mallet herself describes the film as "une recherche sur l'expression de la culture des femmes" in her "notes sur *Journal inachevé*," in *Femmes et cinéma québécois,* ed. Louise Carrière (Montréal: Boréal Express, 1983), 264.
12. Claire Johnston, in *Movies and Methods,* ed. Bill Nichols (Berkeley: University of California Press, 1976), I, 210.
13. Varda and Pool have the theme of wandering in common. One might pose the theory that Varda is marked by her Greekness, while Pool is also marked by her ethnicity. Both are Eastern Mediterranean types and Varda's central figure in *Sans toit ni loi* is not the truant woman or the errant (aberrant) woman she is sometimes said to be, but a type of the female Ulysses in reverse, i.e., wandering away from home rather than wandering in search of home. (Varda's film was unfortunately called *Vagabond* in English, thus putting emphasis on a false reading of some strain of truancy in Mona, rather than on her elective homelessness.) Andrea in *La Femme,* does not "feel at home": "je ne suis pas chez moi" is a recurrent phrase in the film. *Anne Trister* is an Eastern Mediterranean who attempts to go West; she seeks self-discovery through voyage, and especially through the act of overthrowing the bourgeois future that threatens her with depersonalization, just as does the *chanteuse* in *La Femme.* Sybille Ashby, the precocious neophyte and the central figure in Nelly Kaplan's *Néa* avoids an impending bourgeois existence through writing and sexual exploration; Mona, the central figure of Varda's *Sans toit ni loi* also overthrows this threat, leaving the "security" of her job and abandoning herself to the elements, to the out-of-doors, to male space. One might make a similar statement about the peasant girl played by the beautiful Bernadette Lafont, in Nelly Kaplan's *Very Curious Girl,* and, no doubt, about many feminist films. At the end of Rozema's *I've Heard the Mermaids Singing,* a film that seems to subvert Prufrock's desperate monologue, Polly (the true artist, one who as a photographer is a seer,

and one who lives in a solitude similar to the Pool character) indicates to the two lesbians—false artists if ever there were any—the preferable value of awakening to human voices but not drowning in the process: she shows them the superior beauty of nature as subject. (It is not clear whether this presents a solution or resolution to the sexual connotations of the film or not.)

14. A somewhat facetious statement, based on the viewing of dozens of films by women directors from Lois Weber, to Germaine Dulac, to Alice Guy Blaché to Kaplan, Varda, Pool, and a host of other gynefilms from a wide range of countries, in many of which the cat seems to be an almost inevitable presence.

15. Lynne Fieldman Miller, editor and interviewer of *The Hand that Holds the Camera* (New York: Garland, 1980), writes: "The women sometimes use work created by others or sometimes write their own scripts based on auto-biographical material or the lives of others. But always the choice is to work with personal and intimate thoughts, feelings, and experiences of women in dilemmas that are specific and transcend the specific. . . . This selection of personal material often characterizes the best of the work of women filmmakers and video artists, whether they are independent filmmakers or filmmakers who produce feature length films." Though Miller scarcely has Pool in mind, the passage applies to Pool's work, as it treats her own observations on *les désordres de l'amour* most uncannily.

PART IV

PERSPECTIVES ON INDIVIDUAL FILMS

1.

LE MATOU,
TIGER IN DISGUISE?[1]

Richard Vernier

Even a superficial reading of Yves Beauchemin's bestseller, *Le Matou/ The Tomcat,* suggests that the idea of a film or television adaptation may have lain all along not too far in the back of the author's mind. In fact, a superficial reading may be the only one possible for *Le Matou,* which was awarded in 1983 the appropriate *Prix du Livre d'Eté.* The story is crowded with fast-moving episodes, surprises, and cliff-hangers, the dialogue exploits all the colorful resources of the Montreal street vernacular, but the characters and their milieu are barely delineated, mere sketches awaiting the actors and the camera work that eventually did give them substance and dimensions. For as it happens, Yves Beauchemin's success was so complete that his novel was realized both as a feature and a television miniseries. But how realized, to what extent interpreted, transformed? We shall see that, just as it fleshes out the characters and gives sound and color to the back alleys of Montreal, the filmic treatment also reveals, often more clearly than the written page, some of the intentions and meanings dormant under the surface of the novel. However, since I have not seen the television series, I shall discuss only the theatrical film version of *Le Matou.*

In all three versions, book, film, and television series, the narrative can be boiled down to a common synopsis: a struggling young *Québécois,* Florent Boissoneault, helps the victim of a street accident. An old man who has observed Florent offers to help him realize his dream of owning a restaurant: the mysterious Ratablavasky knows not only Florent's secret desires, but also the exact amount of his savings account and other details of his private life. Thanks to Ratablavasky's limitless knowledge and influence, Florent and his wife Elise soon acquire "La Binerie," a modest restaurant, little more than lunch counter, but known for its traditional *québécois* fare such as *tarte aux fèves, pâté chinois,* etc. All would be well,

Cinémathèque québécoise

Le Matou

but there is a snake in the grass: Florent has accepted the financial partner-
ship of his *Anglo* friend Slipskin, who is eventually revealed as a tool of
Ratablavasky's occult power. Slipskin puts barbiturates in Florent's lunch
and so tricks him into believing not only that he is dangerously ill, but that
the cause of his illness lies in the overwork and stress that come with the
ownership of his restaurant. Completely demoralized, Florent sells
"La Binerie" to Slipskin for a fraction of its worth. Meanwhile, the
Boissonneaults have more or less "adopted" a loud, offensive, and alco-
holic street urchin who insists on being called *Monsieur* Emile and is
always accompanied by a large tomcat—the *Matou* of the title—named
Déjeuner. Depending on the version, there are long and short variants
of Ratablavasky's persecutions and of the Boissoneault's attempt to
recover their health and some of their vanished prosperity. In the end,
Florent gets his revenge by opening a successful restaurant opposite "La
Binerie" and playing a few dirty tricks of his own. Slipskin is routed, forced
to close his establishment. But monsieur Emile, in drunken pursuit of
Déjeuner, falls to his death in an "accident" in which we more than sus-
pect the hand of Ratablavasky, manipulating the tomcat.

 The superiority of the film to the novel is clear enough: characters
no longer speak in throwaway lines, but define themselves in deed as

well as in speech; the dialect is used as a support to the narration, rather than a picturesque but distracting ornament, etc. Esthetic evaluations are less important here than the choices made by the filmmaker, with the omissions or the added images that turn a diffuse and on the whole unconvincing narrative into a coherent, yet equivocal allegory. Some of the discrepancies between the filmed and written versions of *Le Matou* have to do with genre or format, and concern mostly episodes and characters retained or eliminated. In the novel, for instance, a lengthy episode takes place in Florida, where the Boissoneaults, in a futile effort to escape Ratablavasky's persecution, seek refuge with Florent's rich and eccentric aunt, Madame Jeunehomme. While the theatrical feature completely suppresses this episode, the *dossier de presse* provided by the production company Cinévidéo, Inc., lists the French film star Madeleine Robinson in the part of Madame Jeunehomme: it seems that the Florida chapters have been included in the mini-series. If this is the case, generic imperatives can explain the difference: a more compact version for theaters, an expanded one for television. However, Madame Jeunehomme's son, an absent-minded, literary young priest, seems to have been dropped altogether from both screenplays.

Again, structural explanations can be found: in the novel, the Abbé Jeunehomme is an episodic character who floats in and out of the story, one of many in an odd collection of colorful, often amiable but at best two-dimensional misfits. But it can be argued that the film retains such characters—for instance Florent's friend Ange-Albert, or the newspaper-man Rosario Gladu—who are no more indispensable to the plot than the easily forgotten abbé. We could even go so far as to say that, at least in the film, the title character—the tomcat, *Déjeuner*—serves no sustained narrative function, for the climactic scene of the novel, in which the cat claws Ratablavasky's face to a pulp, is omitted. Instead, Ratablavasky is figuratively bloodied by the explosion, engineered by Monsieur Emile, of several institutional size cans of tomato sauce. It also prevents the expenditure of misplaced sympathy toward Ratablavasky: the sight of an elderly gentleman being savagely clawed, perhaps blinded, is pitiable, no matter how much we despise him; the same old villain covered with tomato sauce is merely grotesque. In any case, the cat is no longer an agent of retribution, and yet the opening shot of the film is of Monsieur Emile carrying his cat, and the last image is the silhouette of *Déjeuner* sitting in the Boissoneault's window: while the family is toasting the birth of Florent's and Elise's first child, only the cat sees the ominous, indestructible shadow of Ratablavasky. If the rôle of *Déjeuner* is an indication, it may well be that the characters of *Le Matou* are not only actors of the drama, with specific functions relating to plot and/or situation—protagonist, supporting cast, comic

relief, Greek chorus, etc.—they are also living signs and symbols who may be read singly, or in combination, or in opposition to one another.

The simplest and most easily read of these allegories centers on the business relationship between Florent and Slipskin, his English-speaking fellow employee who takes economic control of the young *Québécois,* his life, and his dreams. The identification of Slipskin with the insidious imperialism of Anglo-American capital is obvious enough. So is the operation, only too familiar to the *québécois* public, whereby he takes "La Binerie" away from Florent: a seemingly innocent, initially useful Anglo investment becomes a controlling interest in a Quebec enterprise. The point need not be labored further. However, the symbolism becomes more subtle when it concerns, not the domination of the French by the English, but their corruption by Anglo-American influences. Where the novel can make much of the way Slipskin, having conquered "La Binerie," subverts its traditional *québécois* menu and turns it into an American diner, the film finds a more visual resource in the leering, greedy face of Rosario Gladu. As he and Slipskin strike an instant friendship over the reporter's collection of pornographic photos and adjourn immediately to a go-go bar, Gladu appears as the sort of pimp who, in occupied countries, panders to the enemy. Let us note in passing that Slipskin's facial pantomime of uncontrolled lechery rounds out his character, confirming that the corruptor is himself completely rotten. But for Gladu at least, there is the hope of a redemption of sorts as in the end he aligns himself with Florent: the fly-by-night reporter uses his dubious connections to serve his compatriot's revenge by arranging to bribe a health inspector to close "La Binerie." Thus Gladu, by changing sides, sheds the image of the servile *maquereau,* and we are made to see his corruption as the guerrilla cunning of the oppressed, working in its own dirty but lovable way for the good cause.

A more tragic aspect of this allegory of corruption concerns the case of Monsieur Emile. The child is abandoned to degradation by his mother, a night-club entertainer whose talent seems to be largely defined by her physical measurements. She is evidently too busy entertaining men— especially loud Americans—to care for her son. Indeed, Madame Chouinard's irresponsibility is an operative element of the plot, as in her haste to fly off to a Florida vacation with a coyly improvised "uncle," she leaves Monsieur Emile in the care of the Boissoneaults. Thus the bond is strengthened between the young couple and the back-alley brat whom we see, in Elise's maternal embrace, as the vulnerable child he really is. Still, Madame Chouinard's ineffectual love is sincere. Significantly, in both the novel and the film, we never see her and Monsieur Emile together, and yet when at the end she blames Florent and Elise for his death, she is not so much odious as pathetic, for although the injustice of her resentment is obvious, she has somehow touched the raw nerve

of an ironic truth: it was Monsieur Emile's involvement with the clean-living, caring Boissoneaults that marked him as a victim of Ratablavasky.

And so, as we read the allegories, we are left with the eternal question: who is to blame? Madame Chouinard, whose abundant flesh is all too weak, or the American who offers her two weeks in Miami? Gladu, eager to sell his postcards—and who knows what else—or Slipskin, even more eager to buy? If we were allowed to spin out only the socio-political, cultural, and economic interpretations of the story, the answers could probably be tied into a rather neat package, all loose ends tucked in. But we are not allowed to forget the presence of the Devil, who has ways of multiplying dimensions and questions.

Le Matou

At first glance, the Devil and his helper are very easily identified. Ratablavasky is openly characterized often enough in both film and novel as a diabolical being, endowed with mysterious, perhaps super-natural powers, hinted at by the existence of a coded book, amulets, etc. As for Slipskin, his very name evokes the snake in the Garden of Eden, who slips at will out of his skin, and Miguel Fernandez lends him in the film the most villainous saurian face since Jack Palance. But

Ratablavasky is more complex. His name begins to alert us, as a grotesque variation on that of Madame Blavatsky, the late nineteenth-century Russian theosophist whose writings are said to have influenced W. B. Yeats's turn to mystical speculation. One notes also that, while the one and only priest in the novel, l'Abbé Jeunehomme, provides nothing more than a rather ineffectual comic sideshow, he is dropped altogether from the film, leaving no representative of a priesthood that was until very recently the most conspicuous, and appeared to be the most powerful, *corps de métier* in Quebec. In the film, however, Ratablavasky always appears in almost clerical garb: not only does he wear an old-fashioned black cloak and a black hat of unusual shape, black shoes and gloves, and a stiff collar, but his speech and his whole manner exhibit the kind of composure that in earlier times was identified with *onction ecclésiastique*.

Who is Ratablavasky then: a fiend, or a priest? The conjunction of the two is not impossible, and there is of course a well-established tradition of the "Bad Priest," especially in French Romantic literature, where the Archdeacon Claude Frollo of Victor Hugo's *Notre-Dame de Paris* comes to mind as the most monumental example of the species. Since Ratablavasky never takes on the kind of vibrant intensity that makes Frollo such an explosive package of self-contradictions, it would be tempting to see him only as an allegorical figure. In keeping with some of the more simplistic anti-clerical manifestations of the post-*Révolution tranquille* culture, he could be seen—especially on the screen—as an image of the Church as it conspires with the temporal powers of Anglo-American capitalism to keep the souls of the *Québécois* away from the temptations of this world by denying them material success, and even the control of their own economic destiny. But then, why should Ratablavasky entice Florent and encourage him to enter into a business venture, unless he is the Devil, whose function it is not to forbid or punish, but to tempt mortals into sin? Although his appearance and his manner suggest the ecclesiastic, Ratablavasky's actions and his quasi-supernatural powers suggest even more strongly that he does not serve a merely topical allegory. He is more appropriately seen as an incarnation of several ancient ones, the Tempter, the Trickster, and the Ogre of such traditional folk tales of prowess and adversity as *Jack and the Beanstalk* or *Puss-in-Boots*. These come to mind easily, especially the latter one, in which the hero owes his victory and his fortune to a resourceful tomcat. In *Le Matou*, however, the hero achieves only a partial victory, and this ambiguity is what keeps the story from being a fairy tale: Monsieur Emile dies, Ratablavasky's shadow haunts only the cat—but for how long?

The answer may simply depend on Florent's wisdom, on what he has learned, through his long ordeal, about the ironic permutations of good

and evil. His adventures began with an act of mercy: for this he is apparently rewarded by Ratablavasky's first intervention, which promises the imminent, miraculous realization of his young dreams. But we must remember that very soon afterward, at the very moment when he has just overcome his very understandable apprehensions toward the old sorcerer, he falls from grace: under a vague pretext, Ratablavasky has left him alone in his hotel room with a bottle of cognac . . . and the maid. The filmic treatment of the scene—casting, makeup, and photography—makes it quite clear that this is not just a chambermaid, but the sort of sultry, sulphurous temptress the Devil places in the path of questing heroes. Much later, the incident serves a dramatic purpose and finds its function in Ratablavasky's complication plot, when a photograph turns up, in which a woozy Florent is all too easily recognized as the chambermaid's passive sexual partner. Elise's reaction is so violent that for a moment, that stability of the Boissoneault's marriage is seriously threatened. The incident emphasizes the contrast between the young couple's playful, almost innocent sexuality, and the gamy lechery that seems to prosper in the wake of Ratablavasky's progress, first in the chambermaid episode, and then in Slipskin's appetite for pornography.

But Florent's almost accidental infidelity may also serve as an emblem of his more fundamental "sin," which is the sin of the new, modern Quebec. For, by going into business, by achieving a measure of commercial success, it has transgressed the limits imposed by a Church-sponsored tradition upon an agrarian, almost sacrificial French-Canadian society. The ethical gap between the Boissoneaults and, for instance, a Maria Chapdelaine, is vividly illustrated in *Le Matou* by the Sainte-Romanie episode, where the two young *Montréalais* descend on a remote village of the Eastern Counties. Posing as agents of the railroad, they ensconce themselves in the disused station, dangle before the villagers the prospect of resumed service, and, having thus gained their confidence, buy their "unwanted old furniture" at junk prices. Needless to say, Florent and Elise make a fast and handsome profit from the resale of valuable antiques: they have in effect swindled their rural compatriots. Although less crudely than Gladu as he panders to Slipskin, they are nevertheless engaged, just as he was, in exploiting their own people and liquidating their heritage. Thus, the sin of going into business is compounded with cultural betrayal and plain dishonesty.

Or so it seems. And yet, neither Beauchemin's novel nor Beaudin's film inject the slightest hint of a moral judgment: the Boissoneaults play their profitable prank with great self-satisfied gusto and no one, not even their cook and mentor Picquot, sees anything wrong with the swindle. Nor is there in either version a trace of nostalgia for the vanishing values of *le vieux pays,* its slower pace, its spiritual security. The disorderly proliferation of the book, the fast pace of the film, both proceed from

an exclusively urban, modern sensibility. The primary site, the world where things happen, is Montreal, not the monumental, airy, chic city beloved of tourists, but the back alleys where the struggle for survival takes place. Sainte-Romanie was only an excursion, its villagers are portrayed as bumpkins whose own naive greed deserves exploitation, and the end, viz. the restoration of the Boissoneaults' capital and their victory over Slipskin, justifies the means. Such is very clearly the view of the author, briskly illustrated by the film director. Balanced on the scales of his personal allegory between success and innocence, Florent Boissoneault, himself emblematic of a new, tougher, perhaps more cynical and yet buoyant Quebec, learns the hard way that, even at "La Binerie," there is no free lunch. Against great odds, he and Elise prosper in business, thus exorcising the tradition that made business a sinful activity *ipso facto,* best left to the Slipskins of the world.

But it is true that they succeed at a terrible cost, and perhaps Madame Chouinard is right to blame them for the death of her lovable, derelict child. Who knows? Who is to blame? Will the Devil, that old terror of pitch-dark rural nights, always be with us, even in the city of perpetual bright lights? Only the Matou knows, and he is not telling.

Wayne State University

NOTE

1. Yves Beauchemin, *Le Matou* (Montréal: Québec-Amérique, 1983), and *Le Matou,* a film by Jean Beaudin, screenplay by Lise Lemay-Rousseau. Produced by Cinévidéo, Inc., with the participation of the Société Radio-Canada and with the financial assistance of La Société de Radio-Télévision du Québec, Telefilm Canada, and La Société Générale du Cinéma.

2.

THE DECLINE OF THE AMERICAN EMPIRE IN A NORTH-AMERICAN PERSPECTIVE

Adrian Van Den Hoven

It is our intention to look at Denys Arcand's film from two different angles. First, we will compare and contrast it with the American feature, *The Big Chill,* which functioned as its model, and then we will reinsert *The Decline of the American Empire* into a Quebec cultural context in order to illustrate how it uses certain well-established stereotypes in order to make a point about present-day middle-class society in Quebec.

The Big Chill came out in 1983 and featured actors such as Glenn Close, William Hurt, Meg Tilly, and Tom Berenger. Their characters meet on the occasion of the funeral of Alex Marshall, a fellow classmate from the University of Michigan, who has committed suicide. Alex's death, we shall come to appreciate, symbolizes the end of the dreams of the 1960s generation.

The survivors decide to spend a couple of days together at Harold and Sarah Cooper's place to discuss their past, present, and future. Nick has been left impotent by his Vietnam experience and has acquired a drug habit. Sam, now a famous TV actor J. T. Lancer, keeps reminiscing about his ex-wife and his daughter. Meg is still not married but wishes to have a baby and is looking to one of the men to impregnate her. Karen is unhappily married and would like to run off with Sam. Hope, happiness, and expectations mean little or nothing to them anymore. The dream of changing their own lives and those of their fellow Americans has faded. They have compromised themselves and given in to the lure of money and success. But unlike Alex, the suicide, none has given up completely. They still talk about writing that novel, reaching out to people, and finding love; and each one has an individual solution to his dilemma. In fact, the individuality of the characters and of their behavior is probably the biggest difference between *The Big Chill*

Cinémathèque québécoise

Le Déclin de l'empire américain

and *The Decline of the American Empire.* These eight or nine Americans may well share a common college background and certain ideals, but their lives have taken divergent paths and they no longer think and act in unison. On the other hand, the characters in *The Decline* are like a large family. They act as a group and, with the exception of Mario, "the jeep-driving stud," are obviously compatible with one another. They talk, think, and behave in a like manner, because they have travelled down the same road together.

However, *The Big Chill* remains as a model for *The Decline* in other ways. First of all, each places a group of similar people together for a time and allows them to talk about themselves, each other, and their lives. *The Decline* may also have borrowed the idea of the pseudo-intradiegetic narrator from *The Big Chill.* Michael, the writer for *People* magazine, intends to write a novel about the weekend, the sort of thing he has been intending to do for a long time. We never see the novel, but we do have the filmplay. In addition, the characters put themselves on video and watch each other on TV. In *The Decline,* the script also appears to flow naturally from the opening scenes, in which Dominique St. Arnaud, the author of a historical survey on happiness, is being interviewed and taped. *The Big Chill* serves as an obvious inspiration for certain other scenes: the beautiful sunrises

in the country, having dinner as a group, and dancing together while doing the dishes in the kitchen. In addition, the characters in both movies share a common middle-class preoccupation with food, jogging, and trendy cars.

All the same, after viewing both films one remains more conscious of the differences between them than of the obvious similarities. This is because these movies are very much the products of their respective societies. The Americans have a certain casualness and looseness about themselves, qualities that bring out their individuality and self-assurance. *The Decline* is a much more carefully choreographed and tightly knit work, the obvious reflection of a homogeneous culture and of a more harmonious society.

What makes a comparison between these two movies so fascinating is the fact that they illustrate the dominant but also confining roles of culture, economics, politics, and the language of the cultural elite. For example, in *The Big Chill* the talk is of conglomerates, [qua]ludes, Vietnam, herpes, and surrogate motherhood. These people, however much they regret the loss of innocence and idealism, are well integrated into their society, because they are in fact its motor. Divorce, drugs, and impotence notwithstanding, it is their occupations, their wealth, their toys, and their clothes that count ultimately. These good-looking people are the image makers of America. They are into TV, videos, pop psychology, healing, social work, and real estate. They jog, eat health food, and drive Jeeps, Porsches and Mercedes-Benzes. If these people are all surface and possess no depth, it is because America itself has changed into a giant image-producing machine.

When America lost the war in Vietnam, it did not lose the war against communism but against the leaders of its own industrial and military complex, who had convinced the American government that more and bigger guns, and more and bigger bombs and bombers could crush anyone and anything. They devastated Vietnam; yet in the process they destroyed not Vietnam's spirit but the *raison d'être* of an entire generation of Americans that they left, in ethical terms, stranded high and dry. These remarks are not intended as a moral judgment on the characters' lifestyles, but rather they are intended to underline the ultimate relationship between productivity in the economic sphere and creativity in the psychic realm. To simplify, it could be said that these men and women sit around with nothing to do but spin words and weave images, because the really important work is being done elsewhere—in the Far East, in Europe, and, as well, in America's munitions factories. Then again, in *The Decline* the talk is about the polymorphous perverse, shapely bodies and their appendices, AIDS, and food. After all, its characters are all professionals who have been perfectly protected from the vagaries of Quebec's "yo-yo" economy. These historians are the lucky

Cinémathèque québécoise

Le Déclin de l'empire américain

recipients of Quebec's nationalist policies for which a class of sages and interpreters was required. They possess the best collective agreement in the country and are so well coddled that they create the impression that they are Quebec's exclusive inhabitants. Their obsession with their own personal health and happiness is not necessarily a sign of the decline of the (North) American empire, but it is symptomatic of the navel gazing of a particular class of professionals, which has been deluded into believing that only they and their preoccupations matter.

When *The Decline* appeared it was touted as a candidate for the Academy Awards Best Foreign Film of the year. It lost out to the Dutch film *The Assault*. That film reconstructs, in a series of flashbacks and flashforwards, the story of a young Dutchman's involvement in the horrors of the Nazi occupation, its tragic aftermath, and the present-day nuclear menace. Three films, three attempts to come to grips with present-day reality. The Dutch film takes in a span of forty years. *The Decline*, which did win the 1986 Cannes International Film Critics Award, uses five males and four females of different ages and with different attitudes in order to characterize the generation gap. With the exception of Mario, the crude leather-jacketed, beer-drinking, and *joual*-speaking Jeep driver, the other characters are all members of the professional class: they are historians at the University of Montreal. The females frequent sports centers, the males prepare gourmet dinners at

country homes. With the exception of the fact that we are dealing with Francophones, this movie could have been made in any North American urban center that possesses a university, a sports complex, and a nearby lake and cottages. In other words, middle-class Quebec has arrived and is now largely indistinguishable from the rest of the continent. This is the main point that the movie makes through the setting and the characters' obsession with personal happiness and immediate gratification; indeed, *The Decline* makes this statement over and over again by barely letting the outside world intrude into the characters' concerns.

Let us now glance at the characters: Mario functions as the latest incarnation of Quebec's primitive male, the *coureur de bois*, or François Paradis updated, but it is Diane who is the dominant partner in their sado-masochistic sexual encounters and who wishes to go further and further down the road of pleasure and pain. Remi's wife, Louise, plays the traditional housewife, and Remi, his philanderings notwithstanding, wants to be a traditional husband and father. His colleague Pierre, and Danielle, his young cohort, who is a part-time masseuse and history student, play the more sophisticated couple who are already perfectly

Cinémathèque québécoise

Le Déclin de l'empire américain

at ease in the polymorphous perverse society of today. Dominique St. Arnaud is also a history professor. She has slept with many men, including Remi, Pierre, and the graduate student. She is the author of the book *Variations upon the Idea of Happiness,* which sets the tone for the film and provides its leitmotif. Claude, the handsome homosexual colleague, plays a relatively low-key role. He had peed blood twice and is worried about coming down with AIDS. The pursuit of males brings the animal out in him. He is aware of the inherent dangers, but those are part of the hunt and he abhors the idea of a simple domestic arrangement without adventure, the chase, and the surprise encounters. At the end of the film, when Remi's wife overhears Dominique talk about her husband's multiple sexual escapades, only the male graduate student still retains illusions about love and romance.

These people live at the edge of the American empire and hence they are somewhat shielded from the side effects of the chemical, nuclear, and environmental manifestations of its industrial and military complex, but they cannot escape from time altogether. Remi needs sleeping pills after Dominique has spoken openly about his unfaithful behavior, Danielle is on the pill, Louise is emotionally overwrought, and all are worried about a potential nuclear holocaust.

This is also a very verbal film. Admittedly there are many flashbacks to acquaint us with the kinds of sexual behavior in which the characters indulge, but these sidetrack us only temporarily. We regularly return to the main storyline: the discussion of male and female middle-class Quebec sexual mores.

The movie's portentous tone becomes evident from the second scene, which opens with the female history professor, Dominique St. Arnaud holding forth in a taped interview about the obsession with personal happiness in declining empires—the Roman Empire of the third century, France in the eighteenth century, and the present-day American empire—and when the sun begins to rise at the end of the movie we have been persuaded that happiness is indeed a very momentary and fleeting phenomenon.

The Decline possesses the tightly knit structure of neo-classical French drama, but through the use of flashbacks it also exploits the possibilities of the screen. The unity of the action is always very carefully preserved, the unity of time is also preserved in the sense that, if one leaves aside the many flashbacks, the action can be said to have taken place in twenty-four hours. The unity of place is symbolically preserved. Admittedly, locales other than the country home and sports complex are used, but we never really stray beyond the sophisticated urban and suburban setting that represents the boundary of their professional and social lives. In other words, the movie manifests a great economy of means in order to drive its message home and that is both its strength and its limitation.

The Decline is of course a very literary film. It functions within the confines of two intertexts. The first one is the book that sets the tone for the movie, Dominique St. Arnaud's *Variations upon the Idea of Happiness*. In the taped interview the author provides a broad historical framework for the movie as well as a thesis. All empires eventually decline; now it is America's turn. Canadians, living on the edge of this empire (does this make them a peripheral people?), become the privileged observers of their powerful neighbor's decline. Toward the end of the movie, Mario, the monosyllabic, *joual*-speaking, sadistic lover, gives Diane a present: Michel Brunet's *Our Past the Present and Us*. Implicitly, this book provides the Quebec context for this film. The book seems to say that the following has happened to Quebec society: it has gone from an austere church-going society, where every family was large, and where many women died in childbirth, to a society where everyone cares only about physical health and immediate satisfaction.

In other words, *The Decline* is a tendentious movie. (This is perhaps not surprising, given that it deals with a group of history professors.) But what it is saying is also typical of *québécois* literature, which possesses a whole string of tendentious and moralizing masterpieces. *Maria Chapdelaine* preaches the values of the land and the virtues of staying at home. *Menaud Maître-Draveur* lashes out against the pervasive foreigners and identifies man with his environment. *Bonheur d'occasion* condemns those who would sell their soul for a mess of potage. In *Une Saison dans la vie d'Emmanuel* the characters burn with a hard, gemlike sexual flame, but it sets one to wonder about the relationship between poetry, physical disintegration, and sexual satisfaction. Jacques Poulin's *Volkswagen Blues* and Godbout's *Une Histoire américaine* are searching novels. Their protagonists no longer remain in Quebec. They criss-cross America and they have been in Africa. Nothing is alien to them except that all experiences are alienating to them and their respective futures as *Québécois* in the world remain a question mark.

A recent TV program about Quebec's future as a distinct francophone society in an ocean of English speakers drew similarly pessimistic conclusions. Quebec's birthrate is among the lowest in the world. Immigrants prefer English to French. Those francophone immigrants Quebec attracts are not likely to integrate themselves. In conclusion, Quebec would appear about to lose not only its language but also its culture. Things have never been so bad and they can only get worse.

Of course, another interpretation is possible. *The Decline* focuses on a small group of professionals and the view of Quebec's society it portrays is representative only of the intellectual class. What remains unspoken are other potential points of view. Quebec, although in geographical terms enormous, cannot economically support an ever-expanding population. The *québécois* population seems to have become

aware of this harsh fact and has accordingly limited its birth rate. In the past, the bishops and priests urged the women to stay at home and multiply, while the men were told to go out and cultivate the rocky soil of northern Quebec. In fact, great numbers of *Québécois* ended up migrating to Ontario, the West, to New England, and to California. The present generation seems to be sensing that its salvation lies in a largely urbanized Quebec with a fairly stable population. Such a society, as the film correctly points out, brings with it its own problems. It also demands of its stereotyped characters that they refocus their interests.

Mario, the latest descendant of the *coureurs de bois* and of François Paradis, has traded in his snowshoes, his fur skins, his hard liquor, and his Indian maidens for a Jeep, a leather jacket, a Molson, and a dark-eyed frustrated university lecturer. Claude, the gourmet cook cum homosexual who hunts handsome men while jogging in Montreal's parks, has his antecedent in the homosexual brother-seminarian-poet from *Une Saison dans la vie d'Emmanual*. Like Azarius Lacasse in *Bonheur d'occasion*, Remi, the philandering husband, still fathers children, but not a dozen, and he continues to adhere to the old family values—instead of hanging out in a bar, he frequents bedrooms. Pierre is the sophisticated *Québécois* who, like Jean Lévesque, the budding engineer in *Bonheur d'occasion*, has no moral qualms. He has adjusted perfectly to today's mores. The young graduate student and his embittered older lover represent the opposite poles of idealism and of disillusioned cynicism.

The Decline is part and parcel of the auto-analysis in which Quebec intellectuals and literati have historically indulged. This tendency explains the carefully limited focus of many of the province's cultural products: the slice of life approach in *Maria Chapdelaine* is basically limited to one village—Peribonka—and to one family. Later, in *Bonheur d'Occasion*, the focus is limited to the down-and-outers in Montreal and in *Une Saison dans la vie d'Emmanuel* to those who have remained in the country. Most recently, in *The Decline*, interest is limited to a small group of intellectuals, and in every case the behavior of a handful of people is seen as emblematic, suggestive of Quebec's future while symbolizing its present-day malaise.

Quebec does not like to count its blessings. The French it speaks was a unified language long before France had decided to impose a centrally devised education system on its people. Its singers, writers, and filmmakers transmit a vibrant culture, which is an excellent expression of a unified, homogeneous culture. In one generation, it has created an entire class of technocrats to run its own economy. But as Remi, the philandering historian, proclaims in the very opening scene: "History is a matter of numbers, numbers, and numbers." As a consequence, Quebec is a society that will always feel threatened. This sentiment derives from its geographical encirclement and the conviction that those

derives from its geographical encirclement and the conviction that those who venture off the linguistic island will inevitably drown in the anonymous Anglo-American ocean. Yet all moralizing and tendentious soul-searching aside, the film makes abundantly clear where Quebec's future lies. These men and women lead comfortable lives and they do not feel insecure when they visit California or Italy. They find their joys and despairs in sexual game-playing rather than in exploring the forest or tilling the soil. The fancy sports complexes, the costly cars, and country homes are the exterior signs of a people that has arrived. Agonizing over the future has simply become a national pastime. While establishing the parameters of the national psyche, it does not ultimately impact the enduring material success of the community.

In the meantime, Denys Arcand has produced another movie: *Jesus of Montreal.*[1] It uses many techniques similar to *The Decline of the American Empire.* It mixes history, theater, and real-life drama with modern lifestyles and science. It also introduces the now familiar blending of fiction and reality in the behavior of the actor who, while playing Jesus, begins to believe his message and who, after death, is resurrected in the bodies of those to whom his own bodily parts have been donated. Clearly Denys Arcand agonizes greatly over the relationship between history, morality, and modernity. In the case of

Jésus de Montréal

Quebec, puritanical Catholicism clashes regularly with contemporary urban mores and sophisticated lifestyles. In the later film Denys Arcand finds an ironic and bizarre solution to his dilemma. English-speaking Jewish doctors of the Jewish hospital of Montreal transplant the vital organs of an impoverished and deranged French-speaking actor into the bodies of several grateful recipients. The French hospital to which the actor is first transported is no *Hôtel Dieu*: it is overcrowded, primitive, and its staff is incompetent. Is the contrast with the Jewish hospital meant to imply that Quebec's anglophone Jews are its real saviors and its new Christians? Surely not! Denys Arcand delights in underlining contrasts and in bringing out the coexistence of incompatible realities. In *The Decline*, Arcand mates the young idealistic graduate student Dominique St. Arnaud with the old and embittered author of *Variations upon the Theme of Happiness*, while it is the philandering husband Rémi who believes in the values "of home and family." And it is not Mario, the muscular Jeep driver who is the dominant partner in their sadomasochistic sex games, but Diane, the sophisticated history professor. In *Jesus of Montreal*, the priest sleeps with one of the actresses, has "modern" ideas, and makes conventional decisions, because he does not wish to be exiled to Manitoba. And who can blame him? He is growing old and Winnipeg's winters are long and cold.

In fact, Arcand's movies tend to magnify the contradictions that coexist in Canadian society, while at the same time proposing apparent solutions. After having seen *The Decline* it is impossible to forget the beautiful sports complex, the lovely country home, and the sunrises over the lake. Similarly, the crucifixion scenes in *Jesus of Montreal* are dramatic and highly effective and they stand in sharp contrast with the actors' impoverished daily lives. The ideological core of Denys Arcand's movies—man's need to rediscover a durable value system—is a direct outcome of his *québécois* puritanical Catholicism. It provides a certain unity to his work, because it is the only persistent and coherent element therein. But, in fact, what *The Decline, Jesus of Montreal, The Big Chill,* and the various Quebec novels cited, illustrate best is that cultural products are epiphenomenal. They are an intense, and hence limited, magnification of the conjuncture of cultural obsessions and economic reality. Louis Hémon's *Maria Chapdelaine* may have convinced some *Québécois* that the marginal farmland of the northern regions was worth cultivating, but after one generation of fruitless labor, most of these people moved to Montreal, Boston, or California. The fate of those who ended up in Montreal is described in *Bonheur d'occasion*. Again, it is the dream of material success that makes them join the army, drop their pregnant girlfriend, or, conversely, get married. The fate of those who remain in the country is detailed by the rural unfortunates of Blais's *Une saison dans la vie d'Emmanuel.* The rhetoric, the poetry, the

bombast, and the pathos that is so much a part of Quebec literature is also an integral part of Arcand's movies. While *The Big Chill* starts with the death of an illusion, the group's verbal interactions provide just enough empty talk and hot air for the group to go on with the show. Quebec society, however, is driven by a moral ideology. Whether its members need to believe in God, in the French language, or in survival and the resurrection, it remains a fact that without an intense unifying belief, Quebec, as is evident in Arcand's films, cannot survive; it simply cannot afford the casualness, aimlessness, individualism, and "suicidal" anarchism that ultimately surfaces in *The Big Chill.*

University of Windsor

NOTE

1. Winner of the Special Jury Prize at the Cannes Film Festival in spring of 1989.

3.

SONATINE IN CONTEXT: A NEGLECTED FILM OF MICHELINE LANCTOT

Joseph I. Donohoe, Jr.

INTRODUCTION

In his *Dictionary of Québec Cinema* (1978), Michel Houle notes that prior to 1960, no more than a couple of dozen truly Quebec films had been made.[1] Elsewhere, the same critic points out, the majority of these films, adapted from books published during the thirties, dealt with traditional religious themes, reflecting the enormous influence then exercised by the Catholic church over Quebec.[2] The massive reevaluation of Quebec society accompanying the *Revolution tranquille* (Quiet Revolution) of the sixties, which did so much to secularize life and to stimulate critical thought and creative activity, would soon put an end to this state of affairs. So spectacular, in fact, was the development of film-making in Quebec after 1960, that in Toronto, in 1984, a group of two hundred American and Canadian critics, asked to select the ten best Canadian films of all time, chose six *québécois* films among the top ten, including the number one film, *Mon Oncle Antoine* (1971).[3]

The significant films made in Quebec during the decade of the sixties (e.g., *A Tout Prendre* [1963], *Le Chat dans le sac* [1964], *Trouble-Fête* [1964]) reflect, to be sure, preoccupations of the Quiet Revolution, such as the search for identity, both individual and collective, and the revolt against the various forms of cultural and economic oppression. Since then, while Quebec films have adopted a less militant perspective, they continue to proclaim ever more distinctly the values and priorities identified during the period of critical change: religious skepticism, secularism, and American-style capitalism.

If, in the films of the eighties, these attitudes have changed little, one can, I believe, detect an undercurrent of reaction, for the most part unconscious, in favor of the age-old traditional values so quickly abandoned

some twenty years earlier. *Sonatine* (1983), the film of Micheline Lanctôt, has, it seems to me, the extraordinary merit of confronting directly the spiritual and cultural void left by the changes of the sixties, which is only alluded to in the films of her contemporaries. It is, as a matter of fact, the nonconforming critical aspect of her social vision, which, in the eyes of the most recent historian of Quebec cinema, Yves Lever, may explain the otherwise puzzling lack of appreciation of *Sonatine* in Quebec itself.[4] In order to underscore the significance of Lanctôt's perspective, however, it will be useful to evoke two popular films produced at approximately the same moment, *Le Crime d'Ovide Plouffe* (1983) and *Le Matou* (1985).

CONTEXT

Le Crime d'Ovide Plouffe, directed by Denys Arcand and Gilles Carle, is based on the sequel to the much earlier, far superior novel, *Les Plouffes,* by Roger Lemelin. In the film, Ovide, the protagonist, having returned to Quebec after World War II, has set up a jewelry business, which has begun to prosper. His partner in the business is Berthet, an individual whose physical deformity—we learn later—announces his inner depravity. When Berthet learns of the infidelity of Rita, the some-what flighty wife of Ovide, he attempts, as the price of his silence, to force his own attentions on her. Rita, however, repelled by the advances of Berthet, chooses to confess everything to her husband. The couple, in a moment of crisis, decide to take a trip together in an attempt to work out the problem. Berthet, seeing an opportunity for revenge, uses his watchmaker skills to construct an explosive device, which he hides in Rita's suitcase. When, at the last moment, Ovide decides not to ac-company her, the plane carrying Rita is destroyed by an explosion and Ovide is indicted, on circumstantial evidence and the perfidious testi-mony of Berthet, for murder. Tried and condemned to death, he will be saved only at the eleventh hour by friends who succeed in demon-strating the guilt of Berthet. Completely exonerated, but in some mys-terious fashion enlightened by the close encounter with death, Ovide will leave Quebec for France, where he will become a professor of French language and literature.

Silly and second rate, like the potboiler novel from which it was adapted, *Le Crime d'Ovide Plouffe* offers nonetheless, in its ambiguity, some interesting insights into the psyche of modern Quebec. To begin with, the Ovide of Lemelin's original novel, a mildly kooky idealist and a fanatic enthusiast of the opera, has become a North American capitalist, a transformation that the film appears overtly to applaud, but, if I am not mistaken, surreptitiously to denounce. For while it is true that Ovide, in the time perspective of the film, functions as a positive role model for the thousands of young *Québécois* who will subsequently

Cinémathèque québécoise

Le Crime d'Ovide Plouffe

abandon the liberal professions in a rush to profit from the new business opportunities opened up to them by the breakthroughs of the Quiet Revolution, it is also true, reading the film carefully, that his success seems to dehumanize him and to lead him to the brink of catastrophe. Let us recall, for example, that the decision to choose Berthet as a partner is dictated by simple business pragmatism: the cripple, unable to move about easily, will remain in the shop to look after the technical side of the enterprise, while Ovide, the very picture of success, races about in shiny airplanes securing the deals that will permit the business to expand and prosper. This apparently logical division of labor ignores, however, critical human aspects of the situation: an insensitive Ovide, obsessed with the profit motive, might be said to neglect the psychological problems of his handicapped associate, whose confinement will exacerbate existing feelings of bitterness and frustration and finally lead him to crime. It might also be inferred that the frequent absences of the model entrepreneur on business trips exposes as well the somewhat fragile Rita to the consequences of the frivolous past that preceded her marriage to Ovide, of which Ovide is quite aware. Finally, the film's unacknowledged ambivalence toward the

protagonist's business success will be echoed in the denouement when Ovide, having barely escaped execution, will, in an abrupt, almost comical gesture, surrender his business career in exchange for one of the very same liberal professions once considered the only respectable choice for a young *Québécois*. (Being a teacher clearly appears to him less dangerous!)

In the second of the two films mentioned above, *Le Matou* (1985), directed by Jean Beaudoin and based on the best-selling novel (in France as well as Quebec) by Yves Beauchemin, we find the same curious ambivalence toward material success achieved through commerce. Seemingly devoid of subtlety or layering of meaning, this immensely popular film (it was also made into a mini series for TV), will, like the *Crime d'Ovide Plouffe*, punish without comment or explanation the capitalistic endeavors of the young couple whose success it sets out ostensibly to celebrate.

In the film, a young *québécois* couple, Florent and Lise, dream of starting their own restaurant, but lack the necessary funds. With the aid of the mysterious Ratablavasky, whose diabolic side is for the moment hidden to them, the young people found a small restaurant specializing in *québécois* food, the *Binerie*. No sooner has the little restaurant established its reputation and begun to turn a profit than Ratablavasky reappears, and with the aid of Florent's treacherous business partner, Slipskin, attempts to dispossess its industrious young owners. With the help of Mr. Emile, a poor neighborhood urchin, and other friends, Lise and Florent will successfully defeat the machinations of Ratablavasky, but only at the cost of the life of the youngster. At the end of the film, the young couple celebrates among family and friends the birth of their first child, but outside the sinister figure of Ratablavasky still prowls the darkened street, his mind perhaps occupied with ideas for *Matou II*.

Because of the manner in which I have summarized this eminently conventional film, it may appear evident that *Le Matou* constitutes the same ambiguous celebration of modern Quebec values, in particular entrepreneurial activity, as did the *Crime d'Ovide Plouffe*. Although it clearly shares with its audience the vision of a modern, upbeat, and business-oriented Quebec, the film still manages to articulate in a minor key the axiom that success in business leads sooner or later to retribution.

There is, moreover, in the film a second parallel issue, obscurely interwoven with the crypto denunciation of the capitalist ethic, which has to do with secularism and the denial of faith. Although the principal characters make light of religion—in particular during the faked funeral of M. Ratablavasky—one is forced to admit, upon reflection, that the principal motor of the film is a preternatural force that emanates from the person of this same Ratablavasky, a prescient creature who

rises from the dead and on occasion produces miracles (the one, for example, which opens the film, when he is able to bring together all of the elements of a complex "accident," including the presence of Florent, who only happened to be passing by). But, the admission of a transcendent force for evil implies the presence of its counterpart, since the two represent opposing faces of a single phenomenon, that of a supernatural power capable of intervening in human affairs. Moreover, if Ratablavasky ignores the difference between good and evil, as he says he does, there is clearly a force in the film that not only makes the distinction but that seems to punish rather precisely all transgressions of Quebec's traditional moral code: Lise is punished for her mockery of religion by the fleeting infidelity of her husband; Florent is punished for his enthusiasm for the profit motive by persecution and the temporary loss of the restaurant; and Slipskin is punished for his treacherous greed by the definitive loss of his share of the *Binerie*.

SONATINE

Micheline Lanctôt's second feature film, *Sonatine,* appeared in 1983, the same year as the *Crime d'Ovide Plouffe* and about a year and one half before the release of *Le Matou.* Outside of a particular time period and a shared potential audience, however, the Lanctôt film appears to

Cinémathèque québécoise

Sonatine

have little in common with the other two. The *Crime d'Ovide Plouffe* and *Le Matou* are films made in the classical Hollywood mold, with prominent linear plots, and shots and sequences contrived to relieve the spectator of the onerous task of interpretation. *Sonatine,* in contrast, with a problematic musical structure, dark tonalities, and a carefully made soundtrack with little dialogue, reveals its links to the indigenous documentary tradition of *cinéma direct* and to European *auteur* theory; it also makes certain demands on the spectator. Still, a careful look at the films suggests that they have at least this in common, that *Sonatine* sets out boldly to explore a crisis of values in modern Quebec, which seems rather to insinuate itself incognito into the other films in spite of their directors' efforts to entertain. In the film, Lanctôt focuses on the lives of two adolescent girls, Chantal and Louisette, as they struggle, virtually unaided, to make the transition from childhood to the alien world of adults. True to the promise of its musical title, the film unfolds in a three-movement structure equivalent to I: Chantal, II: Louisette, III: Chantal/Louisette and coda.

The first movement, which occupies about one third of the film, concerns itself with the ritual bus rides of Chantal who everyday, for days on end, arranges to get the same bus, at the same time, in order to spend a few minutes with the same bus driver, with whom she believes she has fallen in love. Day after day, with an intensity and single-mindedness given perhaps only to adolescents, she drinks in the sight of her hero, while recording his most banal propos on her omnipresent Walkman, for later play back and delectation. A chance remark in which he refers to her as a child causes her to bristle with indignation; but on another occasion, he mentions how pretty she looks, and she quivers with pleasure, replaying his comment over and over on the Walkman, even before leaving the bus. Meanwhile, the bus driver, unaware of the adoration he has inspired, contends with his own adult problems: management that threatens his job if he can't run a tighter schedule, colleagues who harass him because he is unwilling to share their strike plans, a scolding wife angry at him apparently on principle. One day, for one or all of these reasons, her bus driver does not reappear, and Chantal is obliged quite abruptly to abandon her life-enriching fantasy. Her shock and pain upon discovering the replacement driver are palpable.

In part II, Louisette, whom we have seen only briefly, under the credits, as the two listen to an audio tape, reappears in a parallel segment of about equal length to the first. Leaving her home one evening in stealth, for reasons not given, she travels to the Port of Montreal, where mysterious lights and activity punctuate occasionally the darkness. Choosing a rusty old hulk of a freighter, Louisette sneaks aboard with the possible intention of stowing away. What follows is a remarkable

chiaroscuro sequence, clearly an *hommage* to Antonioni's *Deserto Rosso,* which suggests a strong parallel between Louisette and the Monica Vitti character of the earlier film. When her presence on the ship is discovered by an angry Russian sailor, the fear and unhappiness on her young face are sufficient to give him pause. Soon he is chatting pleasantly with her in a language she totally ignores. As in *Red Desert,* the alienated state of the young woman is poignantly illuminated by her greedy response to a human contact, which comes through in spite of the formidable barrier of language. She offers him some of her chocolate; they exchange jackets and hats; she laughs for the first time as he mimics comically her stealthy arrival on board. For Louisette, a lover of all things Russian, the moment is exquisite but short lived. With the return of other crew members and preparations for departure, she is soon obliged to go ashore, turning her steps once more in the direction of the empty city. He gives her a half-empty pack of cigarettes and voices the hope that he might return one day to Montreal to see her. Sirens shrill in the background and flames leap from a vandalized bus—the victim of labor unrest—as Louisette leaves the port.

In the third major segment of *Sonatine,* Chantal and Louisette are continuously together, that is to say, together alone. Each one is the only child of a middle-class, two-income family, and has little contact with parents whose time is taken up with jobs, supplementary classes, and the desire to better their already agreeable material situation. A short sequence in the metro sums up poignantly the child-parent relationships as Louisette waves repeatedly to her transit worker father at the controls of a sleek subway train, which speeds abruptly into the darkness before he is able to notice her. Once aboard their own train the girls write their phone numbers on the sparkling clean wall; perhaps someone, anyone, will call.

The school environment echoes that of the home, a clean, modern building awash in computers, special rooms and services; but nothing or no one apparently is up to the task of getting behind the adolescent mask of sufficiency in order to make Louisette or Chantal feel loved or important. Teachers are invisible except, significantly, in a scene strongly reminiscent of Truffaut's *Les Quatre Cents Coups,* in which Chantal is taken to task in the presence of her parents for a recording she has brought to school; its content is not revealed, but the looks on the faces of the parents suggest that it might be something on the order of a family quarrel.

Shortly thereafter, the girls leave a computer session to pillage the pointedly unattended but beautifully equipped school infirmary. Giggling all the while, as if engaged in a childish prank, they succeed in making off with a large quantity of assorted pills. At home, Chantal dashes off a short poem about an oyster caught in a poisonous sea, which closes

its shell definitively and is in time cast up on the shore. Eventually, after some discussion of possible sites, they go to the metro, where they set themselves up in a car under a homemade sign that informs the "indifferent world" that they will swallow pills until someone intervenes to stop them. The subway passengers, caught up in their own concerns, pay scant attention while the girls, still whispering gaily, wash down pill after pill with gulps of milk from a cardboard container. They fall asleep at the moment when the train is pulling into its terminal. Waking passengers quickly leave, but before the conductor is able to carry out his check of the cars he learns that a long-awaited train strike is to begin immediately. At that, he cuts the electricity and quits the train, leaving the unsuspected pair to their fate. Although no one has overtly wished them harm, the youngsters evidently will not survive their lark.

Québec: Duplessis et après

Office national du film du Canada

In *Sonatine*, the seemingly absent-minded ambiguity of the two previously mentioned films is replaced by a strongly ironic structure wherein two sensitive adolescents perish for want of moral sustenance in the midst of the unparalleled material prosperity of the new Quebec. Instrumental in defining the relation between new affluence and the alienated teenagers, are the ever present, upscale Walkmans, which, in this case, can record sound as well as play audio cassettes. In addition, therefore, to the variable volume control, which allows them more or less to distance the world, Chantal and Louisette are able, by the selective recording of their environment, to reinforce the fragmented

grasp of things implicit in their passionately incomplete vision, and thereby to strangle at its inception any impulse to life-promoting dialogue with the outside. But, it might be argued, an even more haunting image of their tragically ironic experience may be found in the glittering, sleek subway train—the triumph of Mayor Drapeau and Bombardier—which, filled with indifferent passengers, nonchalantly whisks the friends to their death in the darkened vaults beneath the city.

CONCLUSION

In her book, *Un Cinéma orphelin,*[5] a study of the *québécois* films of the forties and fifties, Christiane Tremblay-Daviault found herself obliged to interrogate "les secrets, l'envers et surtout les lapsus"[6] of the films in order to uncover their actual relation to the conditions of life in Quebec at the time. In the process, she discovered, behind the pious chronicles of sin, guilt, and remorse, traces of the real evils affecting that society, i.e., political and moral repression. Thus, a spectator of the period responding emotionally to a film like *La Petite Aurore l'enfant martyre* (1951) did so because, as a member of the oppressed francophone majority, he felt a secret affinity with the sorely tried child of the film. Communicating openly on the subject of anglophone colonialism, or the treacherous complicity of elected officials, on the other hand, was something that the censorship of the time—or, to an extent his own colonialized consciousness—could not tolerate.

In Quebec, since the Quiet Revolution, the conditions attending filmmaking have changed radically, with the result that, today, few subjects, if any, lie outside the purview of a responsible director. Yet, in spite of this openness—if films like *Le Crime d'Ovide Plouffe* or *Le Matou* are, as I believe, representative—we still find ourselves forced to use reading strategies analogous to those devised by Mme Tremblay-Daviault in order to determine a film's true relationship to contemporary society. The answer to this puzzling state of affairs, in my judgment, may lie in the ambivalence of today's Quebec to the momentous changes that have come about in the last thirty years.

Most visible signs, including a precipitous drop in the birth rate, a sharp rise in GNP, the conversion or sale of idle churches and seminaries, the rush of students away from the liberal professions into business and applied technology, suggest a strong commitment on the part of the average citizen to Quebec's break with its traditional past. At the same time, more than two hundred years of sustained effort and sacrifice to retain a national identity constitute a heritage not easily set aside. During the Conquest, unsuccessful rebellions, Confederation, and subsequent systematic economic exploitation by the anglophone minority, the penchant toward national disintegration was countered by the elaboration of a strong sense of community based on ethnic pride, religious faith,

and a love for the land. However unfortunate in his material circumstances, every *Québécois* knew (or thought he knew) who he was and where he belonged. The very motto of Quebec, "Je me souviens" (I remember) points clearly to the role of the past in conferring identity and creating a sense of belonging. And yet, at a certain point in the Quiet Revolution, Quebec realized that demythologizing its past, henceforth associated with images of servitude and backwardness, was the necessary price to be paid for moving into the modern era. And at that precise point there occurred the beginnings of a split in the national psyche, which, magnified by the passage of time, has begun to surface in the discourse of the films of the eighties.

While it may accommodate his particular sort of schizophrenia, the average *québécois* film viewer remains, in my experience, unaware of the voice "off camera," so to speak, which continues *sotto voce* to remind him of other times and other values, and this is apparently the way he wants it. The inability to cut one's self off completely from the collective past is one matter, the willingness to make emotionally loaded choices when the past openly confronts the present is quite another. This explains perhaps the negative reception afforded *Sonatine,* a technically and aesthetically superb, second feature film by a prize-winning actress turned director. On its release in 1983, Montreal's *La Presse* (31 March 1983) trivialized its "gloom and doom" mentality and this single-minded assessment rippled quickly through the provincial media. Meanwhile, *Sonatine* was awarded the "Silver Lion" at the 1984 Venice Film Festival, where it placed second to Jean-Luc Godard's *Prénom Carmen.*

Today more than ever, it is appropriate to point out, the message of Lanctôt's *Sonatine*—whatever the reception by her compatriots—has taken on a significance that transcends the borders of Quebec. When countries around the world are eyeing compulsively the lifestyles of the Western Democracies, it is as sobering as it is useful to recall that a capitalist system fired by greed and consumption does not necessarily meet the highest aspirations, nor even the simplest needs, of human beings.

Michigan State University

NOTES

1. Michel Houle et Alain Julien, ANNEXE II (Montréal: Fides, 1978), 309–28.
2. Michel Houle, "Quelques Aspects idéologiques et thématiques du cinéma québécois," in *Les Cinémas canadiens,* ed. Pierre Véronneau (Montréal-Paris: La Cinémathèque québécoise, 1978).
3. Jacqueline Viswanathan, "Approche pédagogique d'un classique québécois: *Mon Oncle Antoine," The French Review,* 63, no. 5 (April 1990): 849.

4. Yves Lever, *Histoire générale du cinéma au Québec* (Montréal: Boréal, 1988), 464.

5. Christiane Tremblay-Daviault, *Un Cinéma orphelin* (Montréal: Québec/ Amérique, 1981).

6. Pierre Véronneau, Préface, *Un Cinéma orphelin* (Montréal: Québec/ Amérique, 1981), 13.

PART V

BIOGRAPHICAL DICTIONARY
Marcel Jean

Denys ARCAND (Deschambault, 1941)
Director, filmwriter.

Historian by trade, Arcand first attracted critical attention for several short documentaries on historical subjects, including *Champlain* (1964) and *Les Montréalistes* (1965). He then went to the ONF, where he made two socio-political documentaries, *On est au coton* (1970) and *Québec: Duplessis et après* (1972). Both were censured, a rare event in the history of *québécois* cinema. Following this reproach, he left the ONF and turned to feature films in which he pursued issues of political interest. A brilliant and critical observer of *québécois* society, Arcand constructed a series of films featuring pointed social comparisons: between employees and their bosses in *Réjanne Padovani* (1973), between a striptease performer and a filmmaker in *Gina* (1975), and between professional men and women in *Le Déclin de l'empire américain* (1986). *Le Déclin de l'empire américain* and the subsequent *Jésus de Montréal* (1989) each won an Oscar nomination for "Best Foreign Film"; the latter also received a Special Jury Prize at Cannes, 1989.

Frédéric BACK (Sarrebruck, Germany, 1924)
Director of animated films.

Back arrived in Quebec in 1948 and began working as a graphic artist for Radio Canada in 1952. In 1970, after a long career as illustrator and constructor of production models, he made his directing debut with *Abracadabra,* a film co-directed with Greame Ross. This was followed by an important series of films based on ecological themes, including *Illusion?* (1974) and *Toutrien* (1978). The well known *L'Homme qui plantait des arbres* (1987) was perhaps his greatest achievement in terms both of theme (he adapted a text by the French writer Jean Giono) and of style. The use of impressionist techniques gave to the animation a rare fluidity and grace perfectly suited to the story being told. This film won for Back a second Oscar, six years after he received the first one for *Crac!* (1981), a film which depicted the evolution of *québécois* society—through the story/history of a rocking chair.

Jean BEAUDIN (Montreal, 1939)
Director, film editor, filmwriter.

After a difficult beginning (*Stop*, 1971; *Le Diable est parmi nous*, 1972), Beaudin gained recognition for a series of short films, including *Par une belle nuit d'hiver* (1974) and *Cher Théo* (1975), which together formed a fresco of everyday life in Quebec. Two period films, *J. A. Martin photographe* (1976) and *Cordélia* (1979), notable for their beauty and their sensitive portrayal of the woman's point of view, also brought him acclaim. After a feature film describing the close relationship between a teen-aged boy and his autistic young brother (*Mario*, 1984), Beaudin directed *Le Matou* (1985), a complicated but unconvincing film based on a best-selling novel by the Quebec writer Yves Beauchemin.

Jean-Yves BIGRAS (Ottawa, 1919—Montreal 1966)
Director, film editor, producer.

Bigras held various positions with the ONF from 1943 to 1945, took an active role in the first attempt to establish a genuinely self-supporting film industry in Quebec, and in 1950 directed *Les Lumières de ma ville*. The following year he made *La Petite Aurore l'enfant martyre* (1951), a film representative of the *québécois* cinema of the period. In this melodrama, certain assumptions of traditional Quebec were crystallized and raised to the level of myth. In 1954, he directed another melodrama, *L'Esprit du mal*; its failure marked the momentary collapse of fiction filmmaking in Quebec.

Michel BRAULT (Montreal, 1928)
Director, director of photography, producer, filmwriter.

A leader in the use of direct cinema in Quebec, Brault was also influential in France, where he collaborated most notably with Jean Rouch and Mario Ruspole. Joining the ONF in 1956, he played a leading role as cinematographer and director of photography. He also co-directed several short films which have become classics, including *Les Raquetteurs* (1958) and *La Lutte* (1961). The poetry of Pierre Perrault, together with Brault's mastery of the camera and his search for an ethic appropriate to direct cinema documentary were the bases for *Pour la suite du monde* (1963), a co-production which advanced the careers of both men. As director of photography, Brault worked on some of Quebec's best feature films, including *Mon Oncle Antoine* (1971), directed by Claude Jutra, and *Les Bons Débarras* (1980), directed by Francis Mankiewicz. At the same time, Brault also began to direct fiction films (*Entre la mer et l'eau douce*, 1967) in which the *mise en scène* owes much to his experience with direct cinema. He continued in this vein with *Les Ordres* (1974), a portrayal of the October 1970 political crisis, for which he was

awarded the prize for *mise en scène* at the Cannes Film Festival. Since then, Brault has made films mainly for television, most notably *Les Noces de papier* (1989).

Maurice BULBULIAN (Montreal, 1938)
Director.

Initially a teacher, Bulbulian was also interested in cinema, and soon became known in filmmaking for a series of social documentaries in which direct cinema was used as a tool of "science and conscience." Among these films are *La P'tite Bourgogne* (1968), *Dans nos forêts* (1971), *Richesse des autres* (1973), and *Les Gars du tabac* (1977). Turning to international issues, he directed such documentaries as *Salvador Allende: un témoignage* (1973) and *Tierra y Libertad* (1978). His greatest achievements, however, were two films which "defended and illustrated" the rights of Inuit and American Indian groups: *Debout sur leurs terres* (1982) and *Dancing Around the Table* (1988). A careful documentarist, Bulbulian combined a keen social conscience with cinematography of great sobriety.

Gilles CARLE (Maniwaki, 1929)
Director, producer, filmwriter.

Carle began his career in cinema with short documentaries (*Patinoire*, 1962; *Percé on the Rocks*, 1964), but only when he began working in fiction films did he reveal his talent for storytelling, his gift for fantasy, and his tender and amused perspective on *québécois* society. With *La Vie heureuse de Léopold Z.* (1965), *Le Viol d'une jeune fille douce* (1968) and *Red* (1969), Carle laid the foundation for a distinctive body of work in which the principal themes were conflict, exploitation, and alienation. *Les Mâles* (1970) and *La Vraie Nature de Bernadette* (1972), which dealt with the conflict between nature and culture, were his greatest achievements. Later, he worked with actress Carole Laure to make *La Mort d'un bûcheron* (1973), *La Tête de Normande St-Onge* (1975) and *Maria Chapdelaine* (1983). In the 1980s, he devoted himself mainly to documentaries, directing loosely constructed films which brought together seemingly unrelated elements: *Jouer sa vie* (co-director: C. Coudari, 1982), *O Picasso* (1985), and *Vive Québec* (1988), among others.

Marcel CARRIERE (Bouchette, 1935)
Director, sound engineer.

After joining the ONF in 1956 as a sound engineer, Carrière worked on more than a hundred films. One of the pioneers of direct cinema, he collaborated in the making of such landmark films as *Les Raquetteurs* (M. Brault and G. Groulx, 1958) and *Pour la suite du monde*

(P. Perrault and M. Brault, 1963). In the early sixties, he turned to direct-ing, both in direct cinema (*Avec Tambours et trompettes,* 1967; *Chez nous c'est chez nous,* 1973) and in fiction. In the latter category, his two most convincing films are *O.K. . . . Laliberté* (1973) and *Ti-Mine, Bernie pis la gang . . .* (1976)—humorous portraits of ordinary *Québécois* struggling with the burdens of everyday life. In 1978, Carrière left direct-ing to assume administrative responsibilities at the ONF.

Fernand DANSEREAU (Montreal, 1928)
Director, producer, editor, filmwriter.

Originally a journalist, Dansereau worked as a filmwriter (*Alfred J.,* B. Develin, 1956), then joined the ONF as a producer in 1960. In this capacity, he participated in the early development of direct cinema, producing *Bûcherons de la Manouane* (A. Lamothe, 1962) and *Pour la suite du monde* (P. Perrault and M. Brault, 1963). His directing career gained momentum with *Le Festin des morts* (1965), a reworking of the Jesuit missionary epic of the sixteenth century. He then turned toward social action films such as *St-Jérôme* (1968) and *Faut aller parmi le monde pour le savoir* (1971). During this period, his interest in collec-tive creation resulted in *Tout le temps, tout le temps, tout le temps . . .* (1969), which was scripted and performed by thirteen residents of Montreal's East End. After making two feature films (*Thetford au milieu de notre vie,* 1978; *Doux Aveux,* 1982), he devoted his attention to writ-ing screenplays for television.

Bernard DEVELIN (Quebec, 1932—Montreal, 1983)
Director, producer, filmwriter.

Joining the ONF in 1946, Develin was one of the pioneers in the area of television films with his reporting series *On the Spot* (1953) and *Sur le vif* (1954). He is best known for his fiction films, however, particu-larly *Alfred J.* (1956), in which he describes the union movement in a working-class setting, and *Les Brûlés* (1958), a historical portrait of the effort to settle northern Quebec in the 1930s.

Georges DUFAUX (Lille, France, 1927)
Director of photography, director, editor.

Immediately after his arrival in Quebec in 1956, he joined the ONF and worked on a number of productions for television. A talented direc-tor of photography, his influence is apparent in the filming of several feature films, including *Les Brûlés* (B. Develin, 1958), *Les Beaux Souvenirs* (F. Mankiewicz, 1981), *La Femme de l'hôtel* (L. Pool, 1984) and *La Demoiselle sauvage* (L. Pool, 1990). His directing career has been

devoted to the documentary, with the exception of *C'est pas la faute à Jacques Cartier* (1967), a comedy co-directed with Clément Perron. His greatest successes include *A Votre Santé* (1973), an investigation of the emergency services of a large hospital, the series entitled *Les Enfants des normes* (1979), which chronicles life in contemporary schools in Quebec, and *Gui Daó—Sur la voie* (1980), a trilogy which, by focusing on a few individuals, depicts life in post-revolutionary China. From 1986 to 1989, Dufaux directed the French program of the ONF.

André FORCIER (Greenfield Park, 1947)
Director, filmwriter.

Despite a limited output (six feature films in twenty years), Forcier occupies an important place in *québécois* cinema as a poet whose fantasy and imagination oppose the chronic misery and poverty of his characters. *Bar Salon* (1973), *L'Eau chaude l'eau frette* (1976), *Au Clair de la lune* (1982), *Kalamazoo* (1988) and, above all, *Une Histoire inventée* (1990) form an abundant, baroque oeuvre which brilliantly depicts a *québécois* society in need of love, haunted by death, enlivened by humor, and awash in alcohol. Forcier's magical realism, oscillating between absurd and tragic, is strengthened by his exceptional sense of setting, which makes him the spiritual heir of Jean Vigo and Frederico Fellini, and a distant cousin of the Yugoslavian, Emir Kusturica.

Roger FRAPPIER (Sorel, 1945)
Producer, editor, director.

Although he began his career as editor and director, Frappier made his mark as a producer. In this capacity, he was associated with several of the most successful *québécois* fiction films in the 1980s: *Anne Trister* (Léa Pool, 1986), *Le Déclin de l'empire américain* (Denys Arcand, 1986), *Pouvoir intime* (Yves Simoneau, 1986), *Un Zoo la nuit* (Jean-Claude Lauzon, 1987) and *Jésus de Montréal* (Denys Arcand, 1989). As a director, he was especially interested in the phenomenon of artistic creation, a theme apparent in *Le Grand Film ordinaire* (1970), about a theatrical troupe, and in *L'Infonie inachevée* (1973), which explores the collaboration of a musician and a poet.

Raymond GARCEAU (Pointe-du-lac, 1919)
Director, filmwriter.

Trained in agriculture, Garceau joined the ONF in 1945. He soon became the voice of traditional agriculture with films like *Montée* (1949). In the 1960s, adapting to the perspective which prevailed during the Quiet Revolution, he supported rural modernization in *Les Petits Arpents* (1962)

and the twenty-six episode series entitled *ARDA* (1965–66). He also made several portraits which reveal his humanity and sensitivity, including *Alexis Ladouceur, métis/L'Homme du lac* (1962), and *Les Diableries d'un sourcier* (1966). After three unsuccessful feature films (*Le Grand Rock,* 1967; *Vive la France,* 1969; *Et du fils,* 1971), he returned to his favorite themes in *Québec à vendre* (1977), which depicts the loss of farmland to speculators.

Suzanne GERVAIS (Montreal, 1938)
Director of animated films.

Although she has made only five films in twenty years (her first, *Cycle,* appeared in 1971), Gervais has made her mark in film animation as a talented artist (*Climats,* 1975; *La Plage,* 1978) who is determined to transcend animation through the dramatic power of her style. Made with paper cutouts and an animation stand, *La Trève* (1983) and *L'Atelier* (1988) displayed a vigorous animation, based on an impressive inter-play of space and light, such as one finds in fiction cinema. Both films contain complex *récits* which explore the inner world of the characters.

André GLADU (Ottawa, 1945)
Director.

Influenced by his pianist mother and art critic father, Gladu devoted the majority of his films to subjects relating either to music or to paint-ing. Thus music is the subject of the imposing series *Le Son des Fran-çais d'Amérique* (1974-1980), which he co-directed with Michel Brault who also acted as cameraman. In the same spirit, *Zarico* (1984) and *Noah* (1985) present the music of the black Cajuns of Louisiana, and *Liberty Street Blues* (1988) focuses on the jazz of New Orleans. Gladu's interest in painting was expressed through two biographies of artists in which the techniques of both fiction and documentary filmmaking are used: *Marc-Aurèle Fortin, 1888–1970* (1983) and *Pellan* (1986).

Jacques GODBOUT (Montreal, 1933)
Director, filmwriter.

A well-known *québécois* writer (*Le Couteau sur la table, Salut Galar-neau*), Godbout made several feature films belonging to widely differ-ent genres. *Fabienne sans son Jules* (1964) paid homage to the first films of the new wave, while *IXE-13* (1971) was a parody of a comic strip spy story, and *La Gammick* (1974) was a thriller. Essentially, however, Godbout has remained a documentarist, a rigorous intellectual whose work is characterized by solid research. As a result of his passionate interest in the world of information, he analyzed the role of the media

in such films as *Derrière l'image* (1978), *Feu l'objectivité* (1979) and *Distorsions* (1981). In tune with the times, he has grasped the significance of social change and expressed it eloquently. The influence of the Californian "new age" on Quebec, for example, is depicted in *Comme en Californie* (1983), while terrorism is the subject of *En Dernier Recours* (1987). In 1988, he made *Alias Will James,* a life of Ernest Dufault, the *Québécois* who became famous in the United States, where he pretended to be an American and, under the pseudonym of Will James, wrote novels exalting the world of the cowboy.

Bernard GOSSELIN (Drummondville, 1934)
Director, director of photography.

Upon joining the ONF in 1956, Gosselin held various positions before becoming a cameraman for *Bûcherons de la Manouane* (A. Lamothe, 1962), *Champlain* (D. Arcand, 1964), *Avec Tambour et trompettes* (M. Carrière, 1967), and for numerous films by Pierre Perrault, including *Le Règne du jour* (1966) and *Les Voitures d'eau* (1968). As director, Gosselin has emphasized the land of Quebec and its history, and thus has often been seen as continuing the work of Perrault. His most notable successes are: *César et son canot d'écorce* (1971), *Jean Carignan, violoneux* (1975), *Le Canot à Renald à Thomas* (1980) and *L'Anticoste* (1986). In 1970, he made *Le Martien de Noël,* a full-length children's film which anticipates the works of André Melançon.

Gilles GROULX (Montreal, 1931)
Director, editor, filmwriter.

Soon after his appointment to the ONF as an editor in 1956, Groulx began to direct. He also participated actively in the growth of direct cinema, working on such films as *Les Raquetteurs* (co-directed with M. Brault, 1958), *Golden Gloves* (1961) and *Voir Miami . . .* (1963). In 1964, he completed his first fictional feature, *Le Chat dans le sac,* which deals with the political questions raised by a young *québécois* separatist. Very loosely structured, the film resembles the first works of Godard and Bertolucci. In subsequent full-length films, which were collage-like in their composition, Groulx sought to define *"québécois"* and to denounce modern alienation. He also condemned political and sexual repression. His films of this period include: *Ou êtes-vous donc?* (1968), *Entre tu et vous* (1969), *24 Heures ou plus . . .* (1976), and *Première Question sur le bonheur* (1977). *Au Pays de Zom,* a splendid operatic work in which distancing techniques intensify the biting criticism of bourgeois society, was completed in 1982, despite the serious accident which two years earlier ended the working career of Quebec's most electrifying filmmaker.

Pierre HEBERT (Montreal, 1944)
Director of animated films, producer.

A specialist in drawing directly on film, Hébert is an innovator in the tradition of Norman McLaren, founder and director of the animation unit at ONF. Hébert joined the ONF in 1965 and made a series of abstract films (*Op Hop*, 1965; *Opus 3*, 1967; *Autour de la perception*, 1968). Refusing to limit himself to purely formal cinema, he turned to films which had political and historical content (*Père Noël, Père Noël*, 1974). He reached a high point with *Souvenirs de guerre* (1982), a Brechtian story denouncing the violence which results from capitalism. Hébert then explored animated film as a means of expression in relation to other arts: poetry (*Etienne et Sara*, 1984), dance and poetry (*Adieu bipède*, 1987), and music and painting (*O Picasso—Tableaux d'une surexposition*, 1985). The complete artist, eager to free himself from the confines of animation, he gave a series of improvisations, performances in which he drew directly on film as spectators watched. In 1985 he won the prestigious Melkweg Cinema Award for Reality Research, given by the Melkweg Center of Amsterdam (Holland), and, in 1988, became the first recipient of the Heritage-McLaren prize.

René JODOIN (Hull, 1920)
Producer, director of animated films.

Jodoin was brought to the ONF in 1943 by Norman McLaren, with whom he co-directed two films (*Alouette*, 1944; *Sphères*, 1969). His principal contribution to *québécois* cinema, however, was the founding of the ONF's French studio of animation (1966), which brought together Pierre Hébert, Co Hoedeman, Caroline Leaf, Suzanne Gervais, Paul Driessen, Jacques Drouin, and others. Favoring individual rather than team projects, as in the Disney Studios, Jodoin encouraged experimentation and personal expression. As director, Jodoin made four didactic films based upon rigorous geometric forms: *Dance Squared* (1961), *Notes sur un triangle* (1966), *Rectangle et rectangles* (1984) and *Question de forme* (1985).

Claude JUTRA (Montreal, 1930–1986)
Director, actor, editor, filmwriter.

Associated with the ONF from 1954, Jutra made several short documentaries there and collaborated with animator Norman McLaren, with whom he co-directed *A Chairy Tale* (1957). Highly productive, he completed his first full-length film (*Les Mains nettes*) the following year, and then worked on several more films before making *A Tout Prendre* (1963), a feature film which, because of the personal tone, is reminiscent of the first works of François Truffaut. This intimate film marked the

birth of a true author. *Mon Oncle Antoine* (1971), depicting the initiation of an adolescent into the world of adults in the Quebec of the 1940s, is one of the greatest achievements in *québécois* cinema. Actor as well as director, Jutra played a leading role in this film, as in *A Tout Prendre*, and later in *Pour le meilleur et pour le pire* (1975). *Kamouraska* (1973), based on a historical novel by Anne Hébert, proved to be less successful than expected. At the end of the 1970s, faced with the crisis which was so unsettling to *québécois* cinema, Jutra went to Toronto and Vancouver, where he made several films in English. He came back to Quebec to film *La Dame en couleurs* (1984), the story of orphans forced to live in a psychiatric hospital in the 1940s.

Jean-Claude LABRECQUE (Quebec, 1938)
Director, director of photography, filmwriter.

After joining the ONF in 1959, Labrecque began to direct in 1964 and rapidly became an important documentarist whose primary goal was to capture on film some of the great historical events of contemporary Quebec: *La Visite du général de Gaulle au Québec* (1967); *La Nuit de la poésie, 26 mars 1970* (1970); *Jeux de la XXIe Olympiade* (1977); *L'Histoire des trois* (1990). His interest in history is revealed in his fiction films, not only in personal ones: *Les Vautours* (1975) and *Les Années de rêve* (1984), but also in works inspired by real people: *L'Affaire Coffin* (1979) and *Le Frère André* (1987). An excellent director of photography, Labrecque worked with Claude Jutra (*A Tout Prendre*, 1963), Gilles Groulx (*Le Chat dans le sac*, 1964) and Gilles Carle (*La Vie heureuse de Léopold Z.*, 1965).

Arthur LAMOTHE (Saint-Mont, France, 1928)
Director, editor, producer, filmwriter.

Lamothe arrived in Canada in 1953, and is best known for his imposing *Chronique des Indiens du Nord-Est du Québec*, a series of thirteen films made between 1973 and 1983. Based on the themes of the culture, dispossession, and future of the Montagnais Indians, Lamothe's films brought important issues to public attention. In 1983, he completed his cycle on American Indians with *Mémoire battante*, in which he presented the spiritual universe of the Montagnais as their ultimate defense against assimilation. Lamothe directed numerous other documentaries and two less successful feature films, *Poussière sur la ville* (1965) and *Equinoxe* (1986).

Micheline LANCTOT (Montreal, 1947)
Director, actress, filmwriter, director of animated films.

Lanctôt was working as an animated filmmaker when she was discovered by Gilles Carle and made the heroine of *La Vraie Nature de*

Bernadette (1972). This was the beginning of an important acting career working with Ted Kotacheff (*The Apprenticeship of Duddy Kravitz,* 1974), Jean-Guy Noël (*Ti-cul Tougas,* 1976), and Jean-Claude Labrecque (*L'Affaire Coffin,* 1979). As a director, Lanctôt first made a romantic comedy (*L'Homme à tout faire,* 1980), which was followed by *Sonatine* (1983), a moving account of the suicides of two adolescent girls. Carefully crafted in three movements, each with its own rhythms and melodies, this film won a Silver Lion at Venice. Subsequent works include a documentary (*La Poursuite du bonheur,* 1987), and a television film (*Onzième spéciale,* 1988).

Paul L'ANGLAIS (Quebec, 1905—Montreal, 1982)
Producer.

The first great producer in *québécois* cinema, L'Anglais was responsible for most of the major fiction films of the 1940s and 50s, including *La Forteresse* (Fedor Ozep, 1947), *Un Homme et son péché* (Paul Gury, 1948), *Le Curé de village* (Paul Gury, 1949), *Séraphin* (Paul Gury, 1950), *Son Copain* (Jean Devaivre, 1950) and *Tit-Coq* (René Delacroix and Gratien Gélinas, 1952). With the advent of television in Quebec in 1952, he worked exclusively in this field, thus giving a new direction to his long career in mass communication.

Caroline LEAF (Seattle, United States, 1946)
Director of animated films.

A specialist in the use of sand in animation, Leaf employed this technique in making two beautiful narrative films, *Le Mariage du hibou* (1974) and *The Metamorphosis of Mr. Samsa* (1977), both of which won international acclaim. During the same period, she also made *The Street* (1976) from a text by Mordecai Richler. In this film, she used paint on glass, a process which allowed her to develop a narrative technique based on metamorphosis and constantly changing spaces. In the following decade, Leaf completed a variety of documentary and animated films, but these lacked the breadth of the three earlier works. In 1988, she began a major project in the French studio at the ONF.

Jacques LEDUC (Montreal, 1941)
Director, director of production, filmwriter.

The important body of work which Leduc has produced is heterogeneous. His works include films close to direct cinema (the series *Chronique de la vie quotidienne,* 1977–1978); some are documentaries with political (*Cap d'espoir,* 1969) or social content (*Charade chinoise,* 1988), hybrid films which combine various elements (*Albédo,* co-directed with Renée Roy; *Le Dernier Glacier,* co-directed with Roger Frappier, 1984), and fiction

films (*On est loin du soleil,* 1970; *Tendresse ordinaire,* 1973; *Trois Pommes à côté du sommeil,* 1989). An original and venturesome filmmaker, Leduc is a perceptive observer of Quebec; his socio-political preoccupations are accompanied by thoughtful consideration of the interaction between cinema and experience, between fiction films and documentaries.

Jean Pierre LEFEBVRE (Montreal, 1941)
Director, actor, producer, filmwriter.

Unlike other *québécois* filmmakers of his generation, Lefebvre began, not with the documentary or direct cinema, but with fiction films. Since 1964, he has made more than twenty feature films, a remarkable achievement explained in part by the complete control which he and his wife Marguerite Duparc, producer and editor (1933-1982), exercised over all aspects of production. Lefebvre, a humanist and moralist, has at times been concerned with the political agitation in Quebec (*Le Révolutionnaire,* 1965; *Mon Oeil,* 1970; *Jusqu'au coeur,* 1968; *Ultamatum,* 1973), and at others with the disarray of individuals who tell of their wounds and suffering (*Il ne faut pas mourir pour ça,* 1967; *Les Dernières Fiançailles,* 1973; *L'Amour blessé,* 1975). Although Lefebvre regularly works on a low budget, his style touches every aspect of his films, and is characterized by the use of natural settings, sequential shots, stationary camera, and consistently bold editing. His films are often on the cutting edge of experimental cinema.

Francis MANKIEWICZ (Shanghai, China, 1944)
Director, filmwriter.

As a director, Mankiewicz won acclaim with his first film, *Le Temps d'une chasse* (1972), the story of three working men whose flaws and frustrations are revealed during a hunting weekend which ends with the accidental death of one of them. After eight years working on a number of assigned projects, Mankiewicz directed *Les Bons Débarras* (1980), which was based on a novel by Réjean Ducharme. Having successfully transposed the novelist's world and sensibility, Mankiewicz directed a second film using a scenario by Ducharme, *Les Beaux Souvenirs* (1981), and in 1988, adapted a novel by Jacques Savoie, *Les Portes tournantes.* After *Le Temps d'une chasse,* in which a child witnesses the death of his father, Mankiewicz created situations in which children strive to recreate an ideal family life centered on the mother.

Léo-Ernest OUIMET (Saint-Martin-de-Laval, 1877—Montreal, 1972)
Director, producer, distributor, theatre operator.

In January 1906, Ouimet opened the first movie theatre in Montreal, the Ouimetoscope. Soon afterwards, he began filming current events

in Montreal and Quebec, making newsreels which he then distributed through various movie houses. His activities were halted, however, by religious authorities, who considered movies immoral, and by the leaders of the American film industry. Forced to sell his distribution business in 1908, he continued his struggle against the clergy until 1912, when the Supreme Court of Canada authorized the showing of films on Sundays. By 1914, the Americans had lost their monopoly on the movie industry, and Ouimet resumed his activities as movie distributor and producer. In 1918, he produced three mid-length docudramas: *The Call of Freedom, Le Feu qui brûle,* and *Sauvons Nos Bébés.* Convinced of the impossibility of making full-length fiction films in Quebec, he went to California to film the only feature he ever produced: *Why Get Married?* (Paul Cazeneuve, 1922). After working in California and Toronto, Ouimet returned to Montreal in 1933 to operate a theater for films in French. He left the film industry in 1936, when a fire in his theater killed two persons. An extraordinary individual, Ouimet was a pioneer in all areas of Canada's film industry.

Pierre PERRAULT (Montreal, 1927)
Director.

A lawyer by training, Perrault became interested in cinema through his work in radio. His responsibilities there brought him in contact with people in many walks of life, inspiring him to film their activities before ancient traditions disappeared and were forgotten. His first long film *Pour la suite du monde* (co-directed with Michel Brault, 1963), was one of the finest achievements of direct cinema. The first in a trilogy of films devoted to the inhabitants of Ile-aux-Coudres, it was followed by *Le Règne du jour* in 1966, and *Les Voitures d'eau* in 1968. A filmwriter and poet, Perrault made two other important series: the four-film cycle on Abitibi, which included *Un Royaume vous attend* (1977), co-directed with B. Gosselin; and the second series, about American Indians, consisting of two films, *Le Goût de la farine,* co-directed with B. Gosselin in 1977, and *Le Pays de la terre sans arbre ou le Mouchouanipi* (1980). Perrault's cinema goes beyond mere observation of reality. Through his use of settings and his editing, he creates a unique world and takes a political stance, as well (*Un Pays sans bon sens!,* 1979).

Anne Claire POIRIER (Saint-Hyacinthe, 1932)
Director, editor, producer.

A pioneer in women's films in Quebec, Poirier has worked at the ONF since 1960. Her work, which adopts a broad feminist perspective, has focused on issues of particular concern to women: pregnancy and motherhood (*De Mère en fille,* 1967), abortion (*Le Temps de l'avant,* 1975)

and rape (*Mourir à tue-tête*, 1979). Her work is characterized by the use of distancing techniques and by editing which boldly juxtaposes images and scenes of differing content and style. This is particularly evident in *Les Filles du roy* (1974), a film which traces the history of women's servitude in Quebec. As a producer, Poirier developed "En tant que femmes," a program which has made possible the debut of several women filmmakers, including Mireille Dansereau (*J'me marie, j'me marie pas*, 1973), and Hélène Girard (*Les Filles, c'est pas pareil*, 1974).

Léa POOL (Soglio, Switzerland, 1950)
Director, filmwriter.

Soon after arriving in Quebec in 1978, Pool made her first feature film, *Strass Café* (1980), which is related in style to the work of Marguerite Duras. Her subsequent films—*La Femme de l'hôtel* (1984), *Anne Trister* (1986), *A Corps perdu* (1988)—depict a world of exile, wandering, melancholy, and the quest for identity. Through her careful exploration of cities, she examines the relationship between art and reality. Pool's cinema, which reflects her high artistic standards, belongs to the post-modern movement of the 1980s.

Maurice PROULX (Saint-Pierre-Montmagny, 1902—La Pocatiere, 1988)
Director.

Ordained to the priesthood in 1928, Proulx discovered cinema while a student of agriculture at Cornell University, thus beginning what was to be a long career. First using film to extol life in rural Quebec, Proulx eventually became the Duplessis government's official cinematographer. His films are frequently didactic, as in *Le Labour Richard* (1939) and *Le Lin du Canada* (1947), but they often contain a certain poetry, too, as in his best known film, *En Pays neufs* (1934–1937), a promotional documentary which emphasized the merits of settling Abitibi. Religious subjects were also of interest to Proulx. In 1939, once again turning his attention to his land and people, he recorded Quebec's tourist attractions in *En Pays pittoresque*.

Albert TESSIER (Sainte-Anne-de-la-Perade, 1895—Trois Rivières, 1976)
Director.

Tessier was ordained a priest in 1920, and in 1924 began making films. Always interested in nature, he not only used it as a dominant theme (*Dans le bois*, 1930; *La Pêche*, 1940; *La Forêt bienfaisante*, 1943), but also sought to show the value of working in close partnership with nature (*Hommage à notre paysannerie*, 1938). Other films were designed to glorify God as the creator of nature (*Gloire à l'eau*, 1935; *Cantique*

de la création, 1942). Like most of Quebec's pioneers in cinema, he made films on religious subjects, as well. In addition, he took an interest in education (*Femmes dépareillées,* 1949) and art (*Quatre Artistes canadiens,* 1939; *Artisanat familial,* 1942). A man who deeply loved Quebec (*Pour aimer ton pays,* 1943), Tessier was also a man of culture, sensitivity, and warmth. Because of his interest in recording the world around him, it can also be said that he anticipated the goals and techniques eventually developed under the banner of direct cinema.

NOTE

1. Marcel Jean is the author with Michel Coulombe of *Le Dictionnaire du cinéma québécois* (Montréal: Boréal, 1988) from which the present "Biographical Dictionary" is in part derived. The English translation of this section was executed by Dr. Katherine Dennis of Michigan State University.

SELECTED BIBLIOGRAPHY

Beatie, Eleanor. *A Handbook of Canadian Film*. 2d ed. Toronto: Peter Martin Associates in association with *Take One* magazine, 1977.

Berton, Pierre. *Hollywood's Canada: The Americanization of Our National Image*. Toronto: MacClelland and Stewart, 1975.

Bérubé, Rénald, and Yvan Patry, et al. *Le Cinéma québécois: tendances et prolongements*. Montréal: Editions Sainte-Marie, 1968.

Bonneville, Léo. *Dossiers de cinéma*. Montréal, Ottawa: Fides, 1968.

Le Cinéma québécois par ceux qui le font. Montréal: Editions Paulines Inc., 1979.

Brulé, Michel. *Vers une politique du cinéma au Québec*. Québec: Document de travail, Direction générale du cinéma et de l'audio-visuel, 1978.

Carriére, Louise, et al. *Femmes et cinéma québécois*. Montréal: Boréal Express, 1983.

CinémAction. No. 40, "Aujourd'hui le cinéma québécois." Paris-Montréal: Cerf OFQJ, 1986.

Coulombe, Michel, and Marcel Jean. *Le Dictionnaire du cinéma québécois*. Montréal: Boréal, 1988.

Daudelin, Robert. *Vingt Ans de cinéma au Canada français*. Québec: Ministère des Affaires culturelles, 1967.

Dérives no. 51, Cinéma québécois, nouveaux courants, nouvelles critiques. Montréal, 1986.

Fournier-Renaud, Madeleine, and Pierre Véronneau. *Ecrits sur le cinéma: bibliographie québécoise: 1911–1981*. Montréal: La Cinémathèque québécoise, 1982.

Houle, Michel, and Alain Julien. *Dictionnaire du cinéma québécois*. Montréal: Fides, 1978.

Lafrance, André (avec la collaboration de Gilles Marsolais). *Cinéma d'ici*. Montréal: Leméac et Droits dérivés de Radio-Canada, 1973.

Lamartine, Thérèse. *Elles cinéastes ad lib 1895–1981*. Montréal: Les Editions du Remeu-Ménage, 1985.

Lamonde, Yvan, and Pierre-François Hébert. *Le Cinéma au Québec: essai de statistique historique: 1896 à nos jours*. Québec: Institut québécois de recherche sur la culture, 1981.

Larochelle, Réal. "Le Cinéma québécois en voie d'assimilation." dans *Pratique culturelle des québécois*. Québec: IQRC, 1986.

Leboutte, Patrick et al. *Cinémas du Québec, au fil du direct*. Liège: Editions Yellow Now, 1986.

Lever, Yves. *Cinéma et société québécoise*. Montréal: Editions du Jour, 1972.

Histoire du cinéma au Québec. Québec: DGEC, 1983.

Lockerbie, Ian. Ed., *Image and Identity: Theatre and Cinema in Scotland and Quebec*. Sterling: The John Grierson Archives, University of Sterling, 1988.

Major, Ginette. *Le Cinéma québécois à la recherche d'un public, bilan d'une décennie*. Montréal: Presses de l'Université de Montréal, 1982.

Marsolais, Gilles. *Le Cinéma canadien*. Montréal: Editions du Jour, 1968.

Morris, Peter. *Embattled Shadows: A History of the Canadian Cinema, 1895-1939*. Montréal: McGill-Queen's University Press, 1978.

Noguez, Dominique. *Essais sur le cinéma québécois*. Montréal: Editions du Jour, 1970.

Pageau, Pierre, and Yves Lever. *Cinémas canadien et québécois*. Montréal: Collège Ahuntsic, Pierre Pageau et Yves Lever, 1977.

Perrault, Pierre. *Caméramages*. Paris: Edilig, 1983.

Tadros, Jean-Pierre, Marcia Couelle, and Connie Tadros. *Le cinéma au Québec: bilan d'une industrie*. Montréal: Les Editions Cinéma Québec, 1975.

Tadros, Jean Pierre, Bernard Voyer, and France Simoneau. *Le Cinéma au Québec: Répertoire 1979*. Montréal: Les Editions Cinéma Québec, 1979.

Tremblay-Daviault, Christiane. *Un Cinéma orphelin, structures mentales et sociales du cinéma québécois: 1942-1953*. Montréal: Québec-Amérique, 1981.

Turner, D. John. *Index des films canadiens de long métrage, 1913-1985*. Ottawa: Archives nationales du Canada, 1986.

Véronneau, Pierre (dir.), et al. *Les Cinémas canadiens*. Paris, Montréal: Lherminier et Cinémathèque québécoise, 1978.

Véronneau, Pierre. *Le Succès est au film parlant français*. Vol. 1, *Histoire du cinéma au Québec*. Montréal: Cinémathèque québécoise, 1979. (Les Dossiers de la cinémathèque, 3)

Cinéma de l'époque duplessiste. Vol. 2, *Histoire du cinéma au Québec*. Montréal: Cinémathèque québécoise, 1979. (Les Dossiers de la Cinémathèque, 7)

Résistance et affirmation: la production francophone à l'ONF—1939–1964. Vol. 3, *Histoire du cinéma au Québec*. Montréal: Cinémathèque québécoise/Musée du cinéma Montréal, 1987.

Véronneau, Pierre, ed. *Self Portrait* (Essays on the Canadian and Québec cinemas). (Traduction anglaise, dirigée par Piers Handling, avec des ajouts, des *Cinémas canadiens*.) Ottawa: Canadian Film Institute, 1980.

Véronneau, Pierre, Michael Dorland, and Seth Feldman. *Dialogue Cinéma canadien et québécois—Canadian and Québec Cinéma*. Montréal: Médiatexte Publications, Inc./Cinémathéque québécoise, 1987. (Canadian Film Studies/Etudes cinématographiques canadiennes, 3).

INDEX

Essays on Quebec Cinema

Production Editor: Julie L. Loehr
Design: Lynne A. Brown
Copy Editor: Martha Bates
Index: Ellen Link

Text composed by Lansing Graphics, Inc.
in Cheltenham ITC Book 10/11.6

Printed by BookCrafters
on 60# Finch Opaque

Bound in Holliston Crown Linen 13745 Country Blue—
stamped with General Roll Leaf semi-gloss foil, pigment #P650